THE MUSEUM of DUBIOUS ART

Collected Drawings

by Neil Baker

authorHOUSE®

AuthorHouse™
1663 Liberty Drive
Bloomington, IN 47403
www.authorhouse.com
Phone: 1-800-839-8640

Published by AuthorHouse 6/18/2013

ISBN: 978-1-4772-8676-0 (sc)
ISBN: 978-1-4772-8675-3 (e)

Library of Congress Control Number: 2012921720

Contents

Introduction

You are about to embark upon a journey in a land of illustrations with a message … multiple messages.

In drawing, my goal is to touch the "child" within all of us. The more humorous the better; however, I do not limit myself to the mere whimsical nature of man, but also attempt to expand my expression into the more serious and somber aspects of existence as well. My style is spontaneous in that I sit down with nothing but a line and the innumerable deviations of such to guide me. Even though my subjects and themes cover a wide variety of topics, my drawings strive for a universal appeal with a bit of social commentary. More often than not my characters will appear off balance, with exaggerated features and proportions, but this is all in an attempt to keep the expression interesting and eye catching. I view my characters as both people and creatures in the world, however distorted. In some form, the following satirical caricatures and scenes should be viewed both as simplistic and challenging.

Please note that according to AuthorHouse's policies, my publishers have removed any depictions of both male and female genitalia from any drawings that contained such visuals. Although the number of these drawings are limited, I, as the artist, apologize for the required discretions.

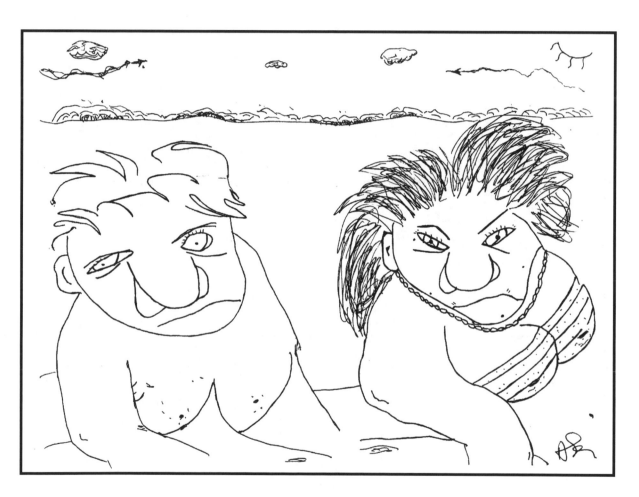

Beach Couple

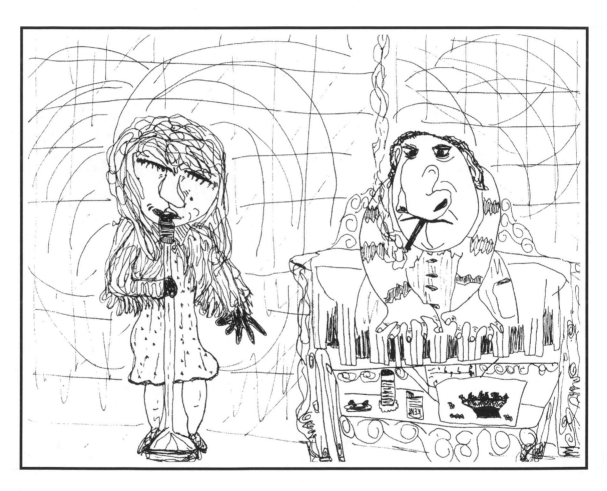

Singing The Blues

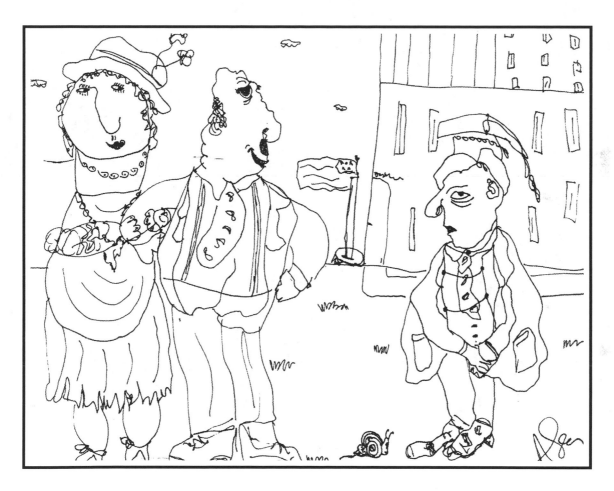

Graduation Day

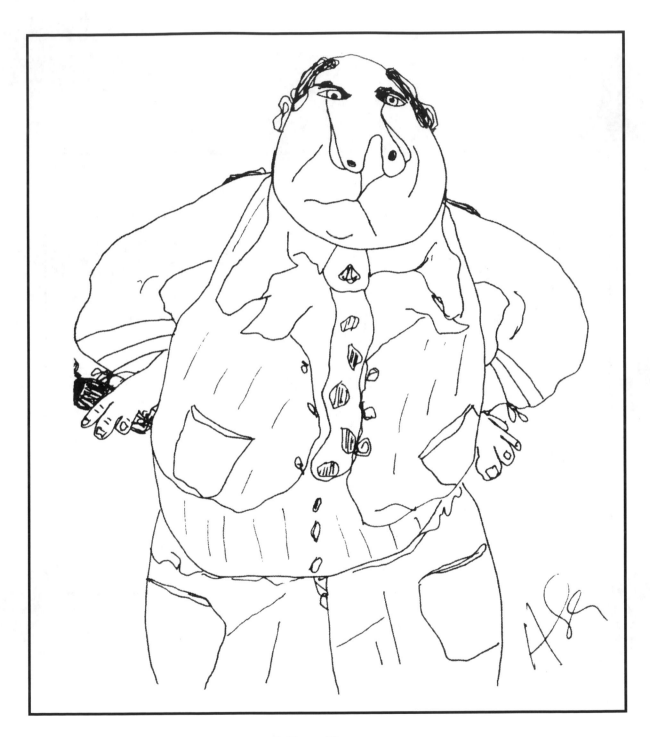

The Boss

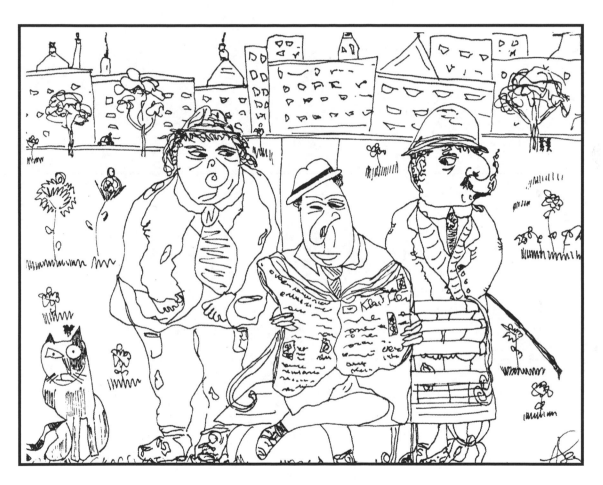

Park Bench

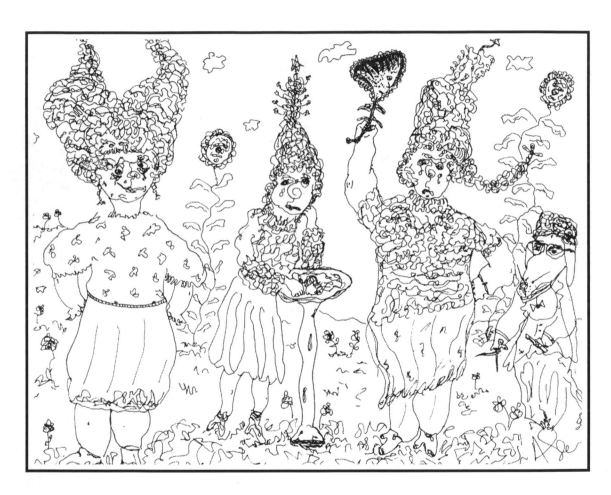

Te Leus Le Dog

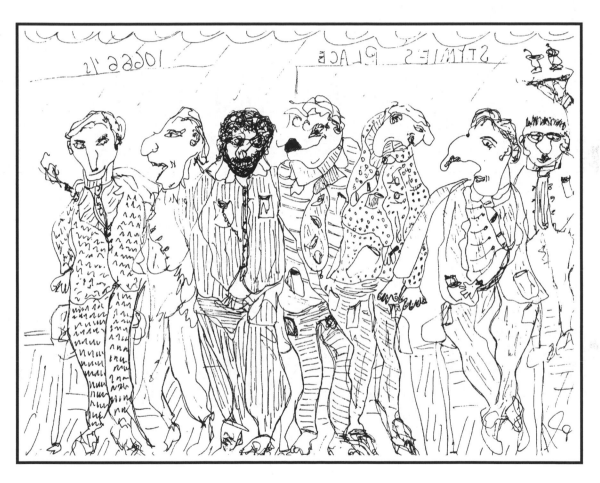

Gay Bar

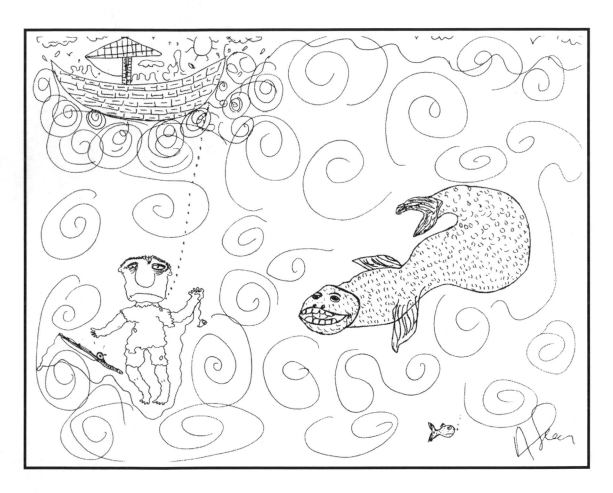

Jonah

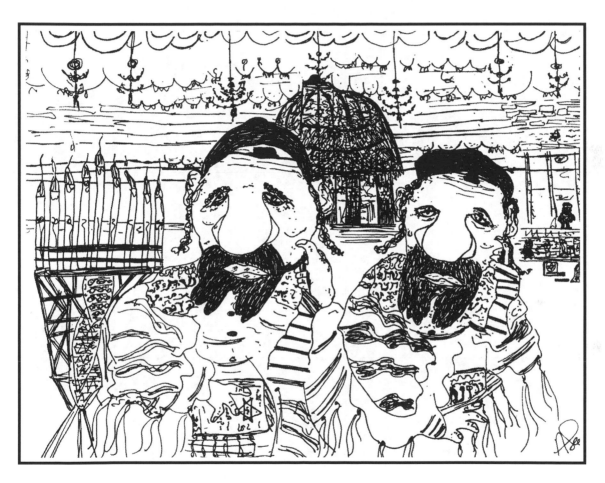

Two Thinking Rabbis

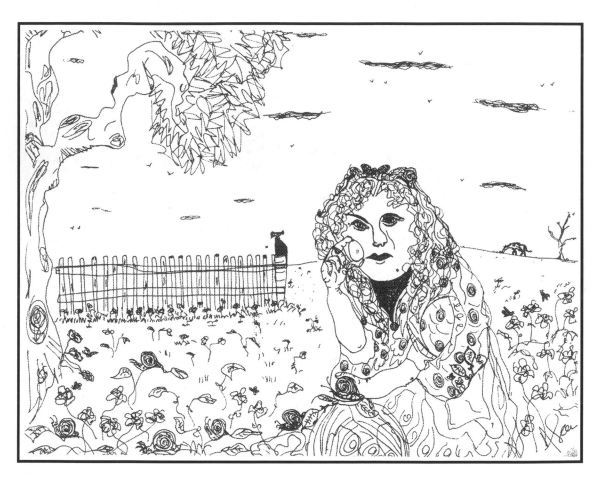

Young Ornithologist

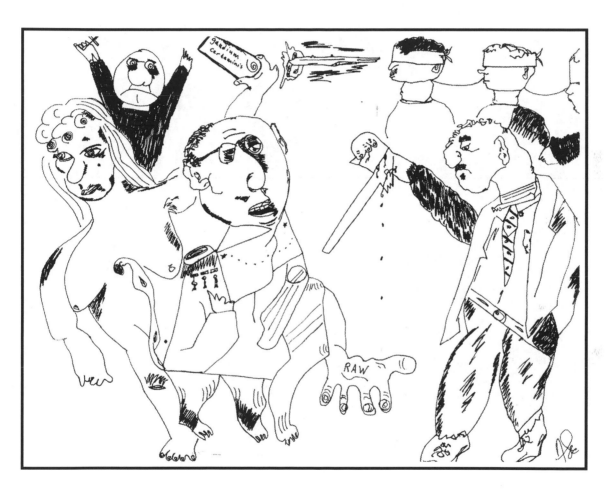

Revolution

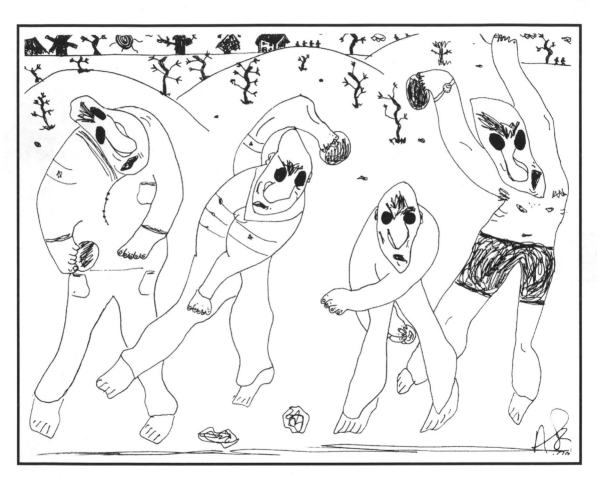

The Stone Throwers

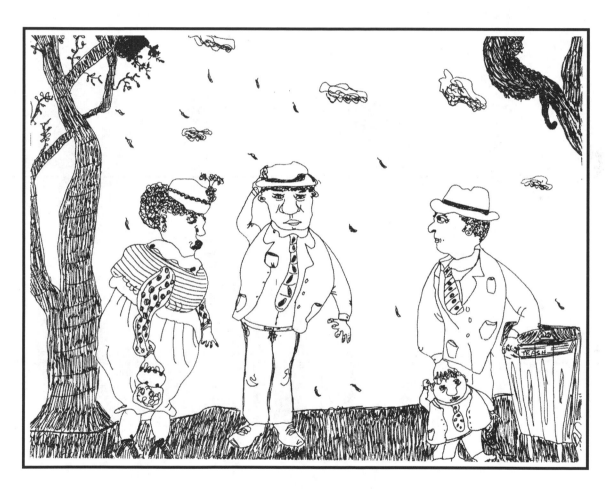

The Lost Child

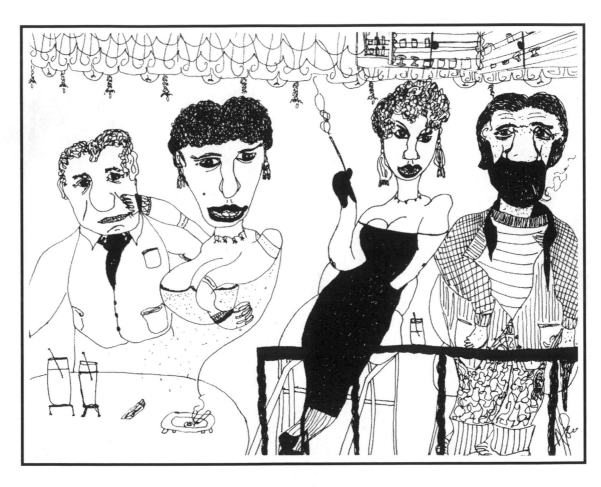

Sophisticated Ladies

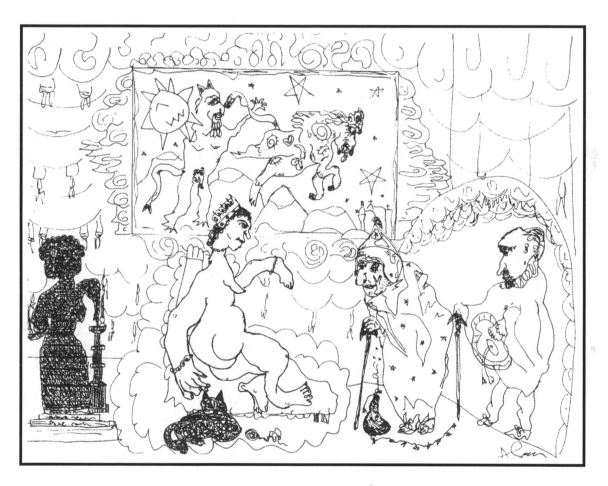

Renaissance

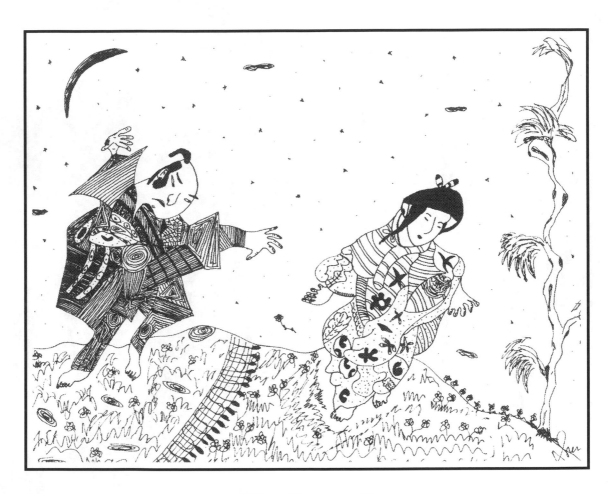

The Pursuit

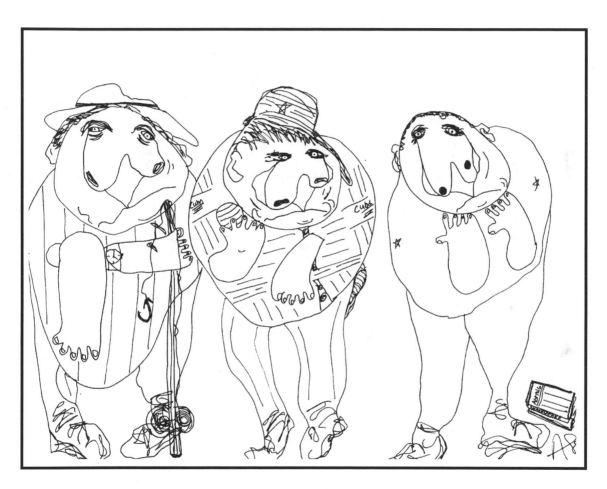

Three Brothers

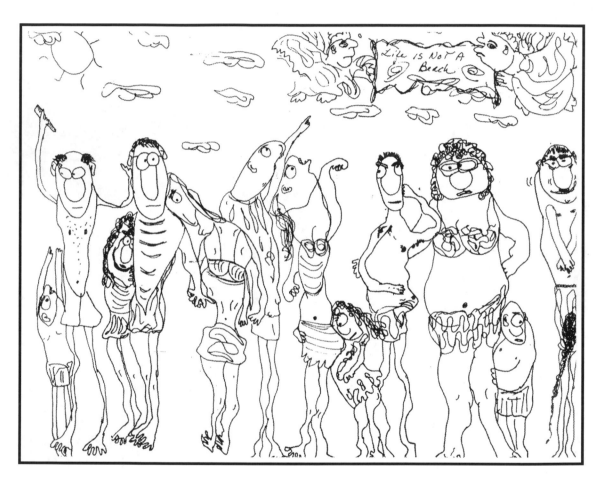

Life Is Not A Beach

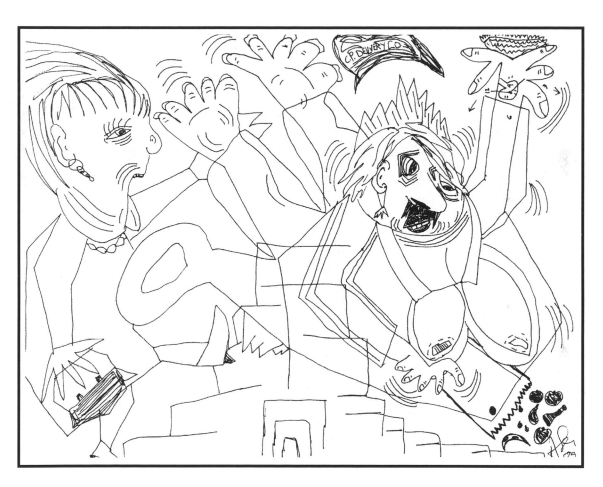

The Stairway

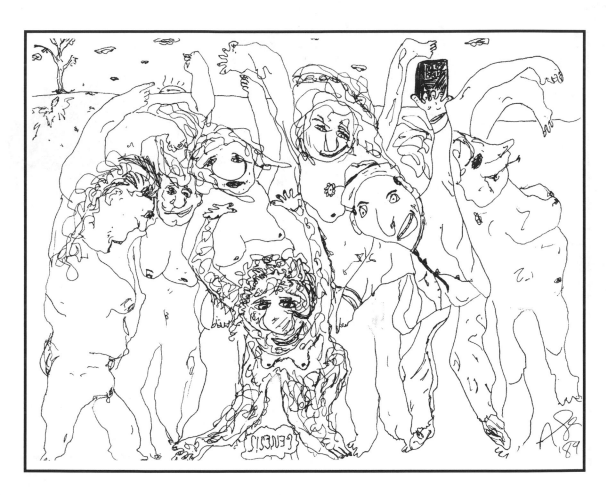

The Evangelist

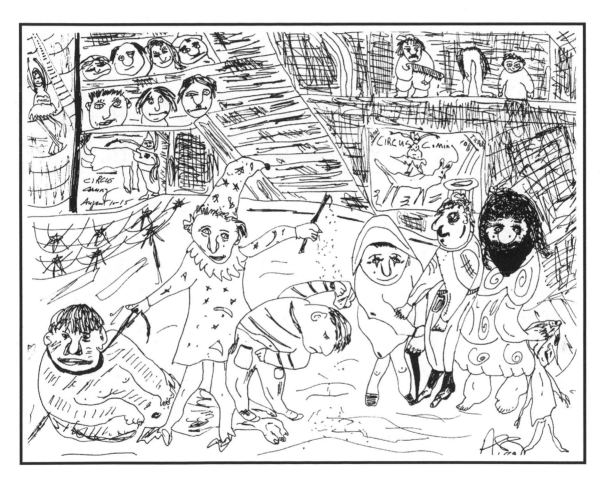

Circus Preview

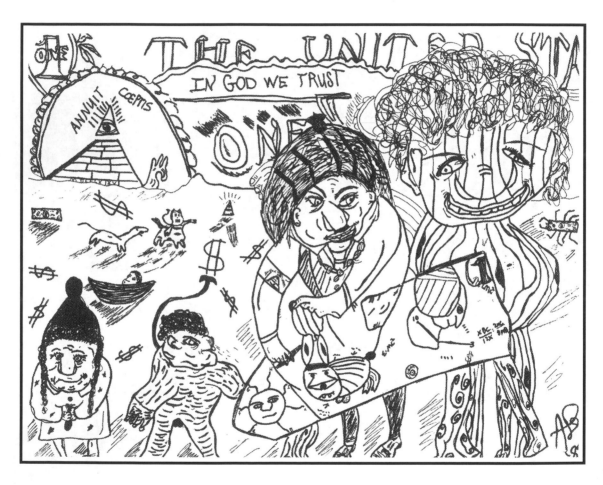

Novus Ordo Seclorum

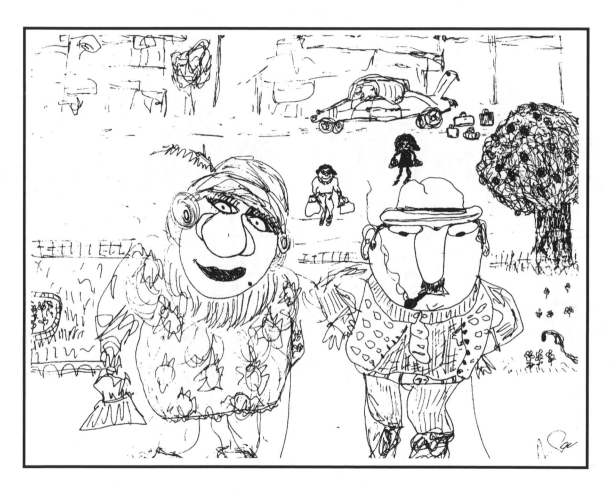

Surprise Visit

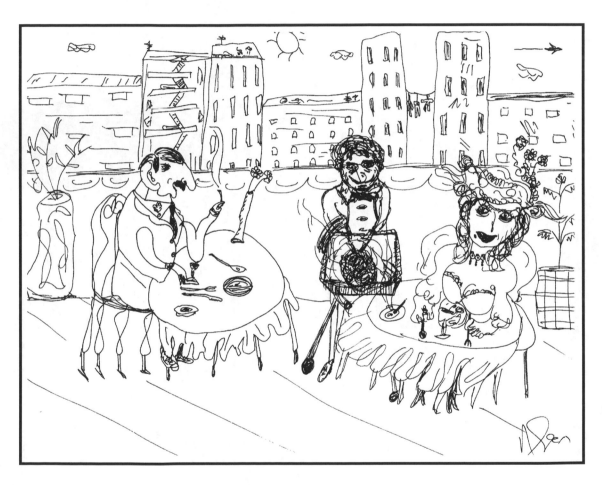

First Glance

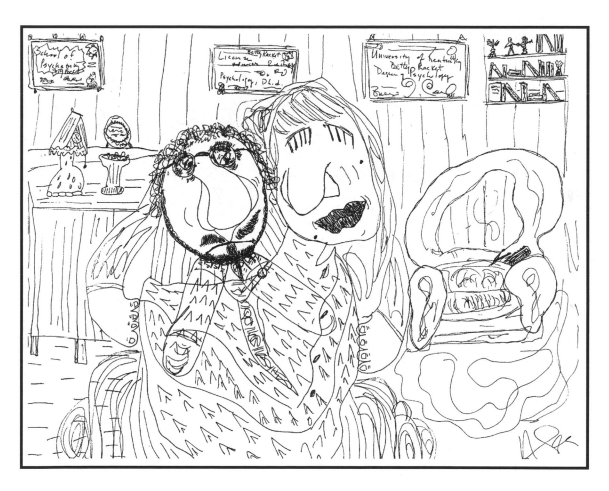

The Comforting Therapist

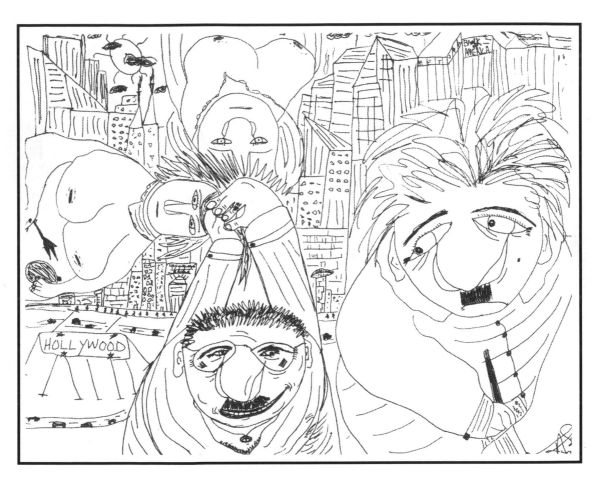

Hollywood Mogul

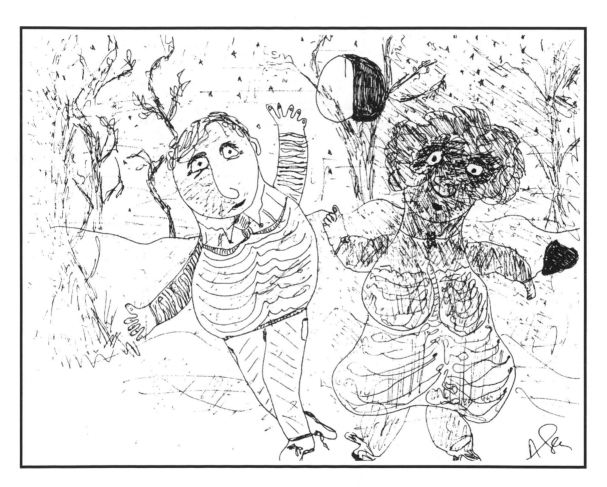

Moonlight Escapade

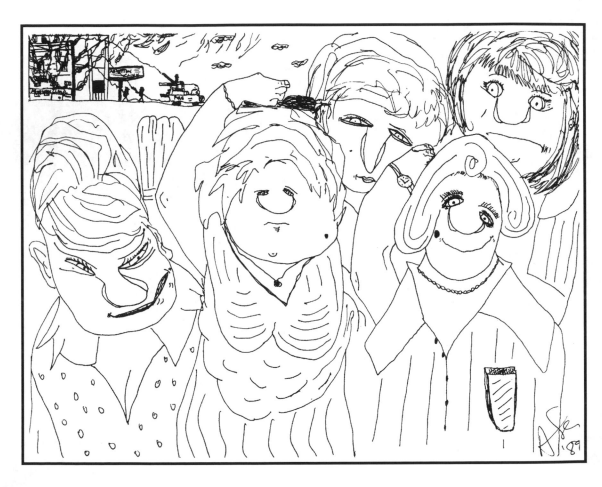

Mother's Against Abortion

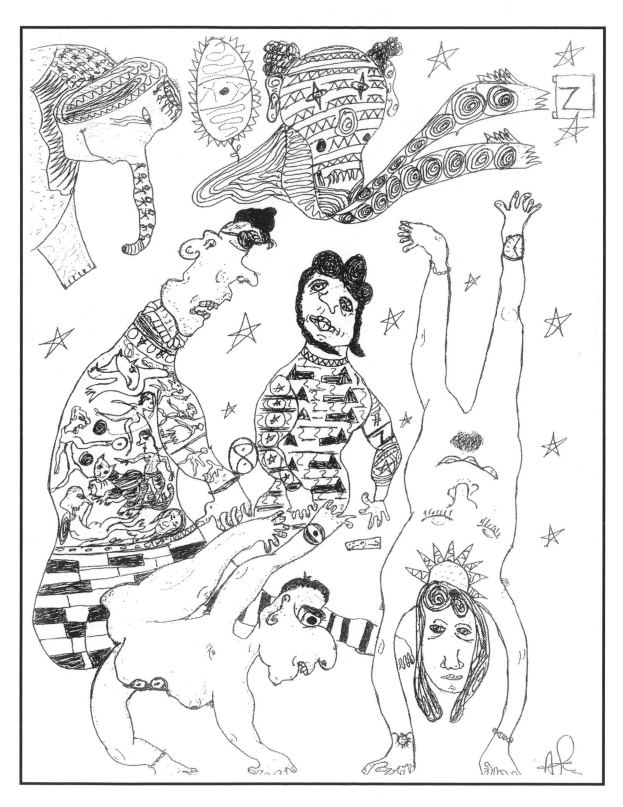

Out The Z Room

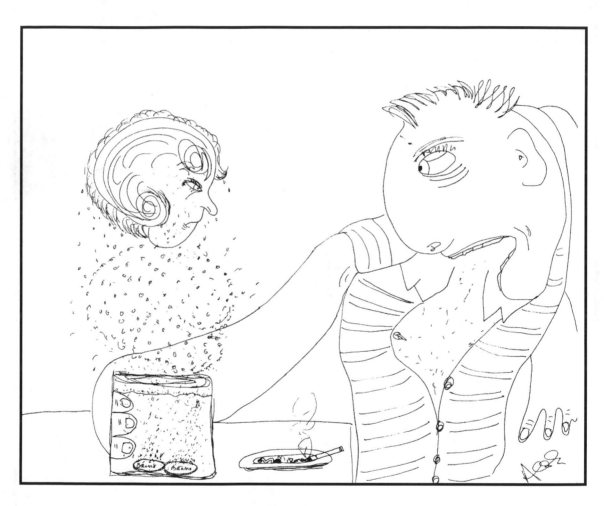

Alka-Helter

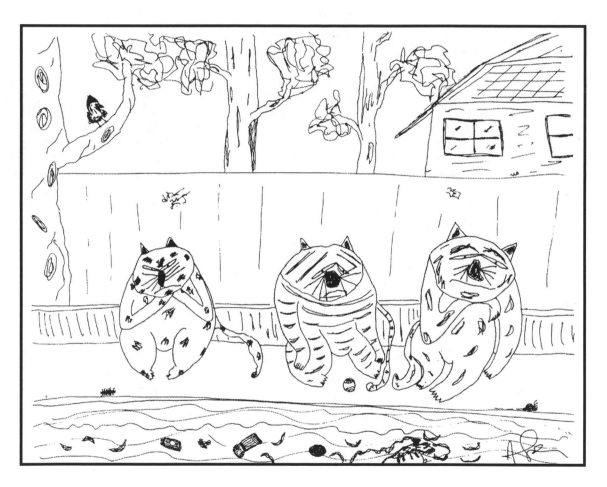

Boredom

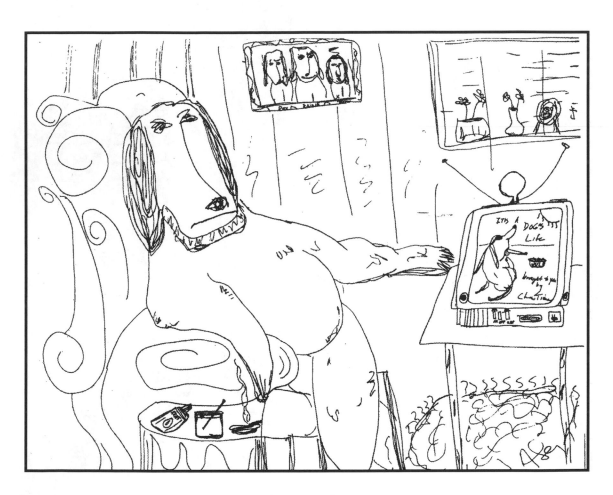

Watchdog

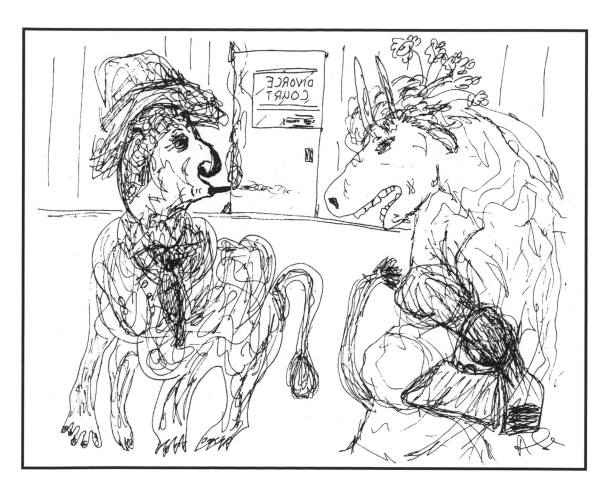

Divorce Court

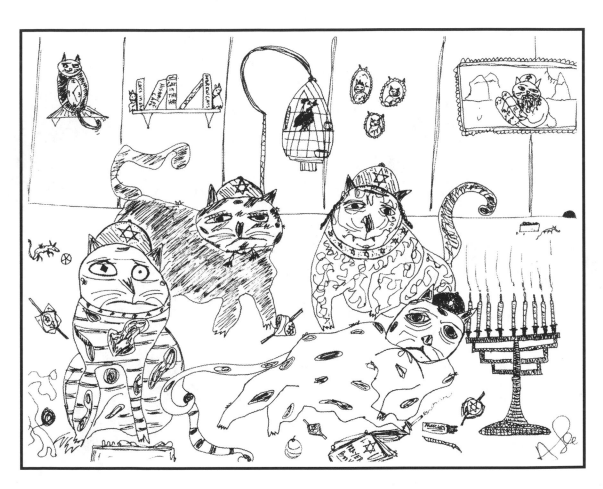

Hanukkah Cats

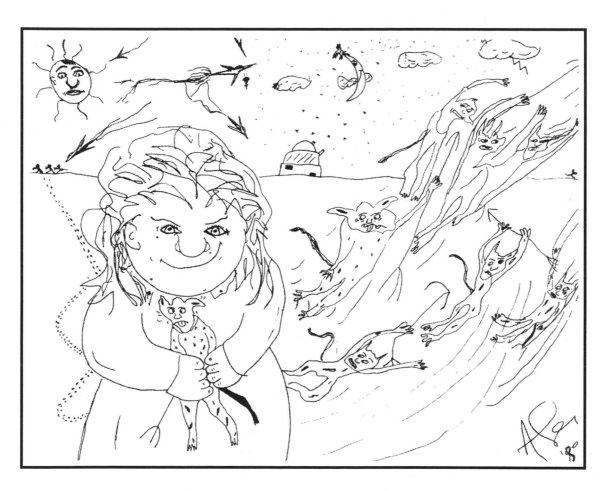

Judy Tormenting Demons

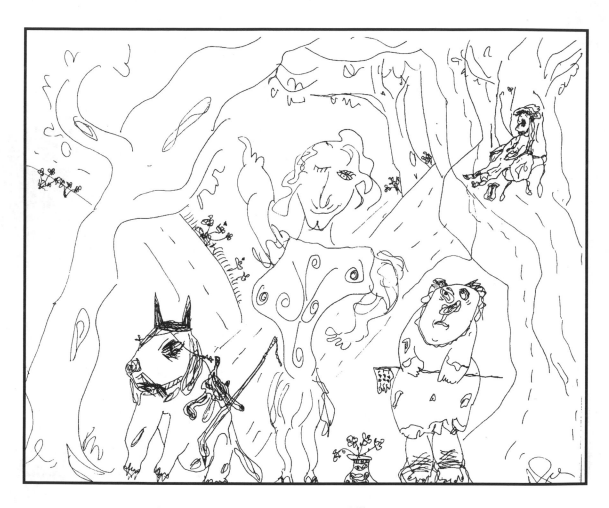

Don Decodey

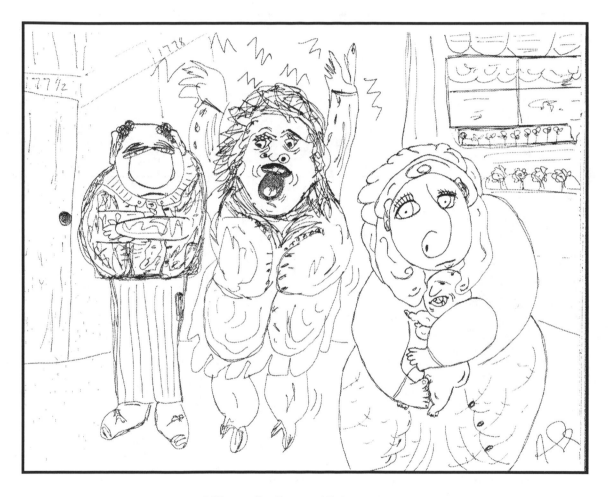

The Other Woman

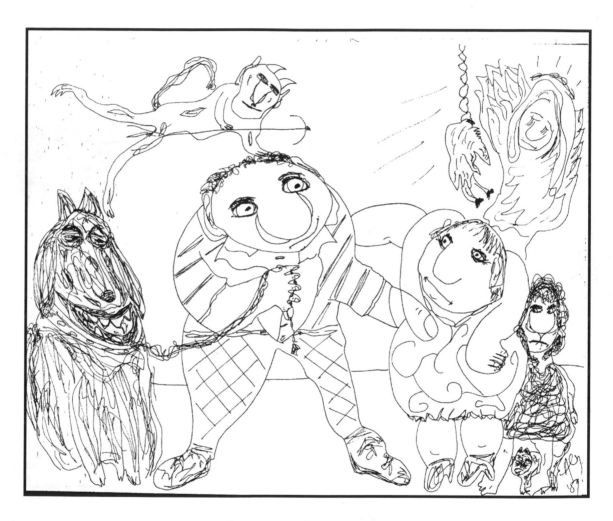

Custody Battle

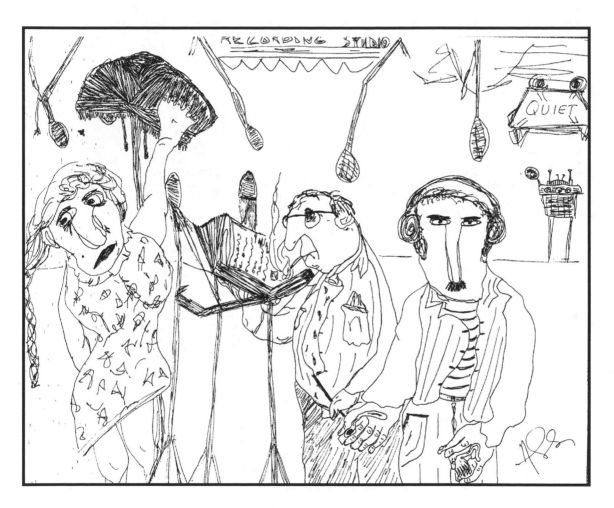

Recording Studio

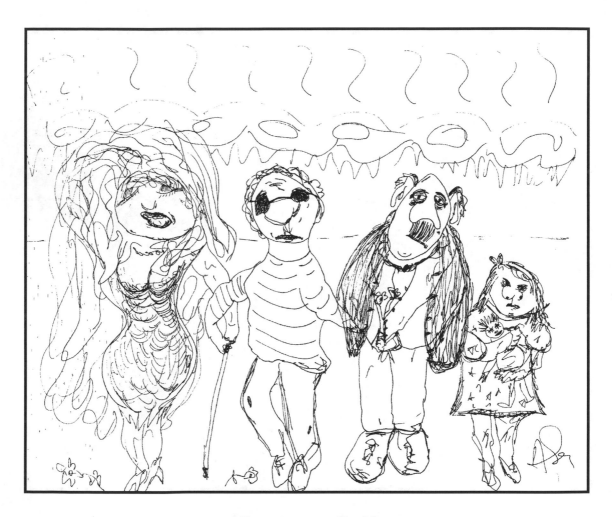

Curtain Call

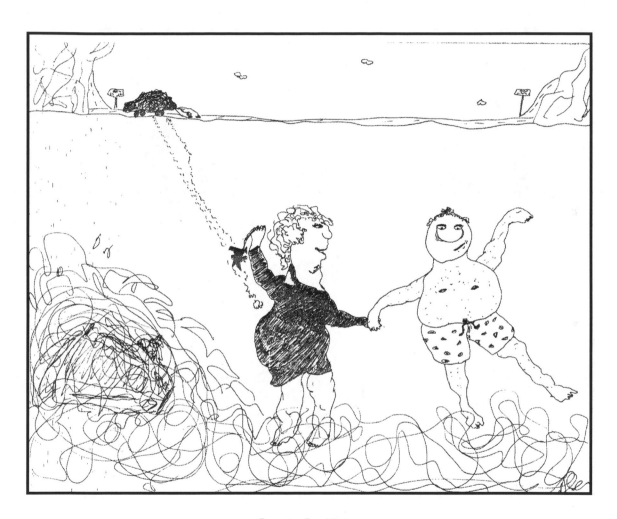

Quick Dip

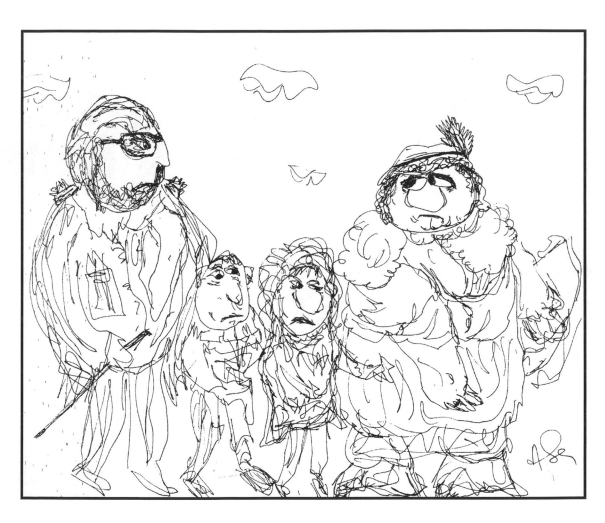

Family Outing

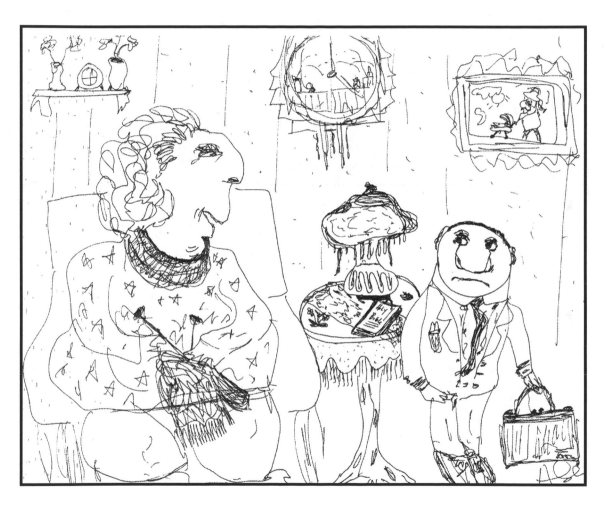

Off To Work

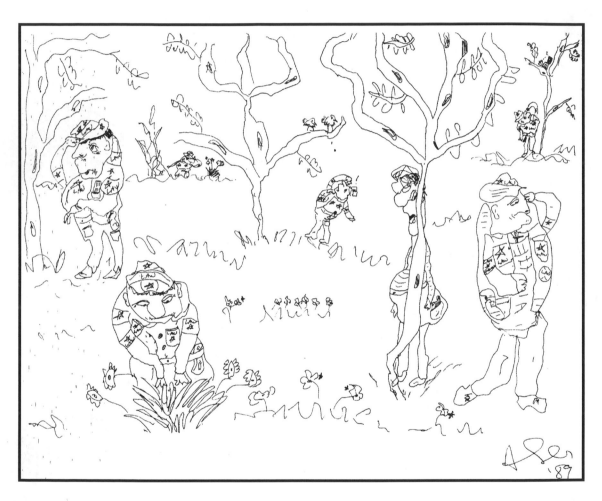

Manhunt

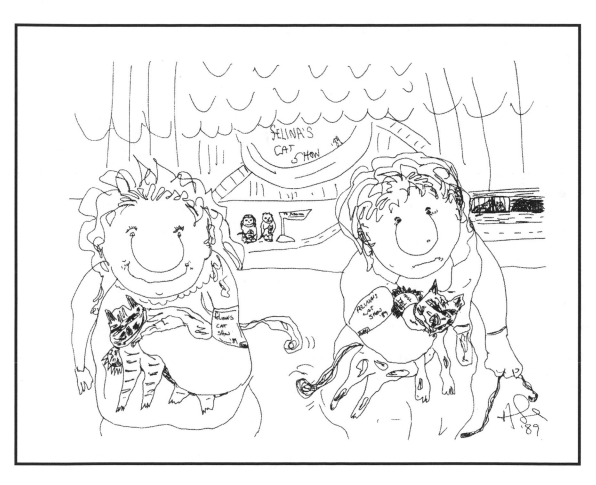

Felina's Cat Show

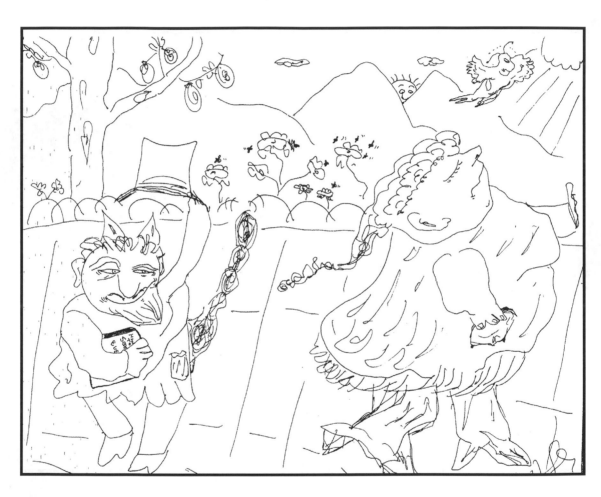

How To Seduce Eve

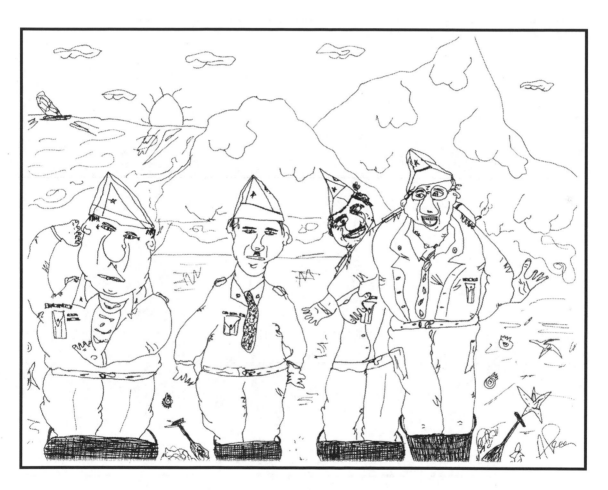

Basket Cases

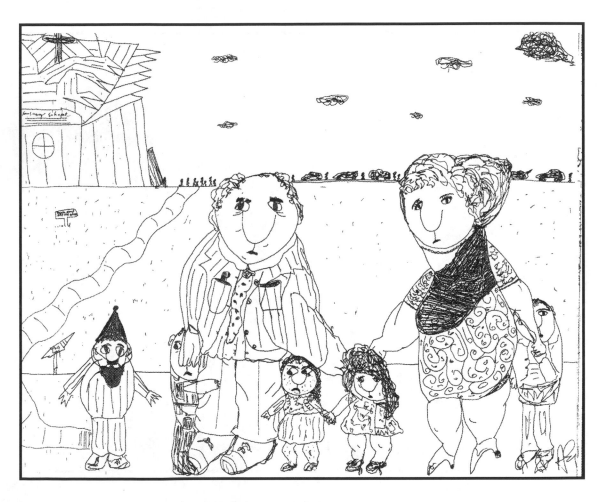

Strange Encounter On A Sunday

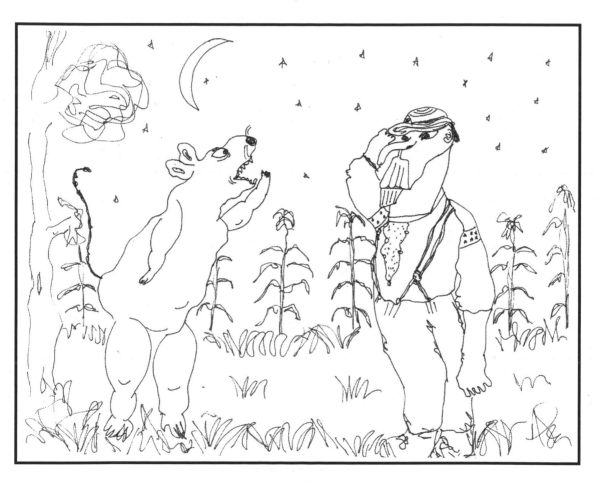

Civil War Secrets

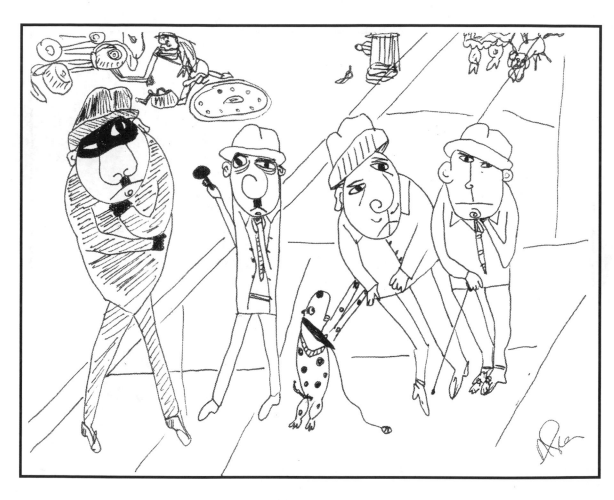

Confounding The Law

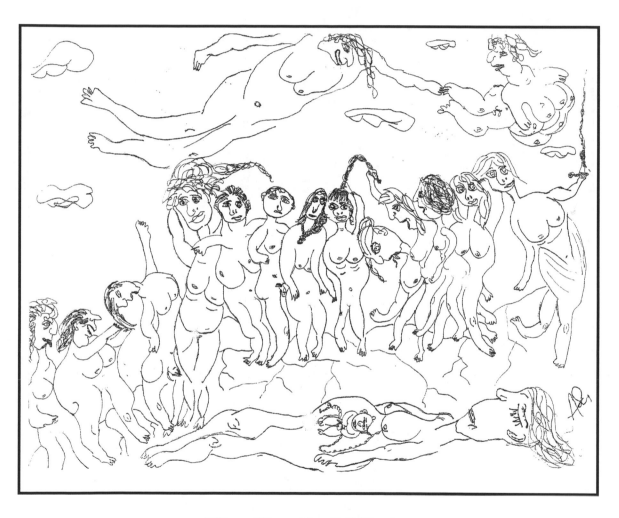

The Death Of Gaia

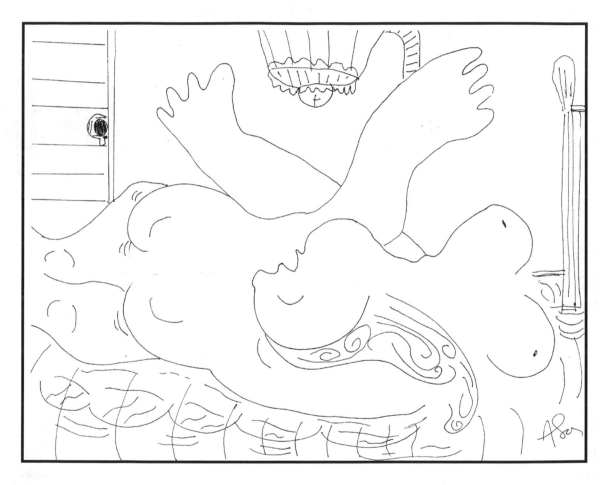

Nude Dreams

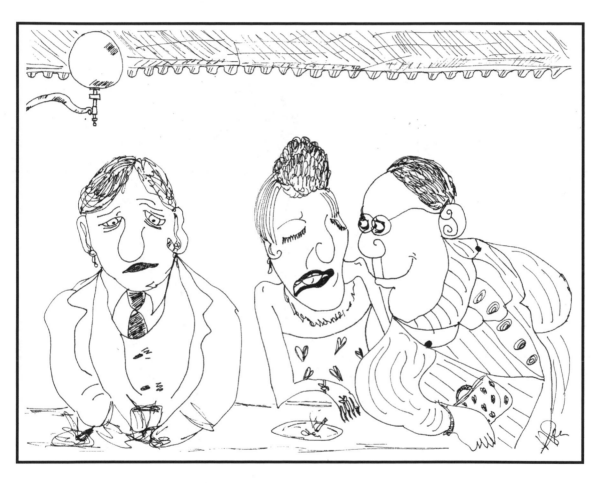

I Prefer Someone A Bit More Agressive

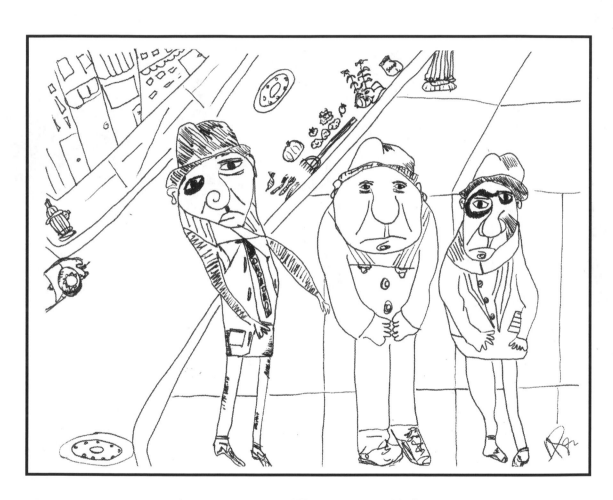

Arresting Farmer John

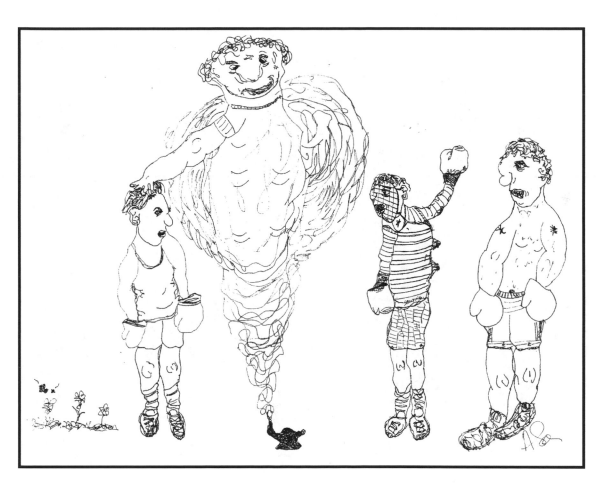

The Boxer's Genie

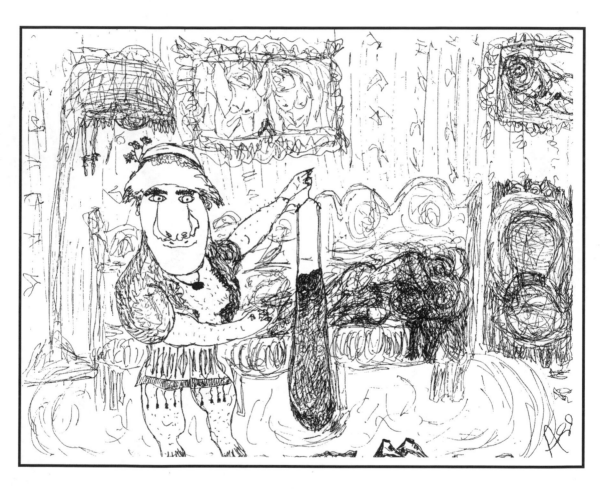

Cross Dresser

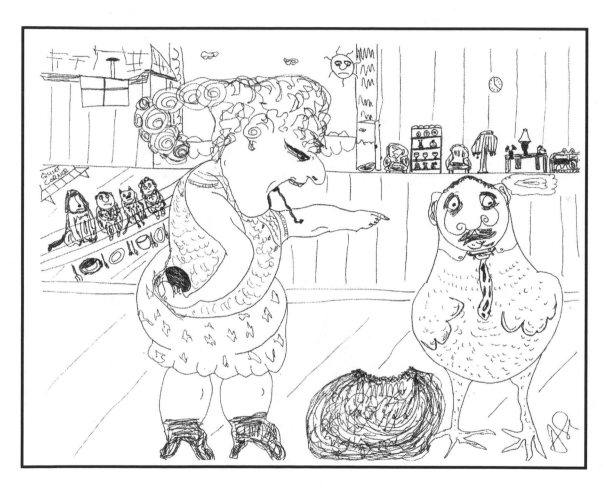

Hen Pecked

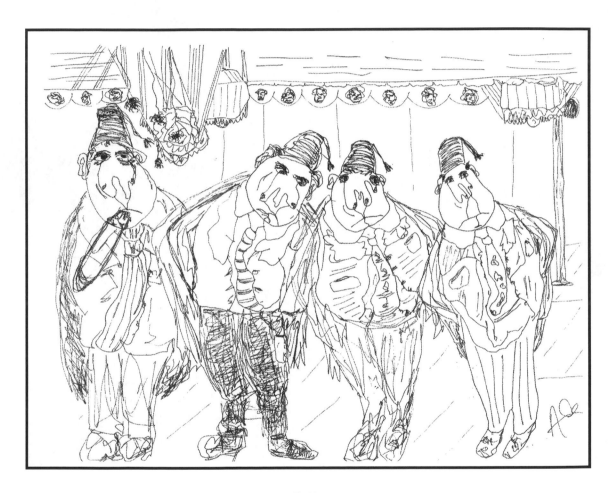

Four Masons

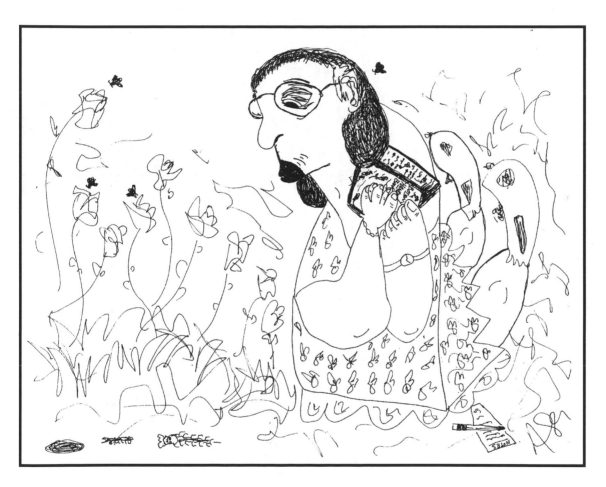

The Entomologist

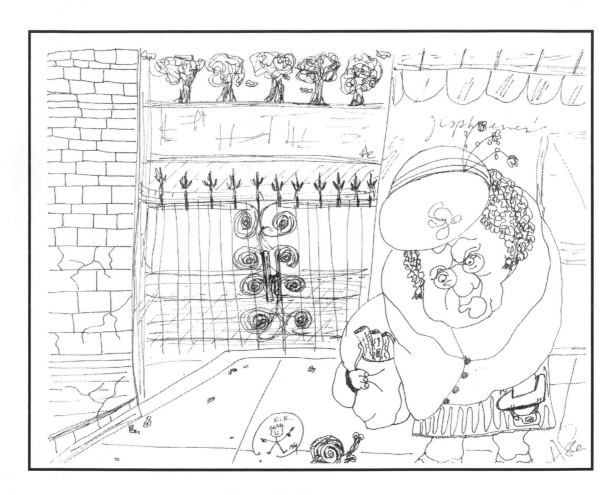

Snail Crossing

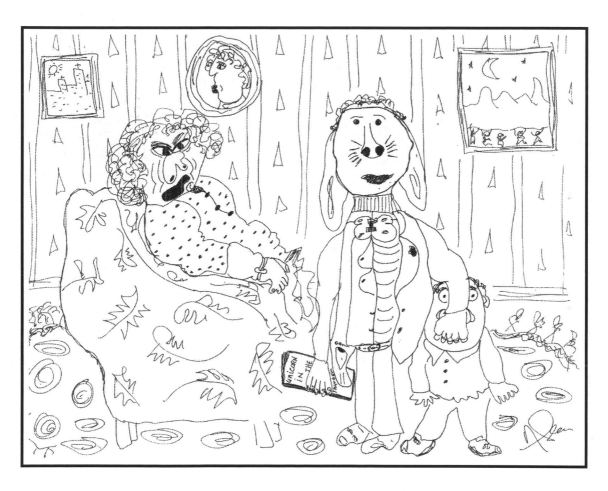

Harvey and the Parlor

Mother's Day

Mother's KISS

Real Estate Ladies

Christmas Day

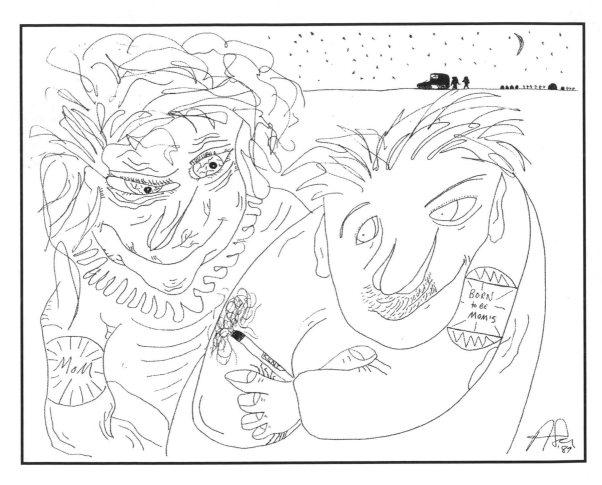

Born to Be Mom's

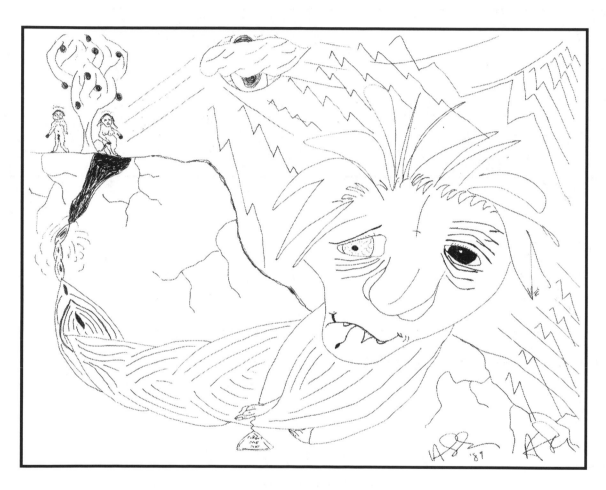

Satan's Flee

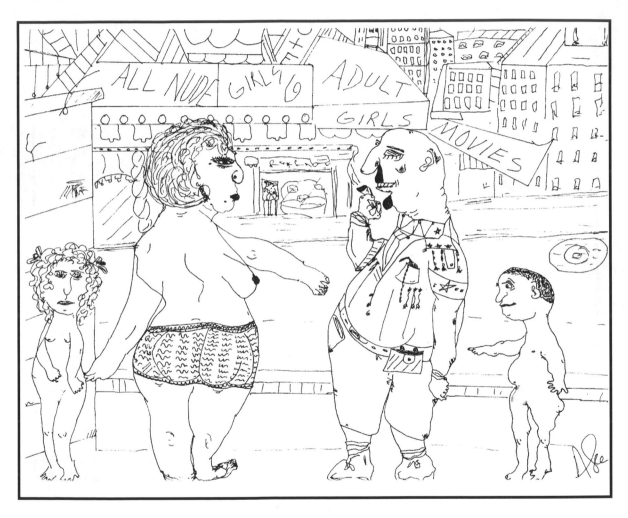

Lost Innocence

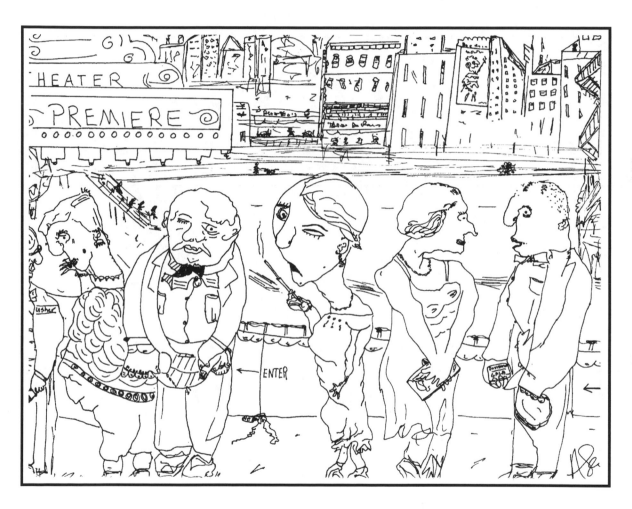

Hollywood Premier

The Actor's Assassin

Garage Sale

Mrs. "L"

Rock Star Obsession

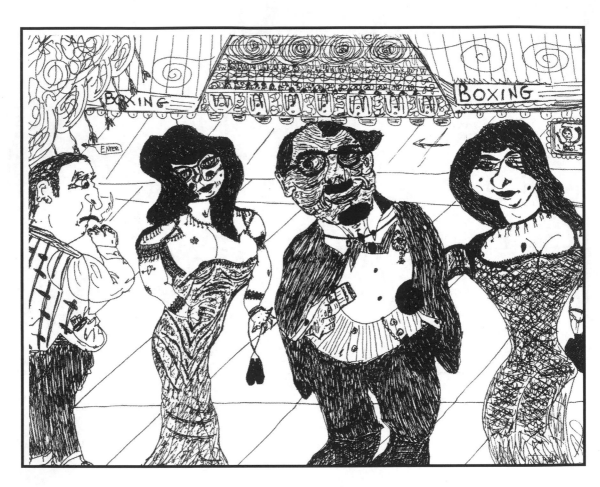

Friday Night Boxing

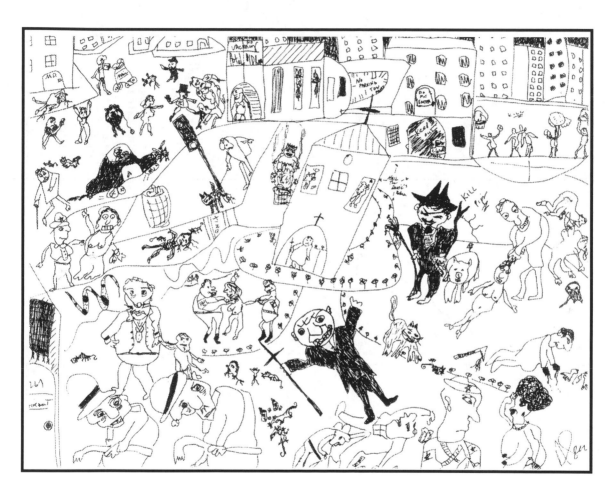

Final Hour

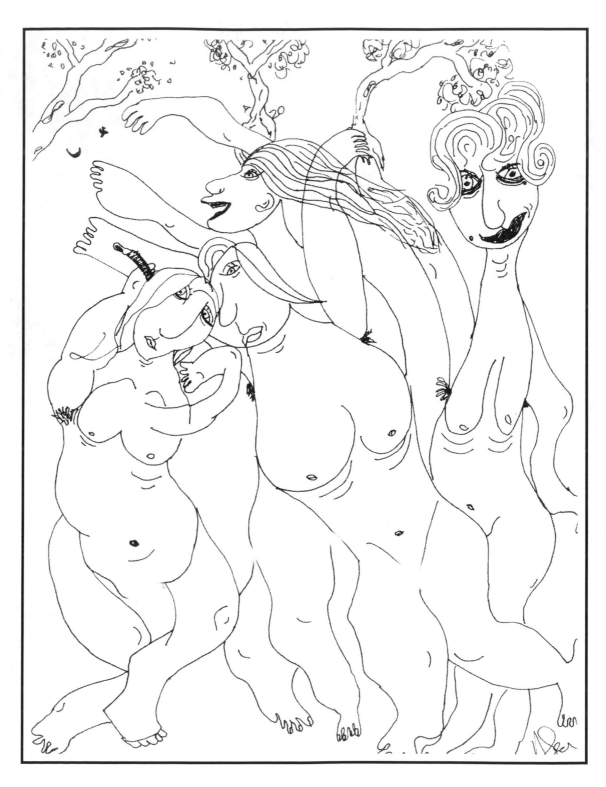

The Nymphs

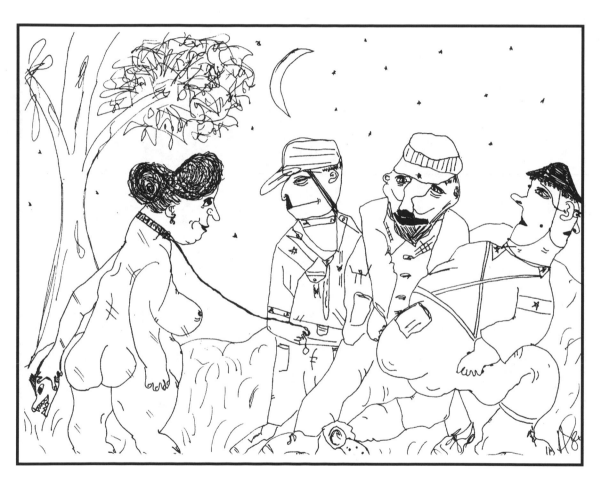

The Prisoner

The Audition

Chinese Cat

Fisherman's Protest

Venice Ballerinas

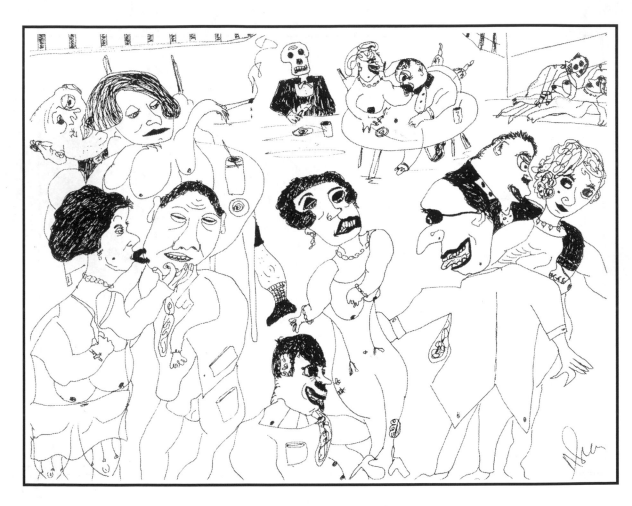

Nightclub Thanatos

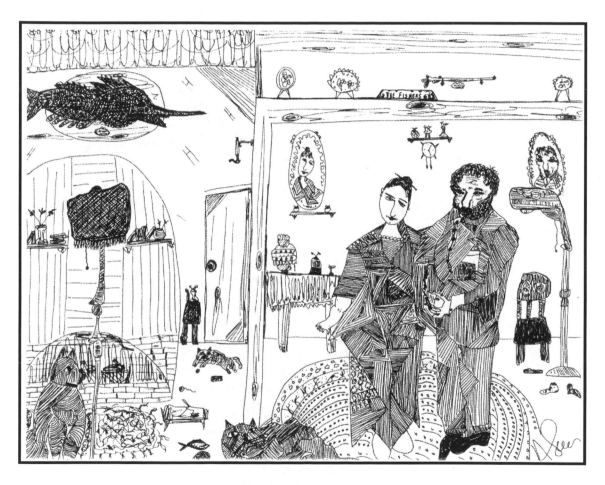

The Fishers

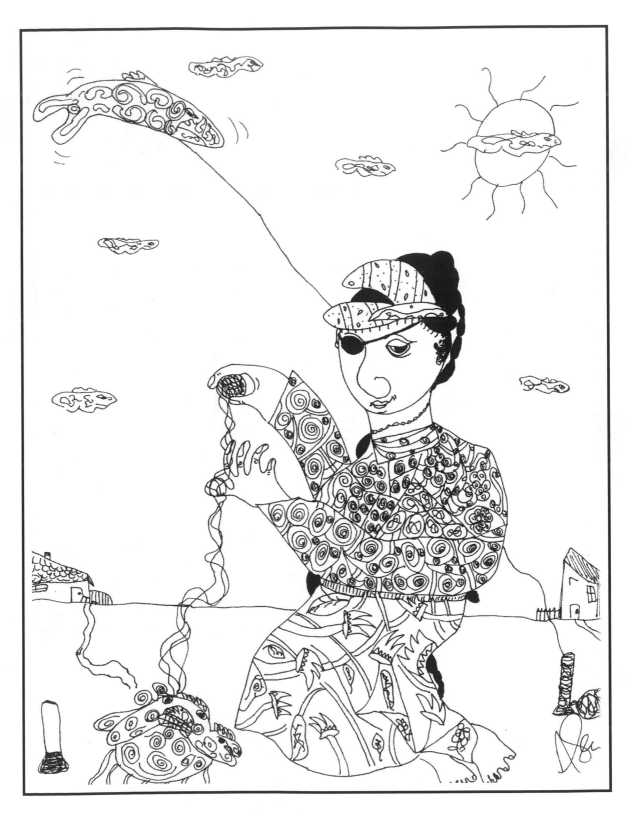

The Kite Flyer

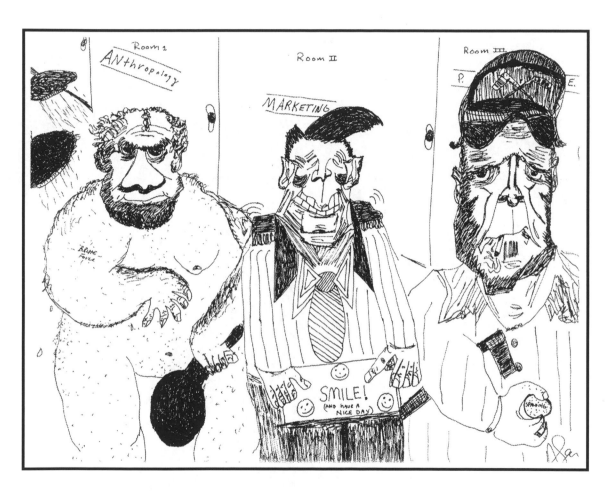

NRF

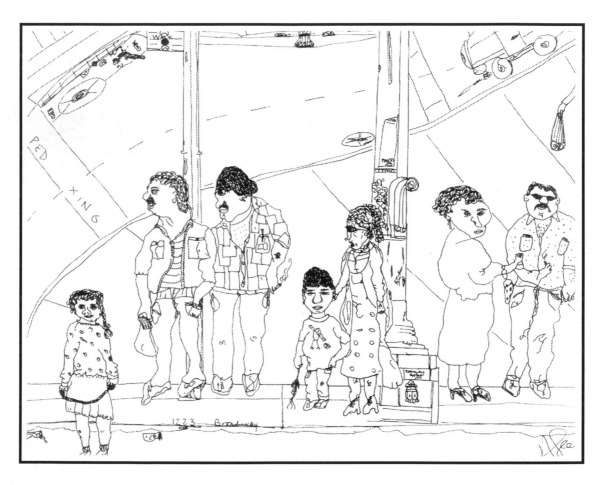

Street Scene

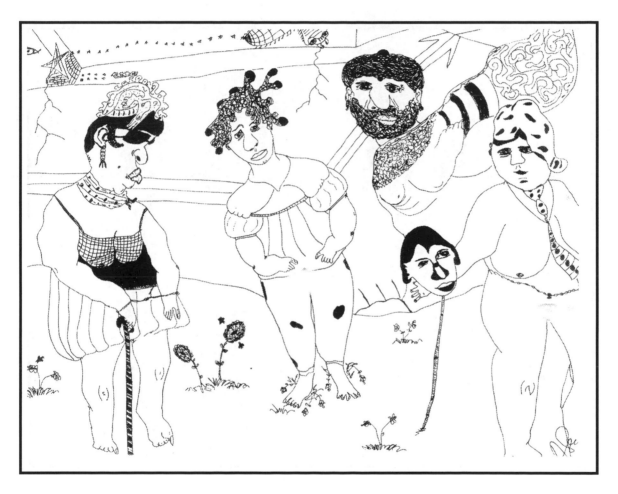

Blind Revision

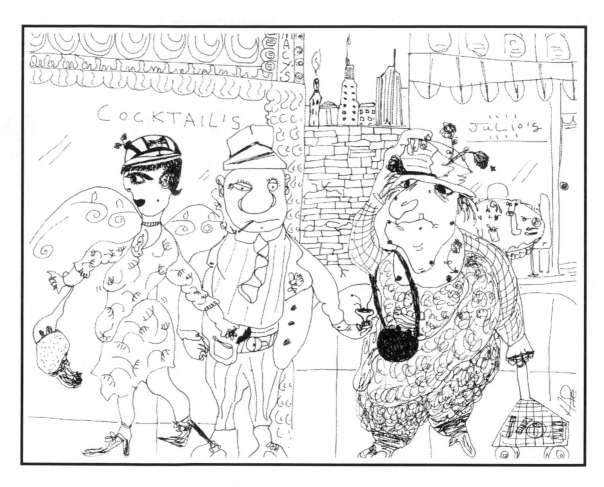

Bit Tipsy

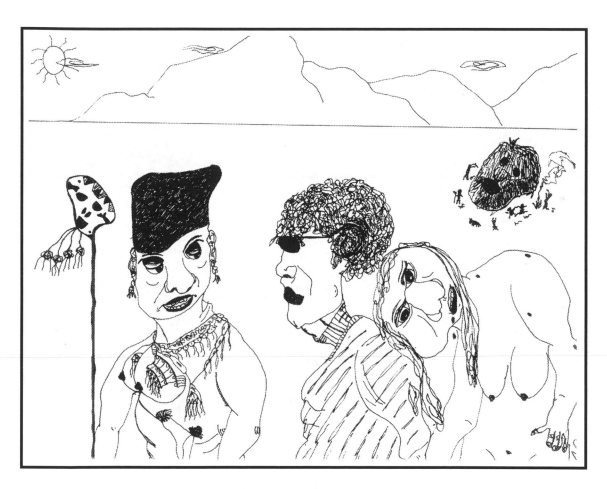

Witch Doctor

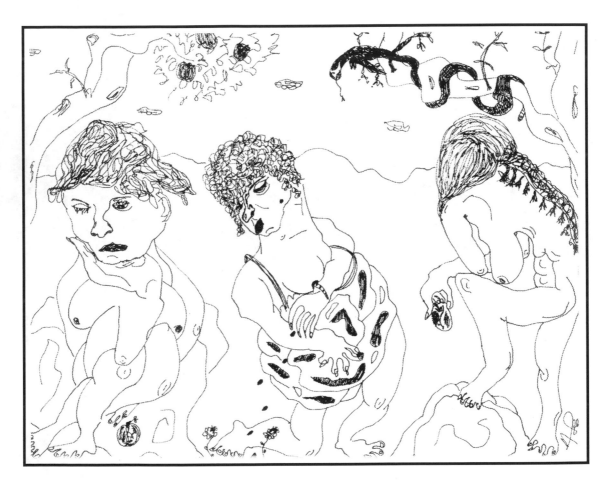

Three Muses

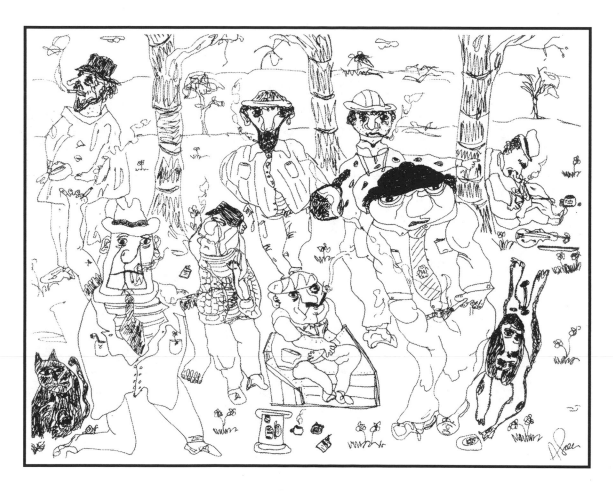

No Smoking

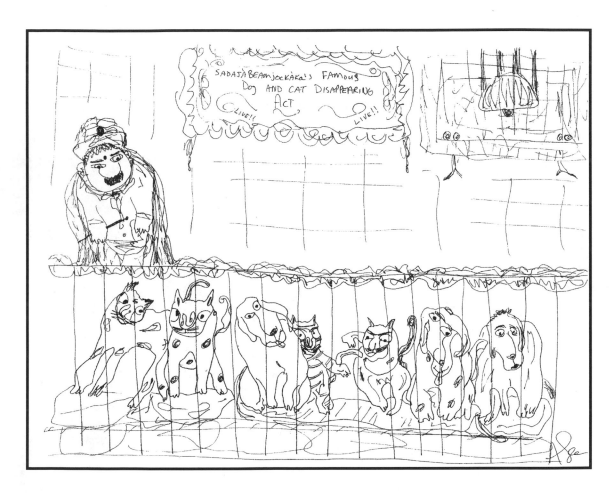

Disappearing Act

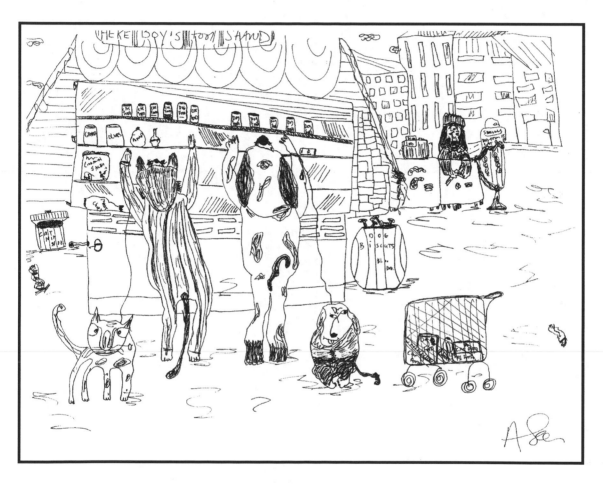

Pet Food Stand

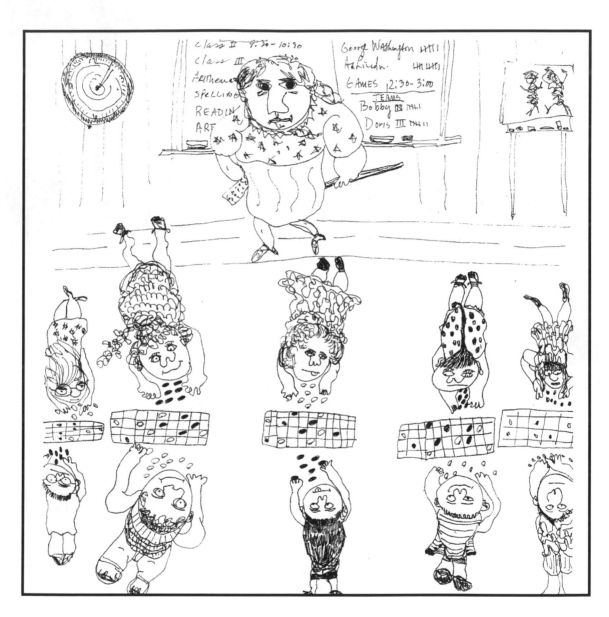

The Classroom

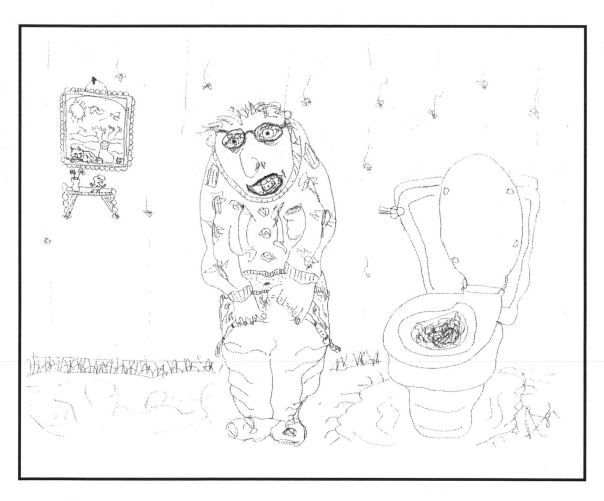

Same Old Shit

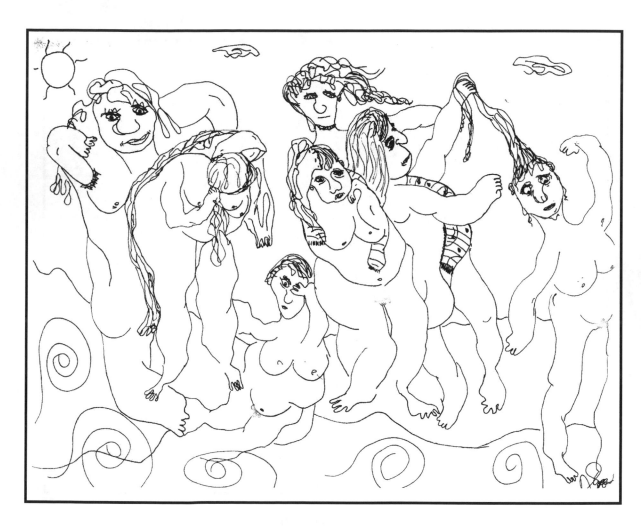

Bathing

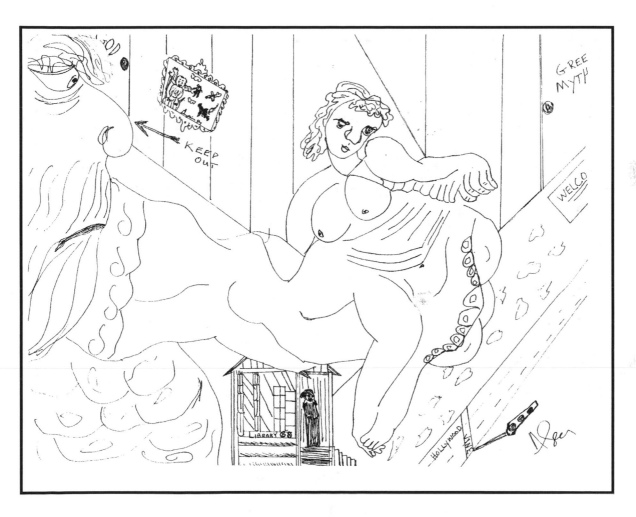

King Zeus

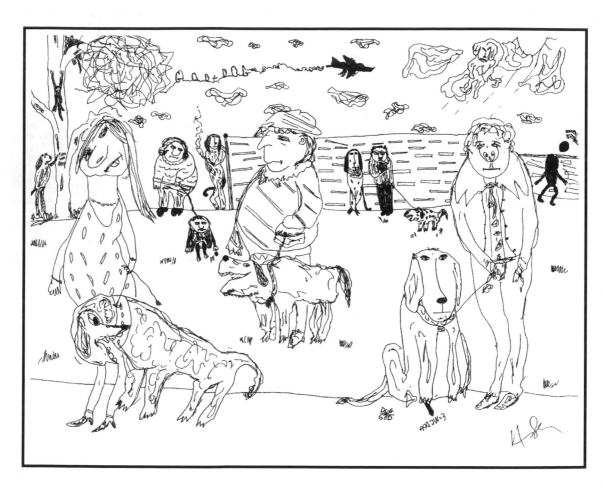

E=MC Dog

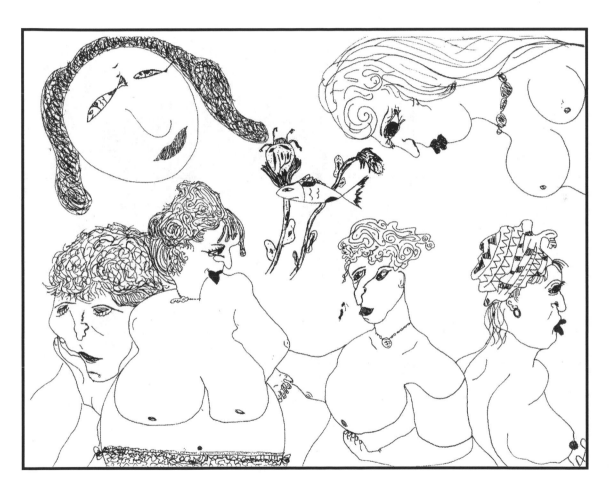

Pisces

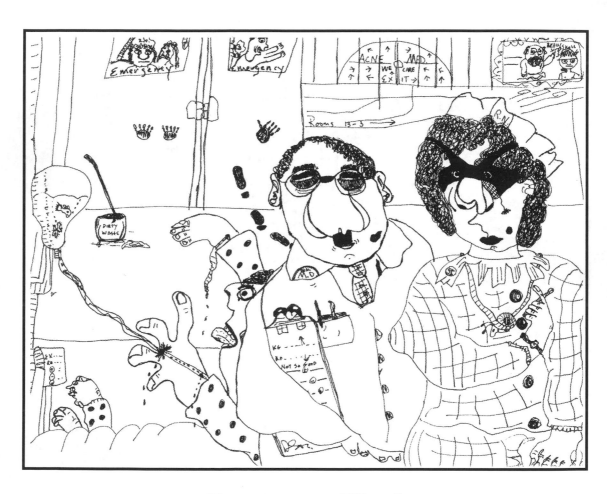

Emergency Ward

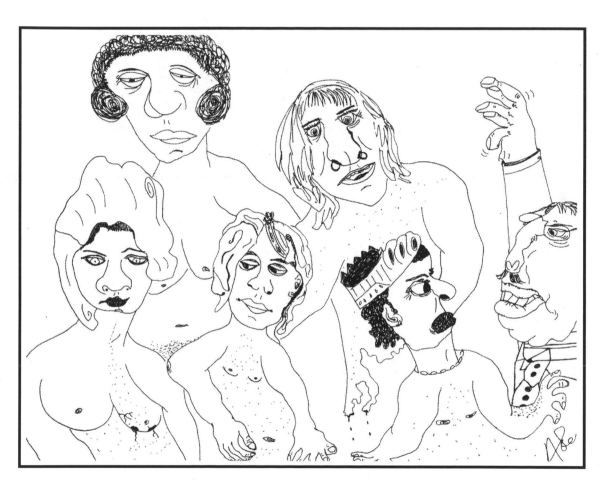

Professor Anthropology

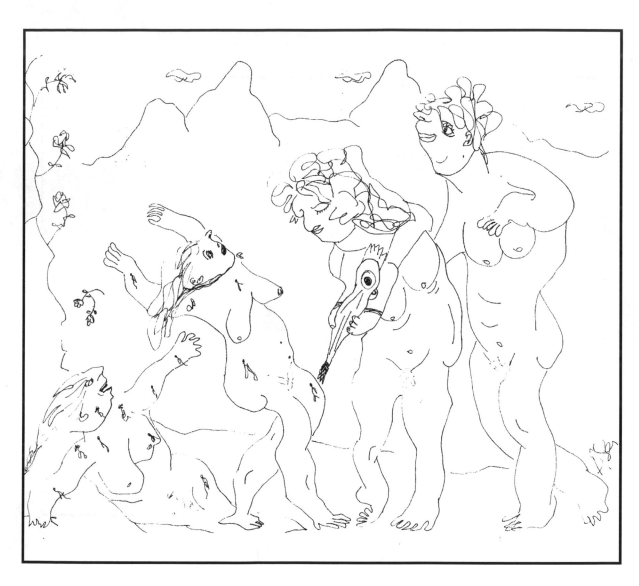

Nude Hazing

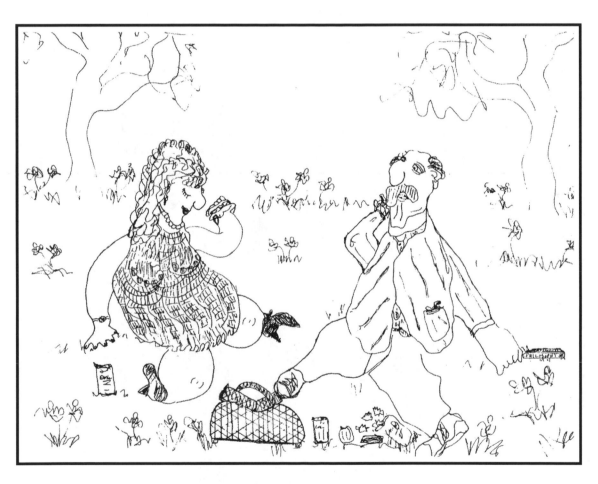

Dating the Professor

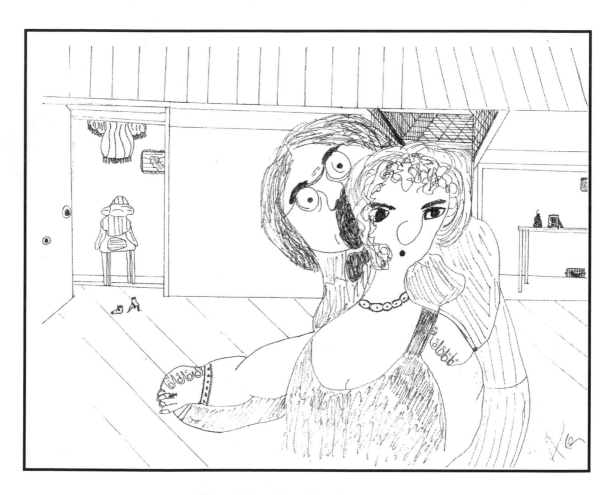

Hypnotic Seduction

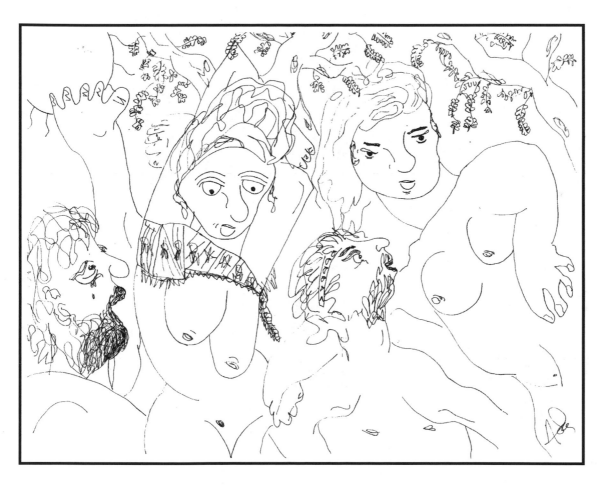

Pan's Education

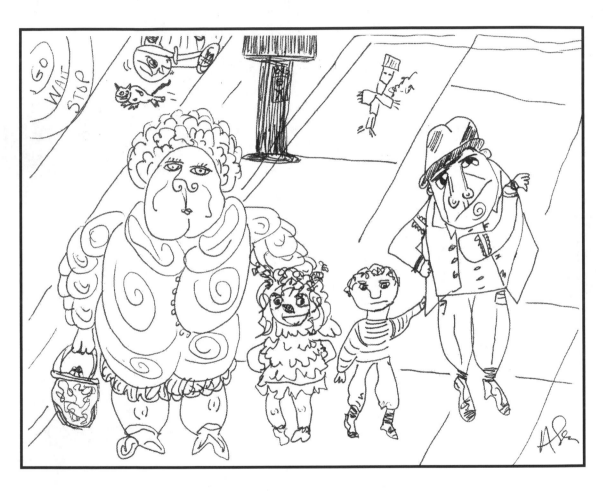

The Long Signal

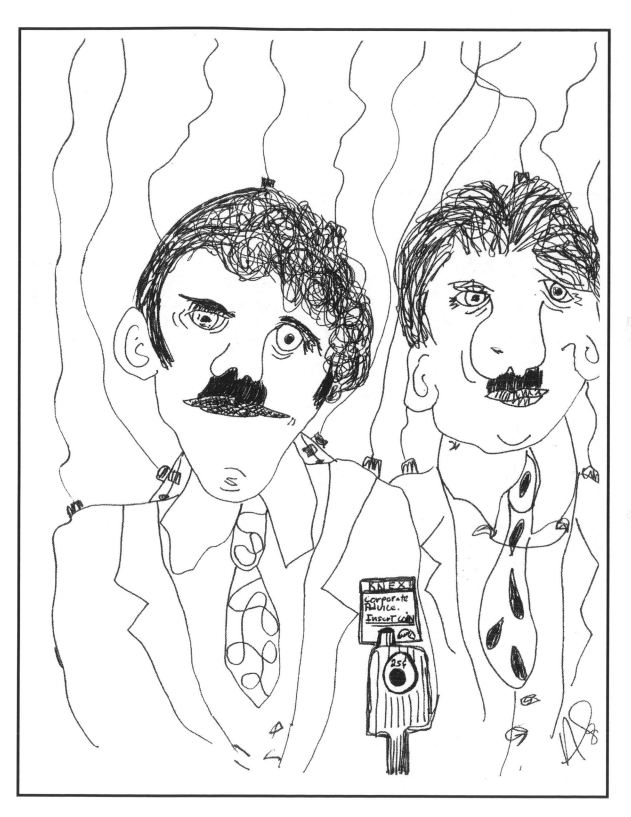

Disc Jockeys

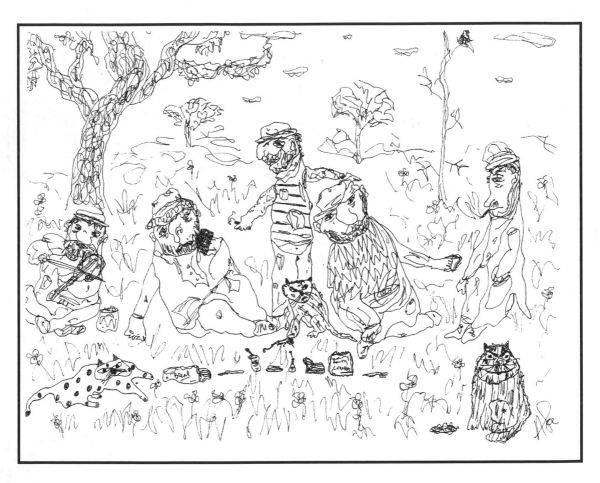

Bums in the Park

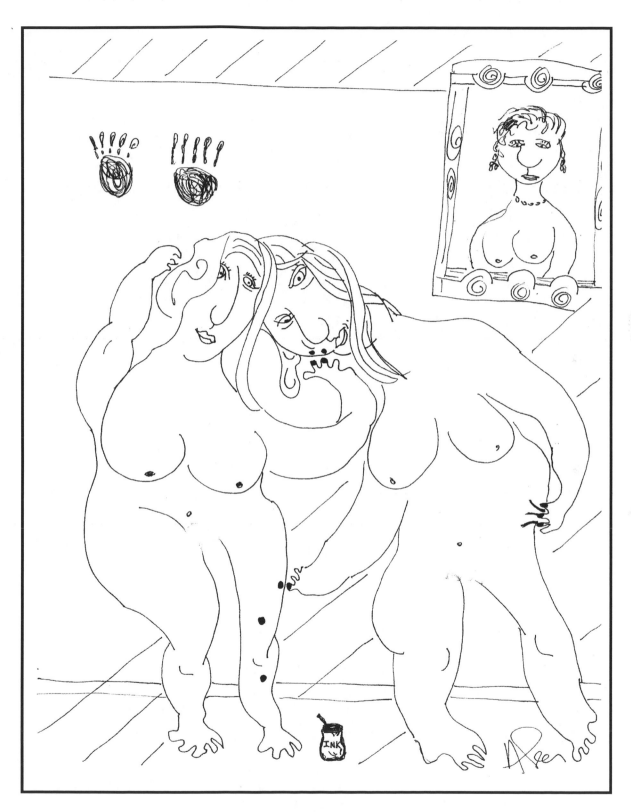

Nude Ink

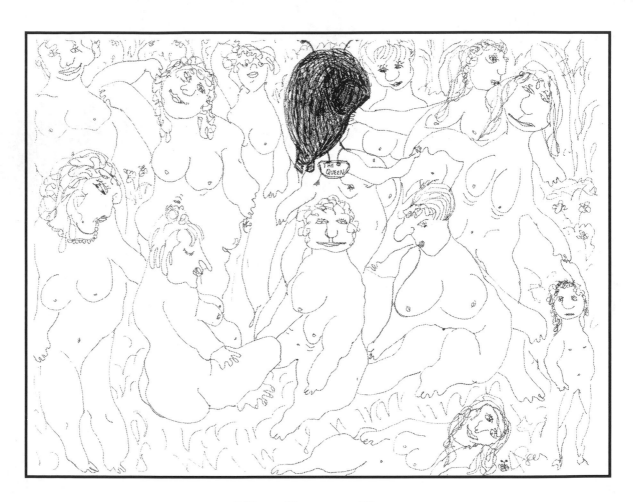

The Queen Bee

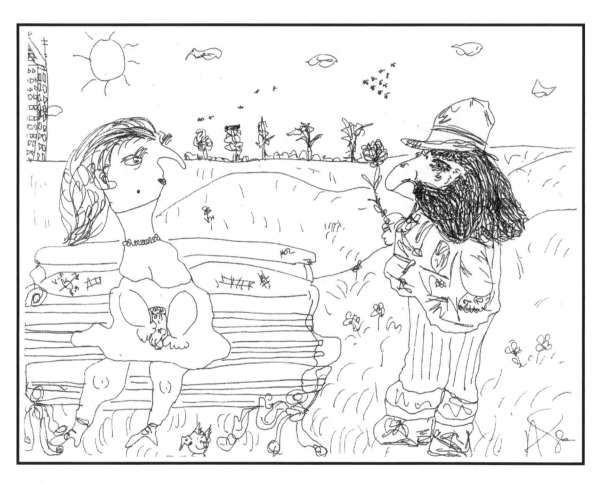

Can You Spare Ten Minutes Of Pure Romance?

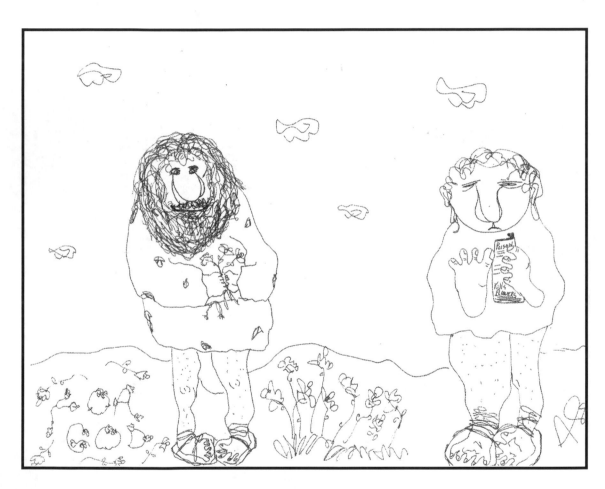

Caen and Mabel

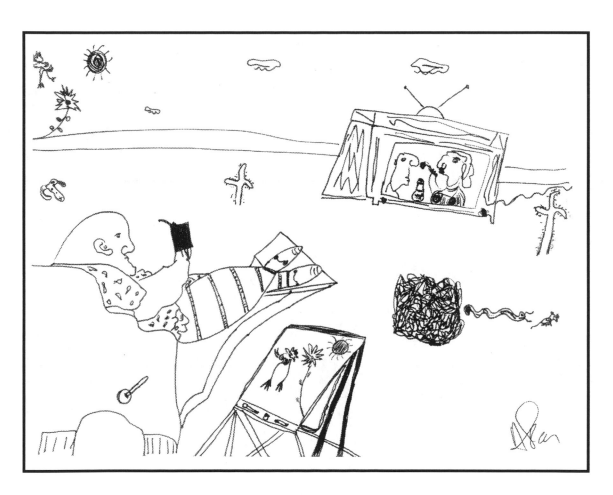

Another Sunday In Death Valley

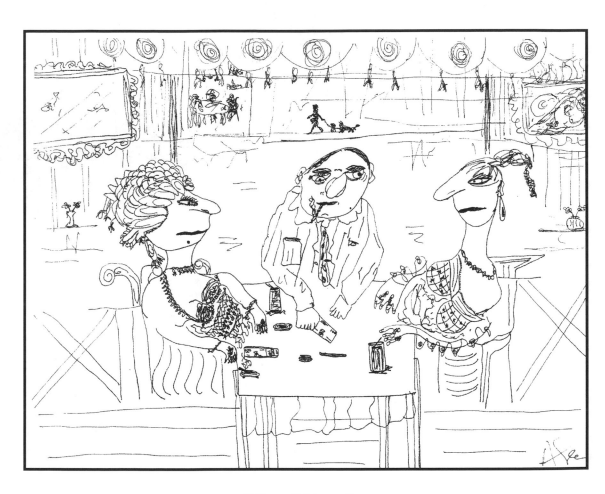

The Rivals

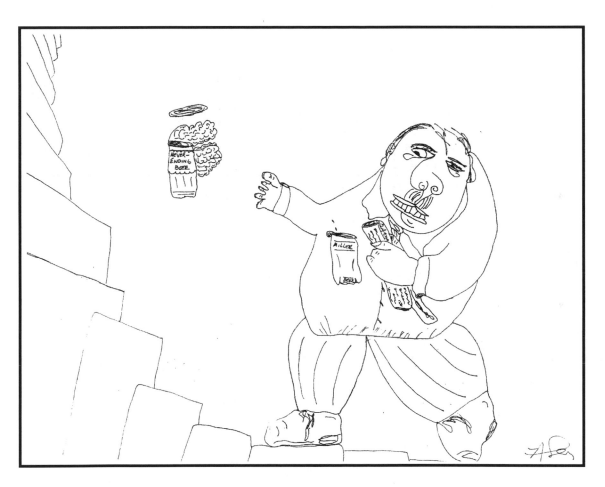

Never Ending Beer

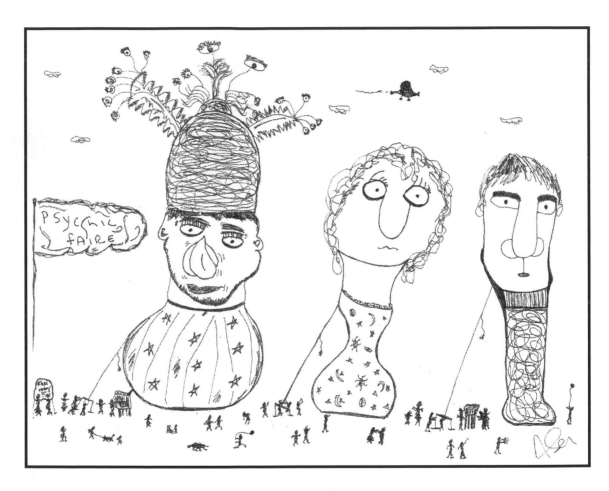

Psychic Fair

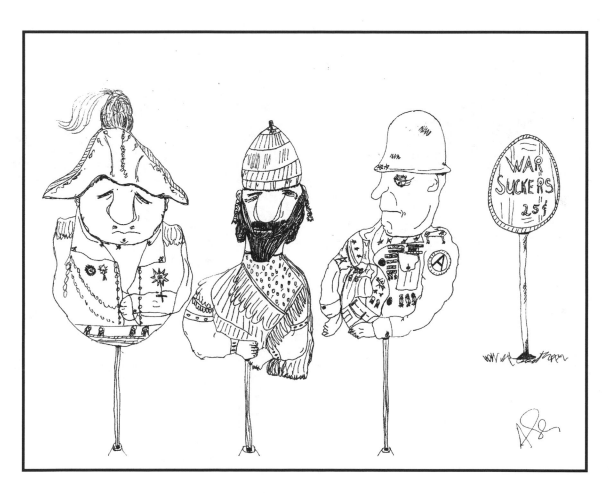

War Suckers

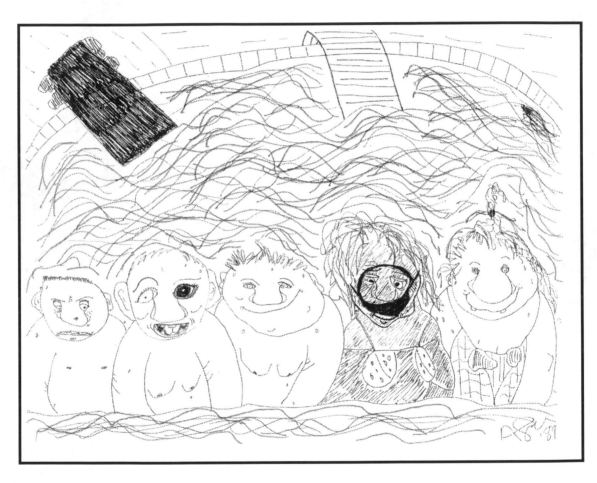

Swimming Pool Lessons

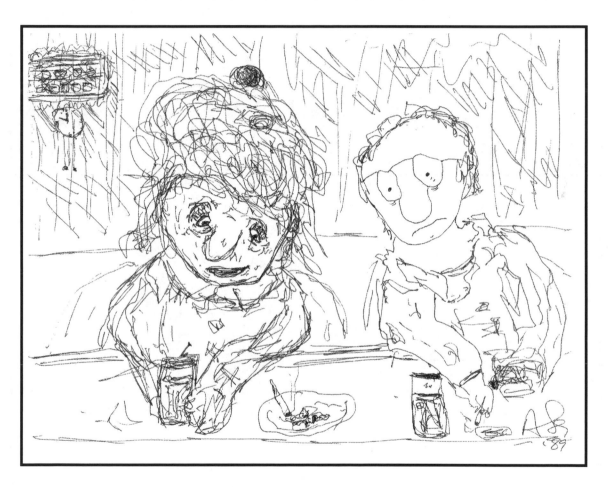

Annie Holic

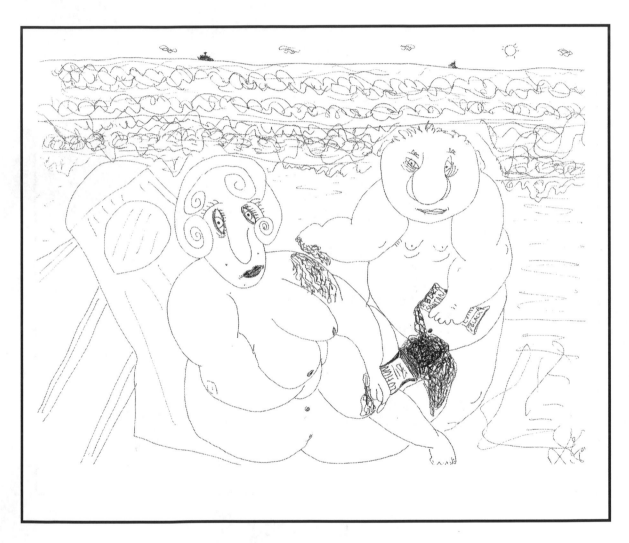

"Too-Much" Lotion

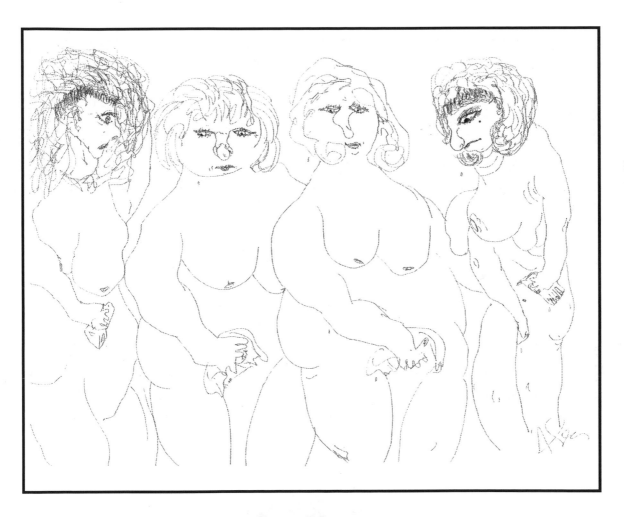

Scrubbing

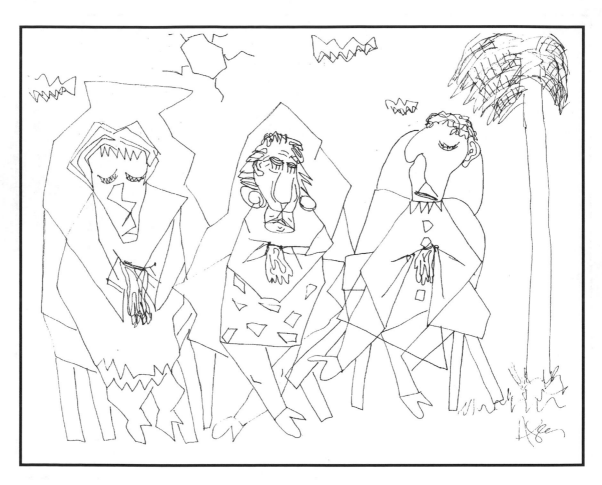

Three Knitters

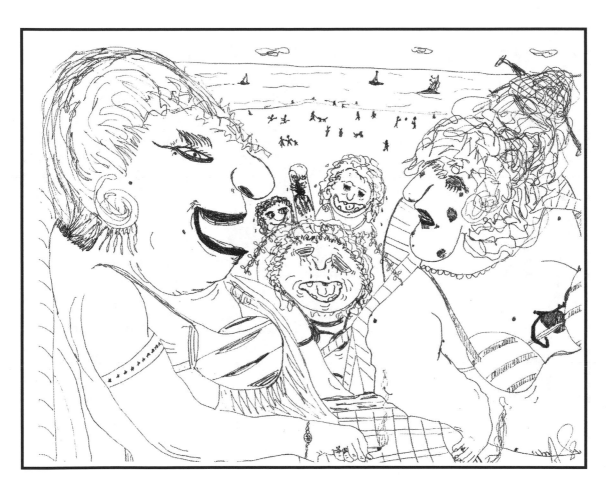

Mothers At The Beach

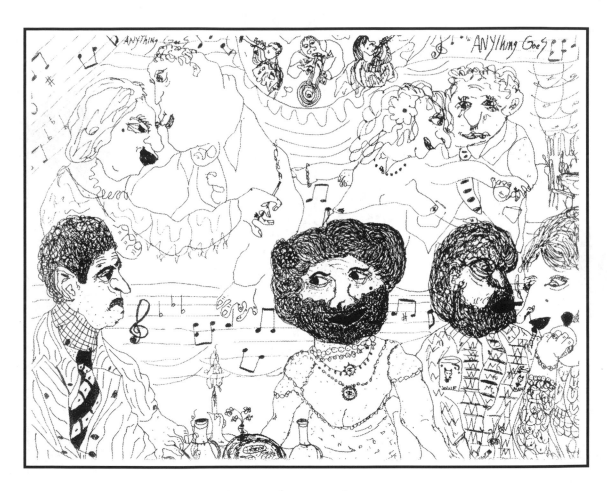

Anything Goes

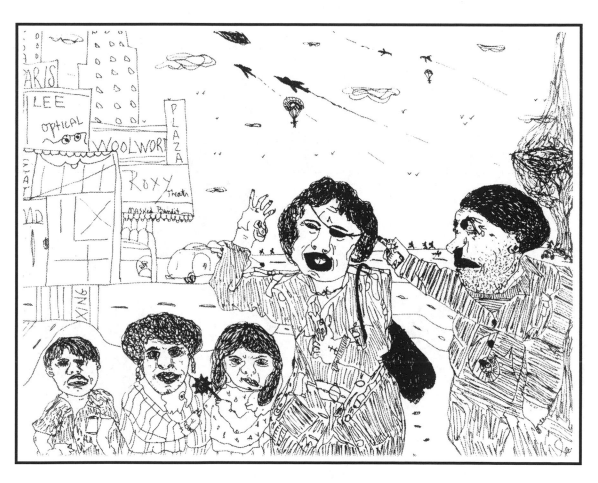

The Holdup

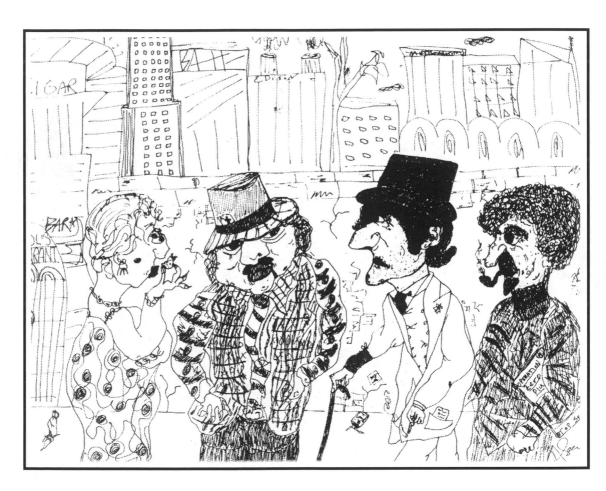

The Payoff

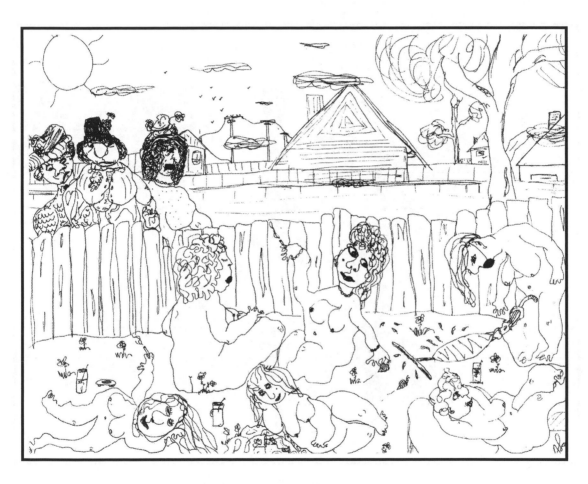

New Neighbors

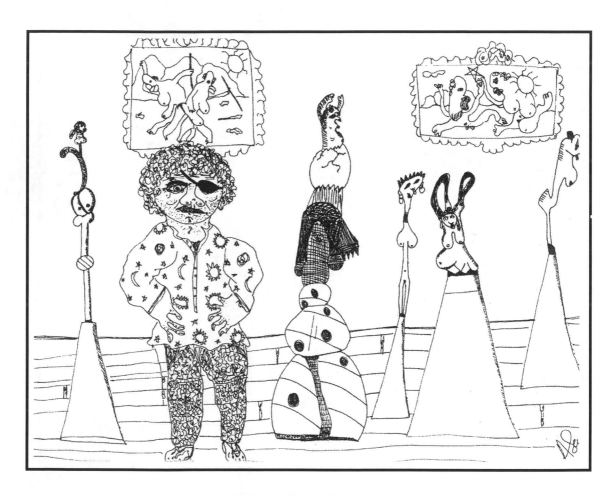

The Sculptor

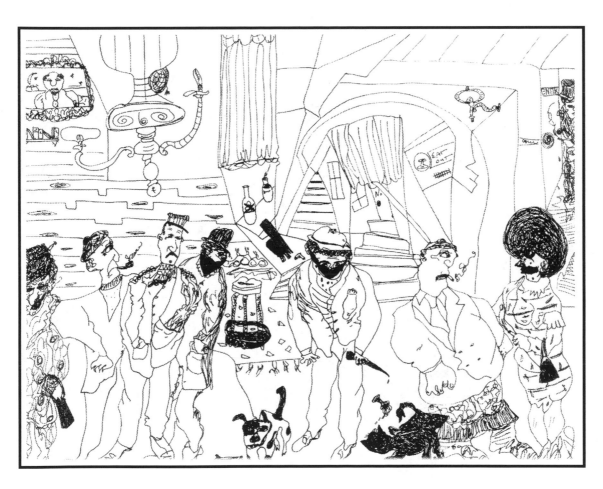

Murder at Motel 6

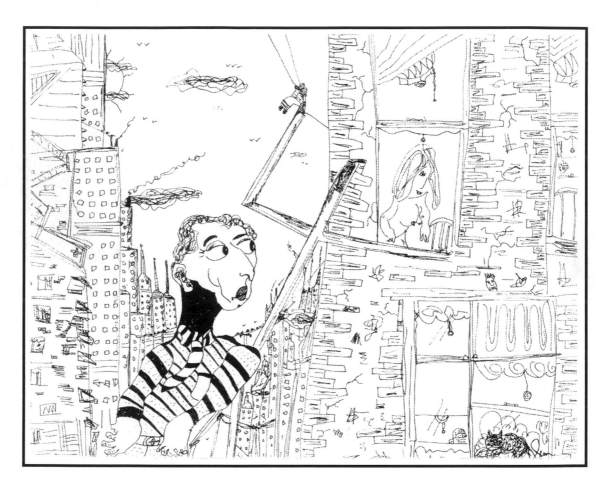

Peeping Tom

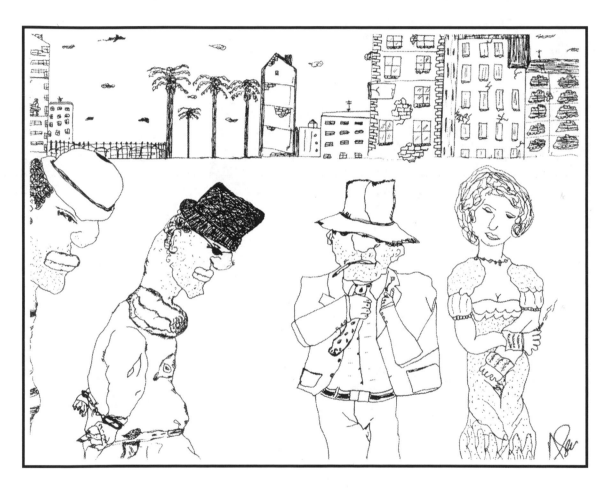

Drug Bust

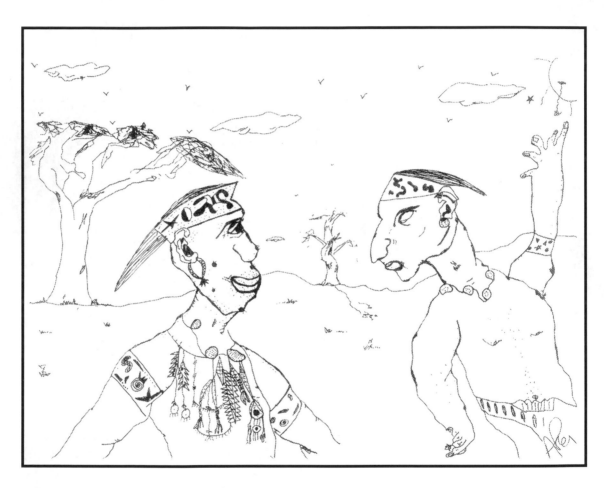

Tribal Chiefs

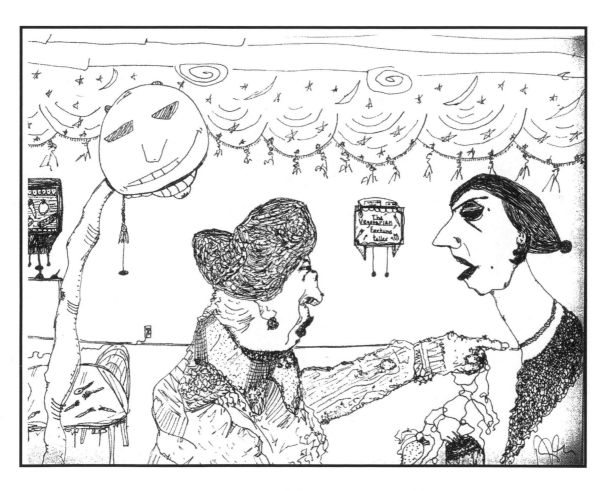

Vegetarian Fortune Teller

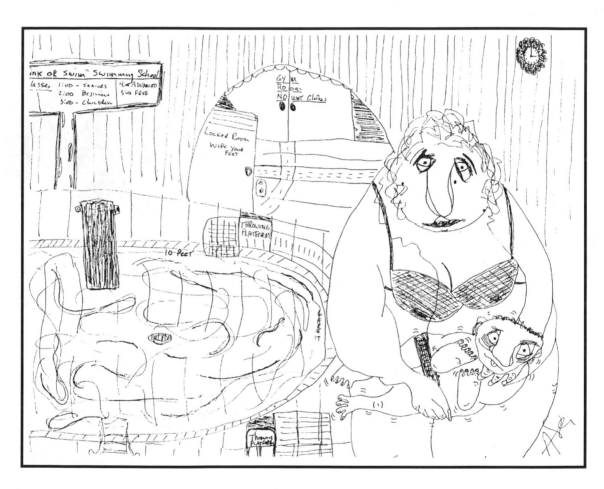

Sink or Swim

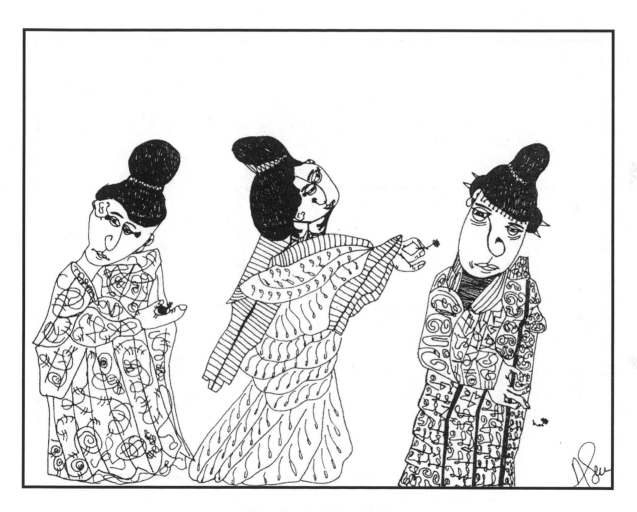

Four Seasons

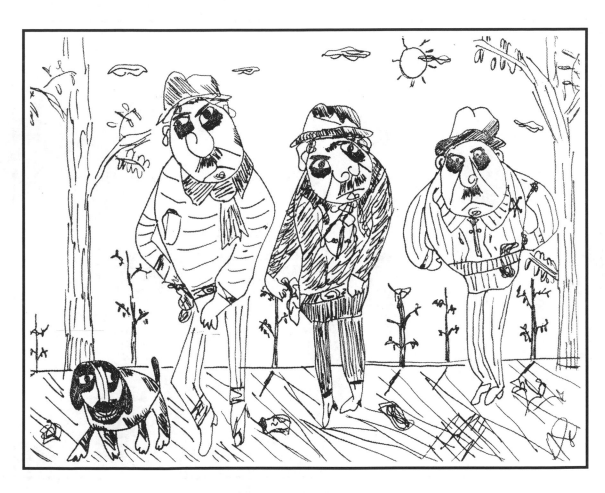

The Outlaws

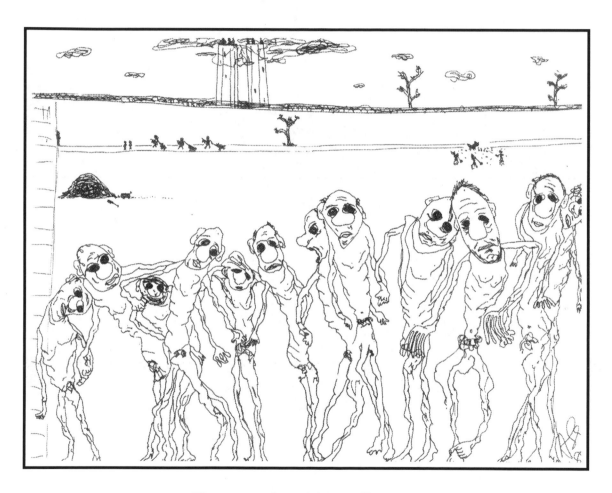

Concentration Camp

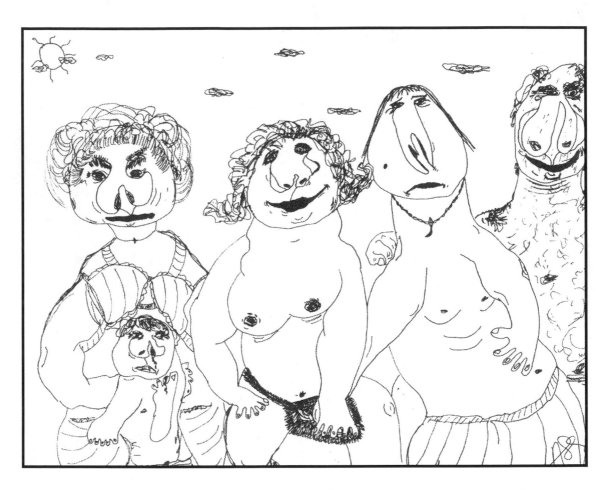

Family Portrait At The Beach

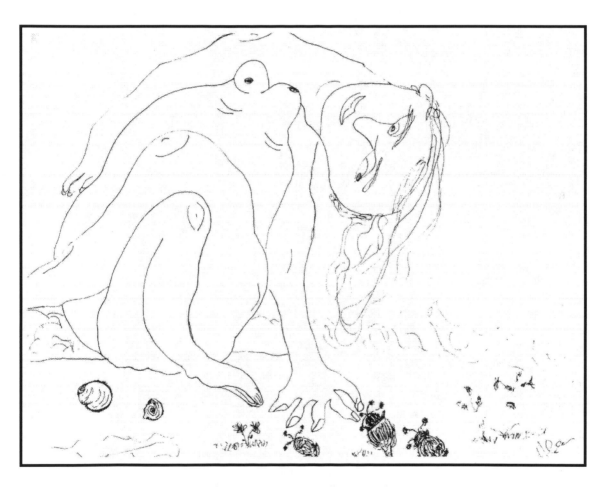

Picking Daffodils

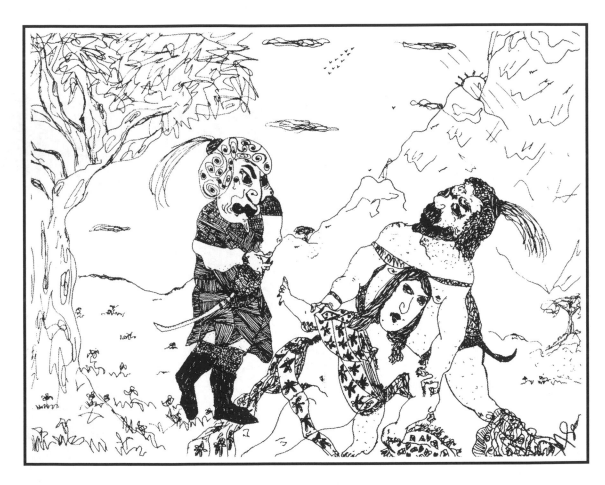

The Rape

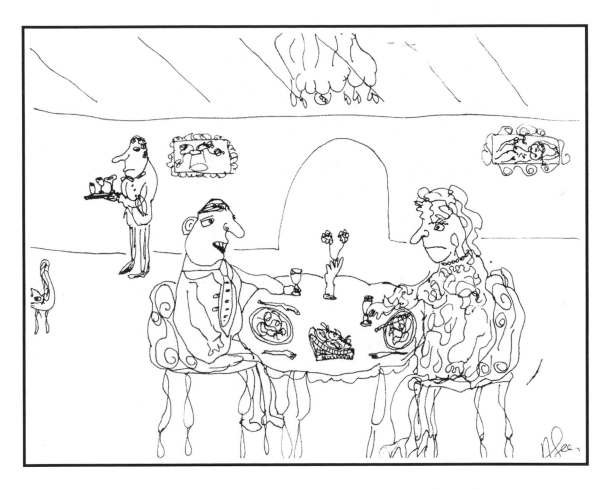

If This Date Doesn't Work Out, Can We Go Dutch?

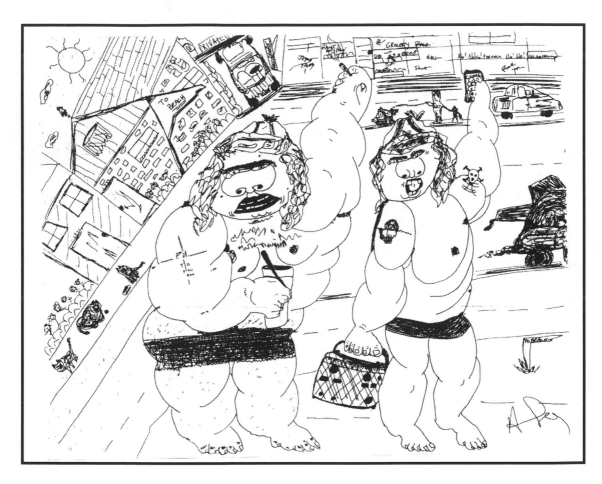

Buddies

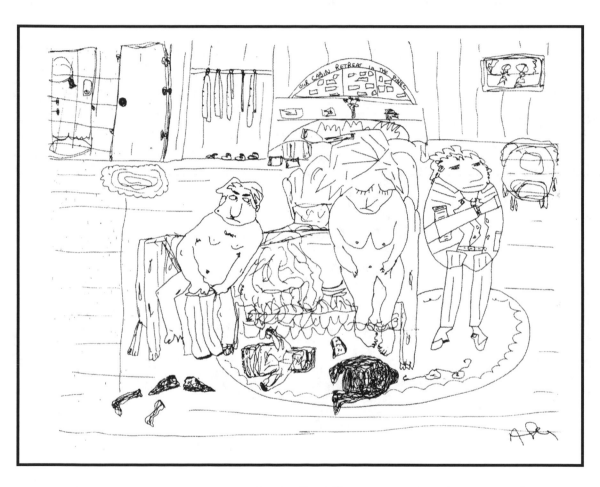

The Affair

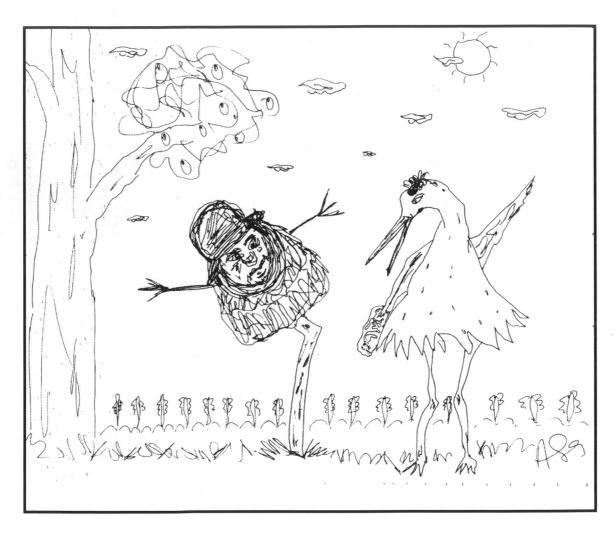

Asking Directions

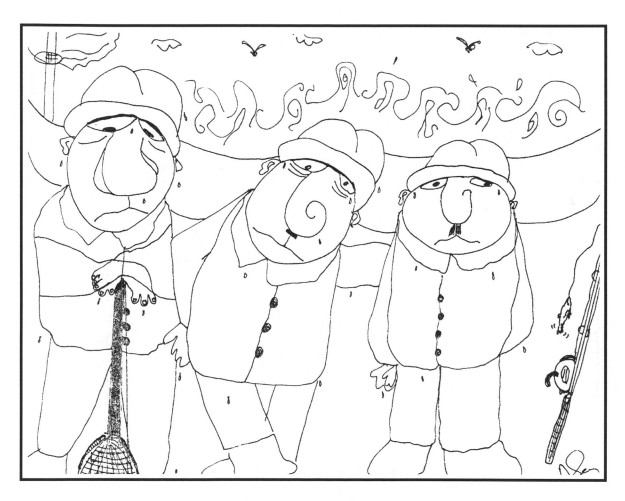

Three Fishermen

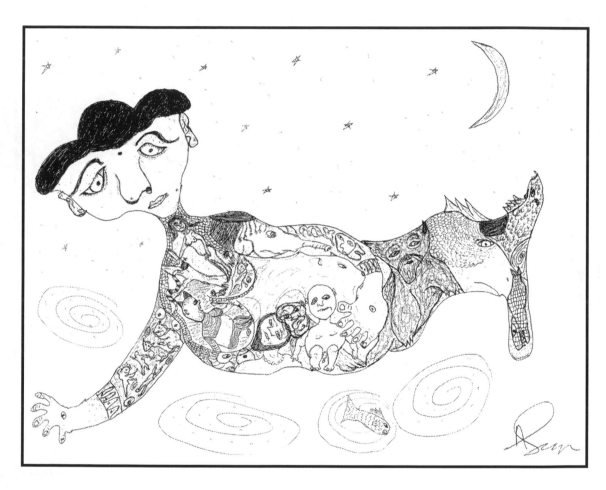

RoseEmerald

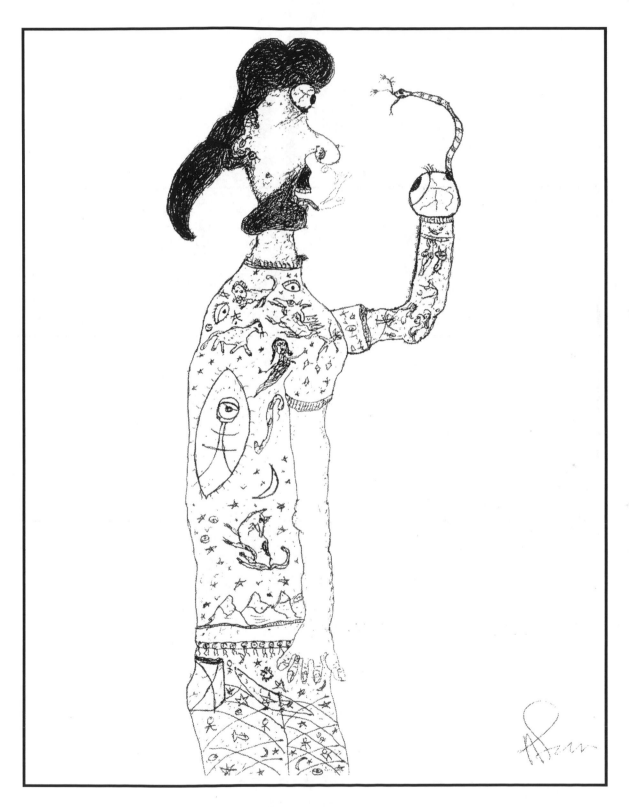

Delusions

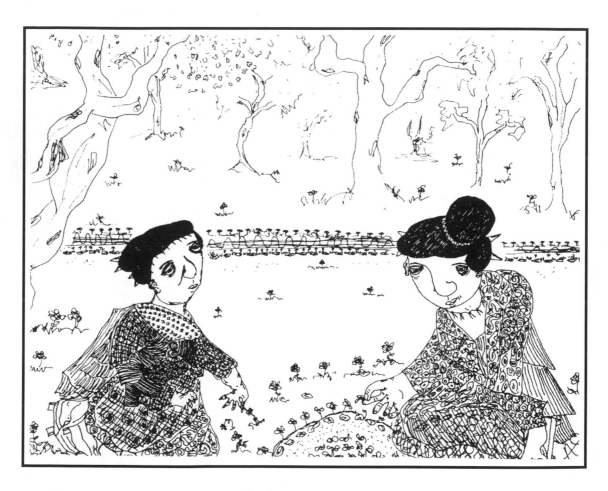

Springtime

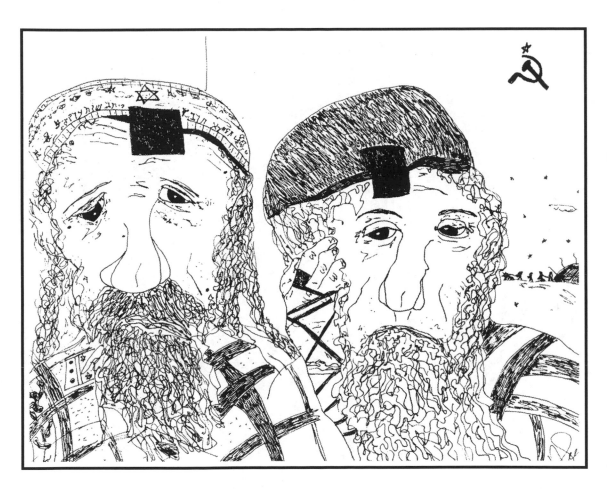

Soviet Rabbis

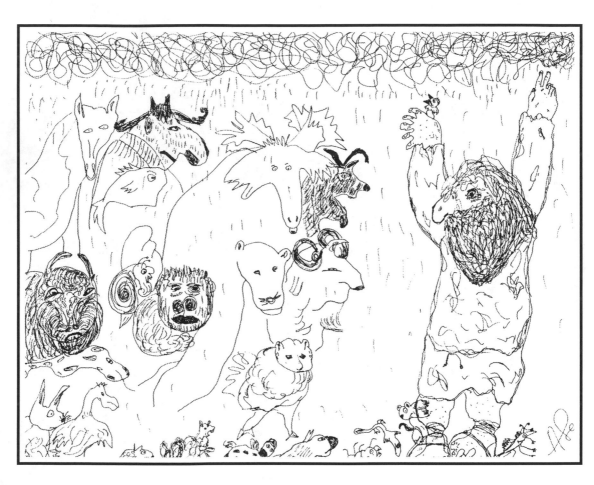

Noah's Ark

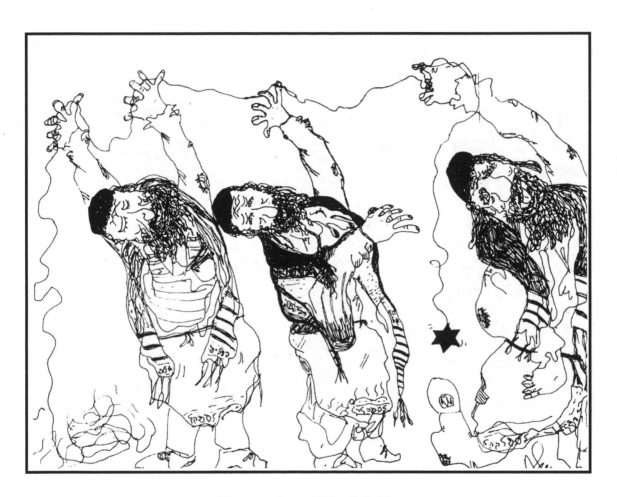

Dancing Rabbis

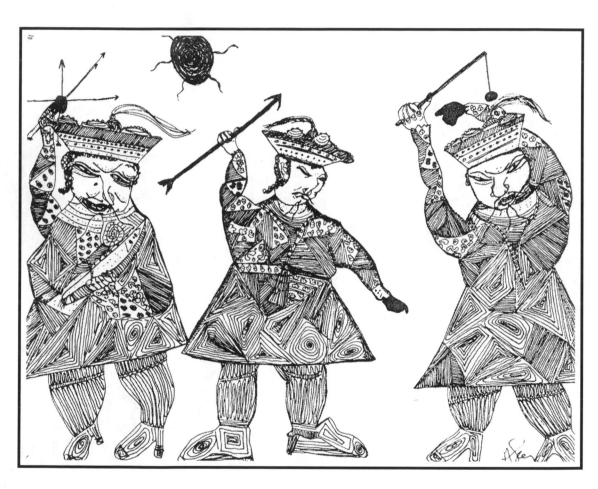

Three Warriors

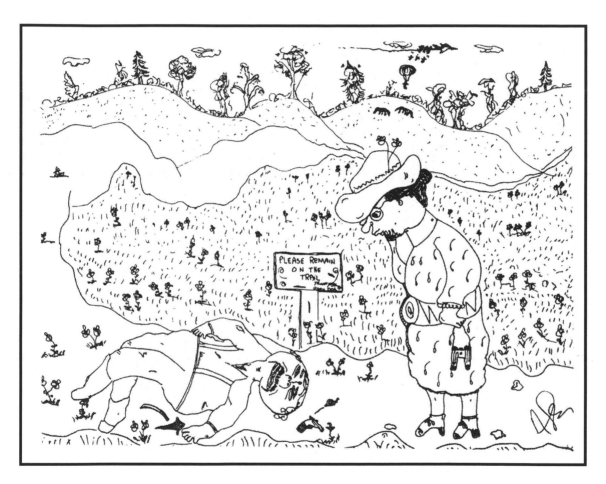

Birdwatcher

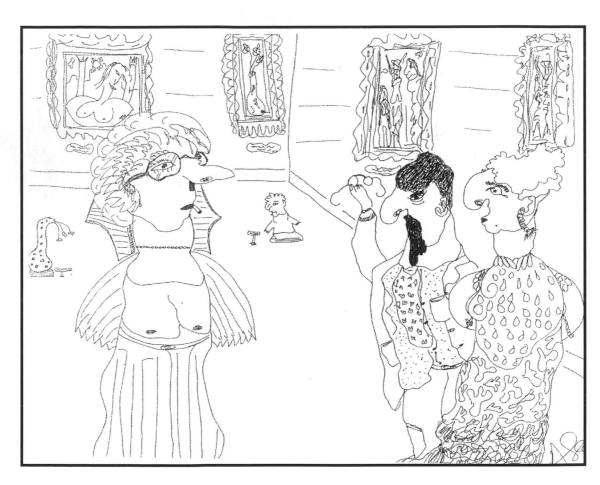

The Museum Of Dubious Art

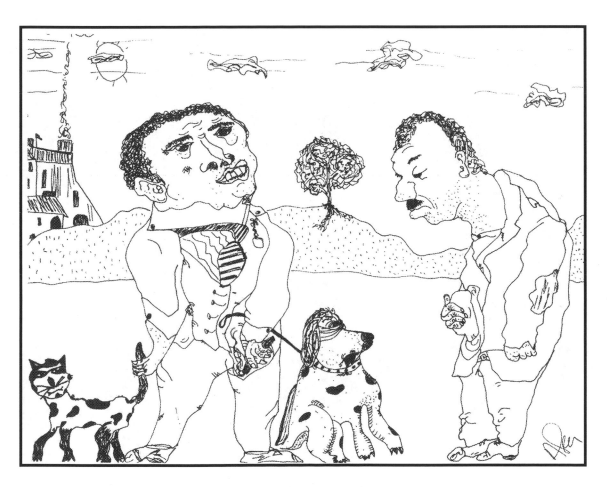

Looking for Work

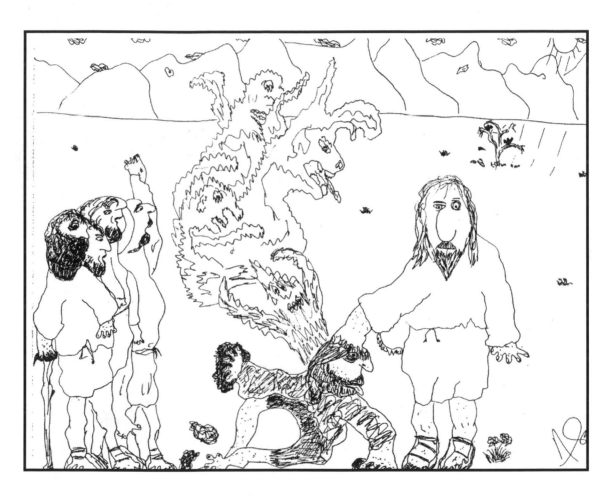

Jesus Casting Out Demons

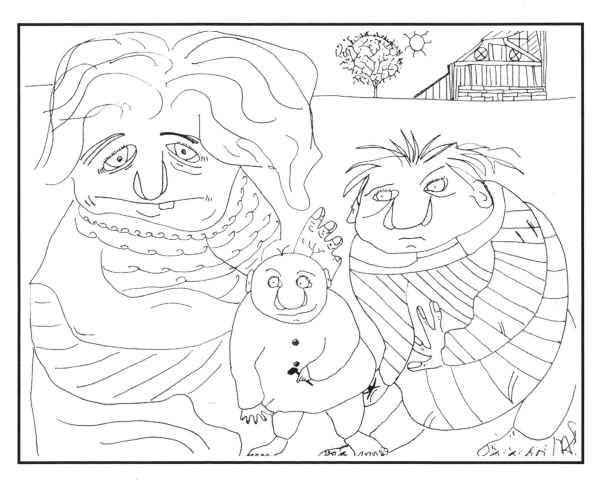

On Grandma's Farm

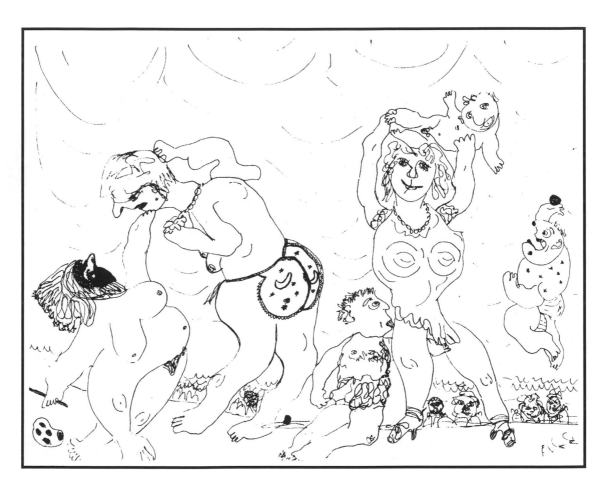

Act IV, Scene I of "Hercules Goes To The Circus"

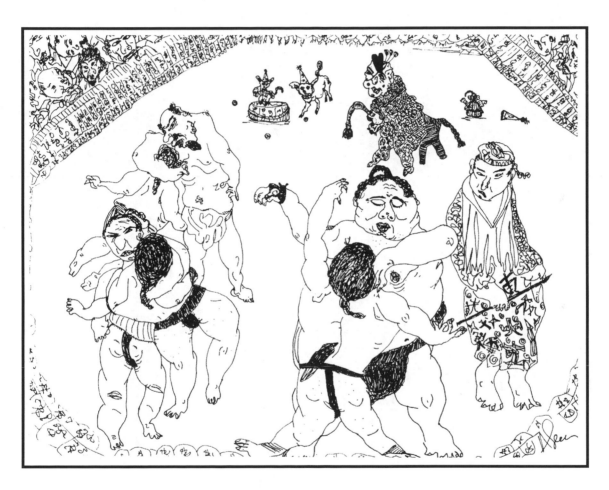

Sumo Wrestlers

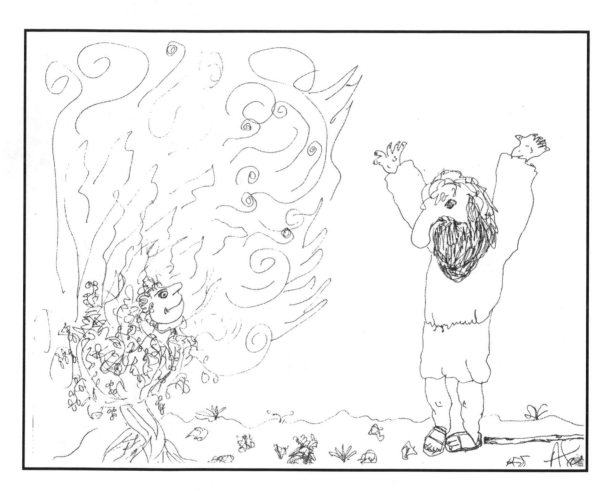

The Burning Bush

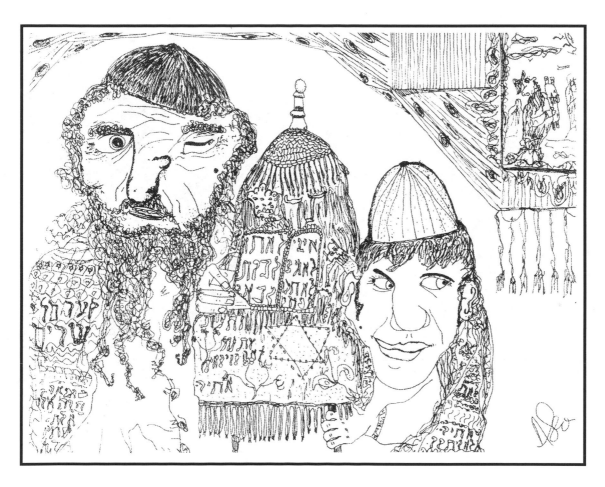

Bar Mitzvah

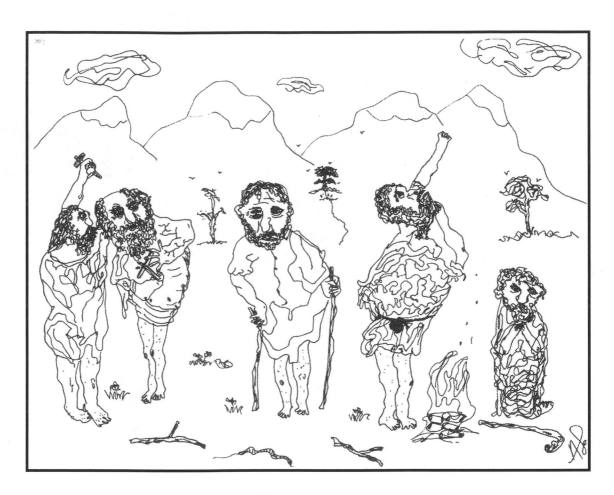

Disciples

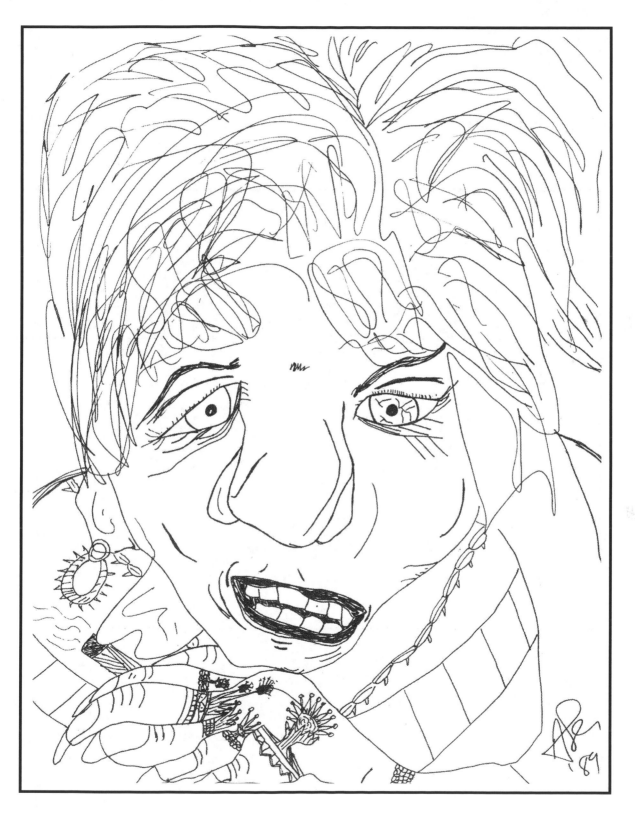

Rings

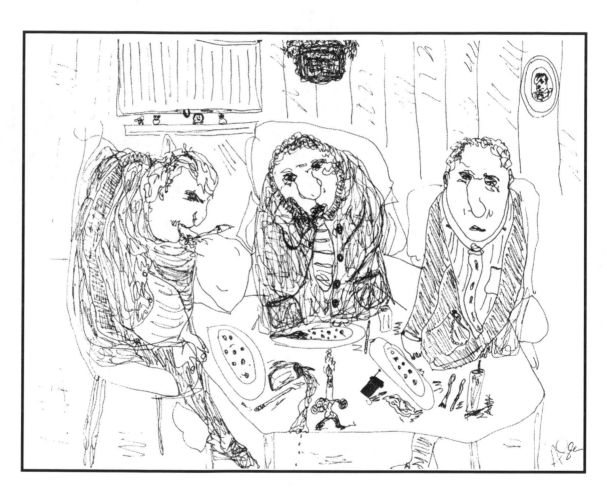

Peas

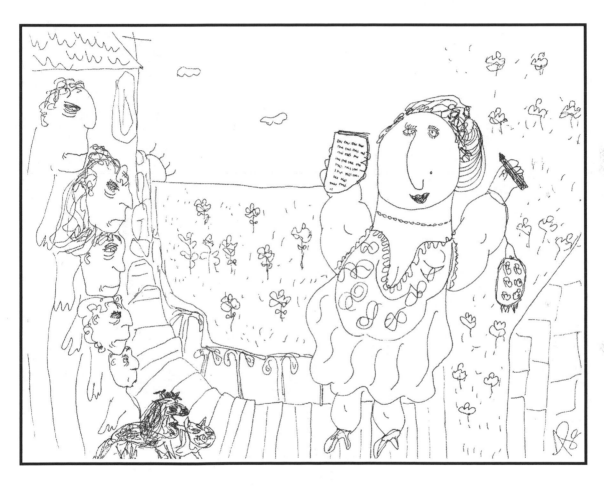

Census Taker

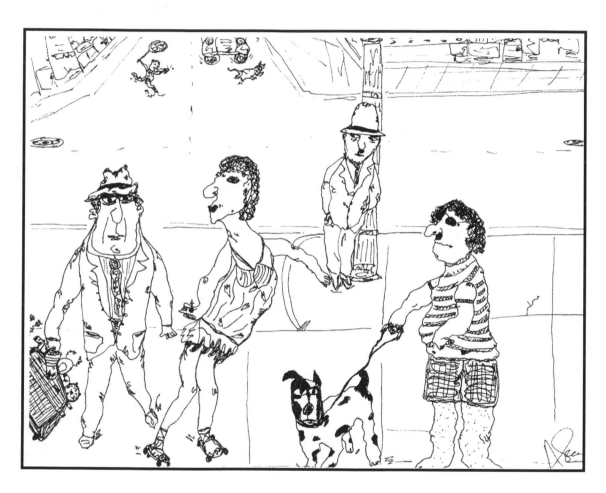

The Terrorist

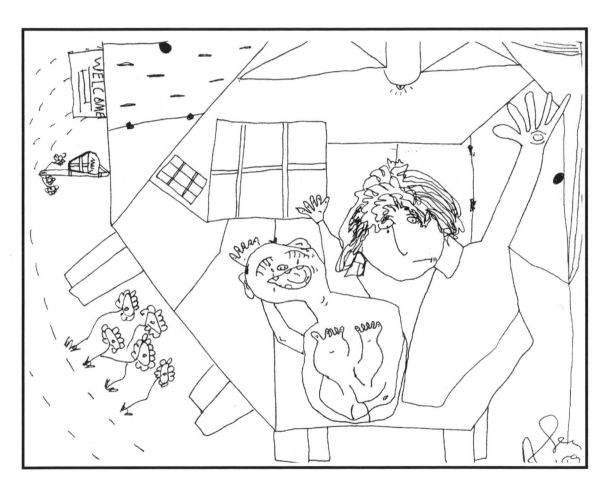

Problem Child

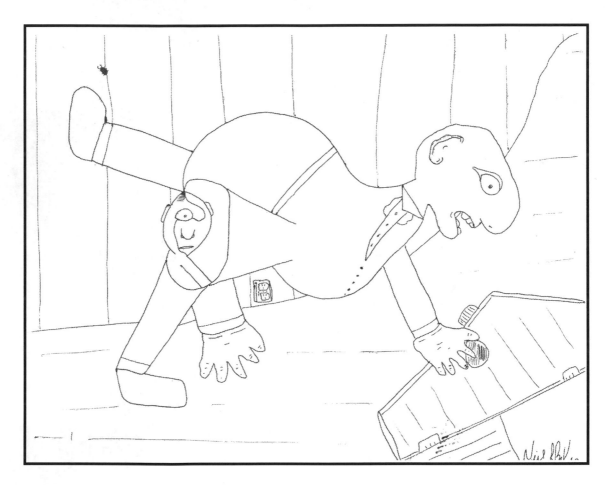

The Bomb Shelter

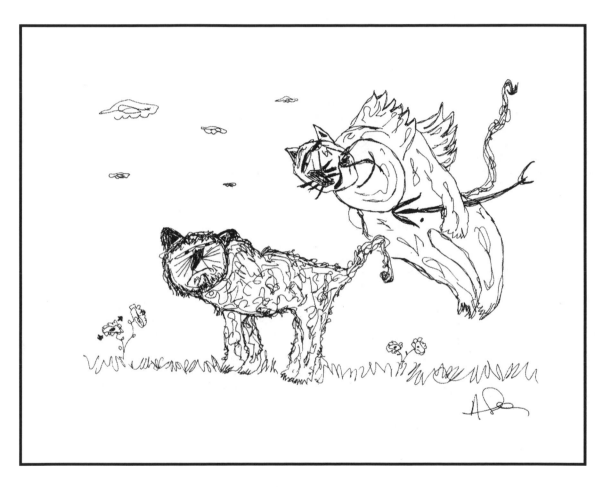

Bad Influence

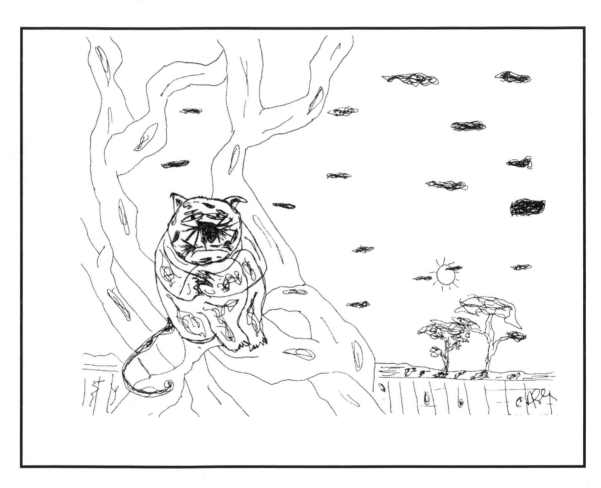

The Outcast

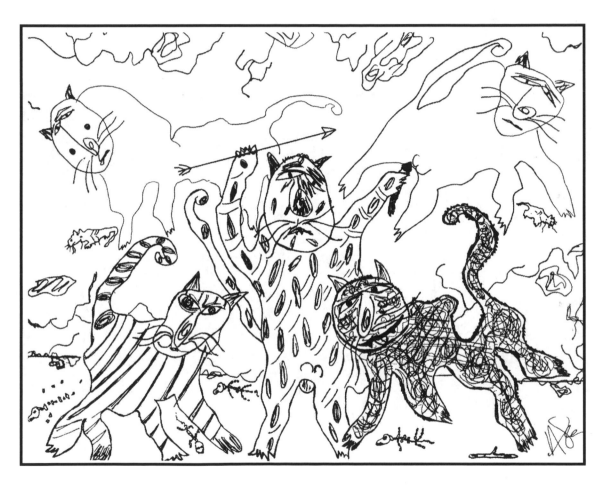

Cave Cats

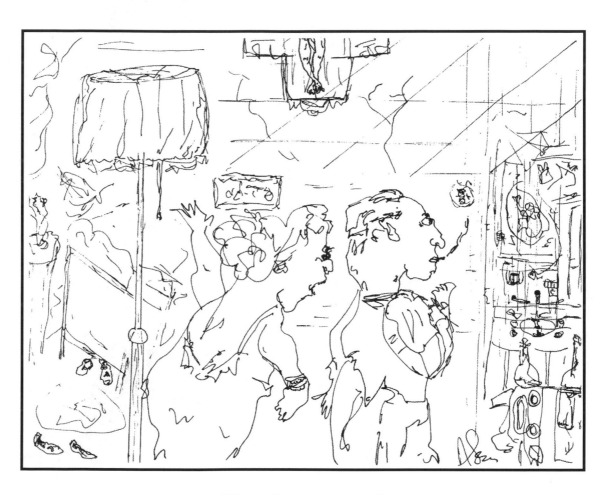

The Argument

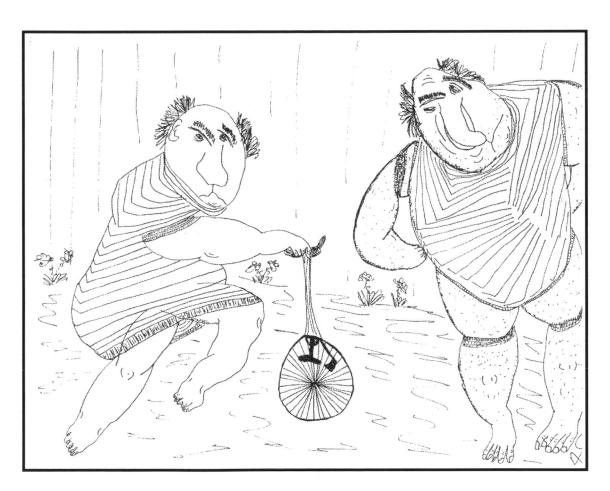

Unicycle

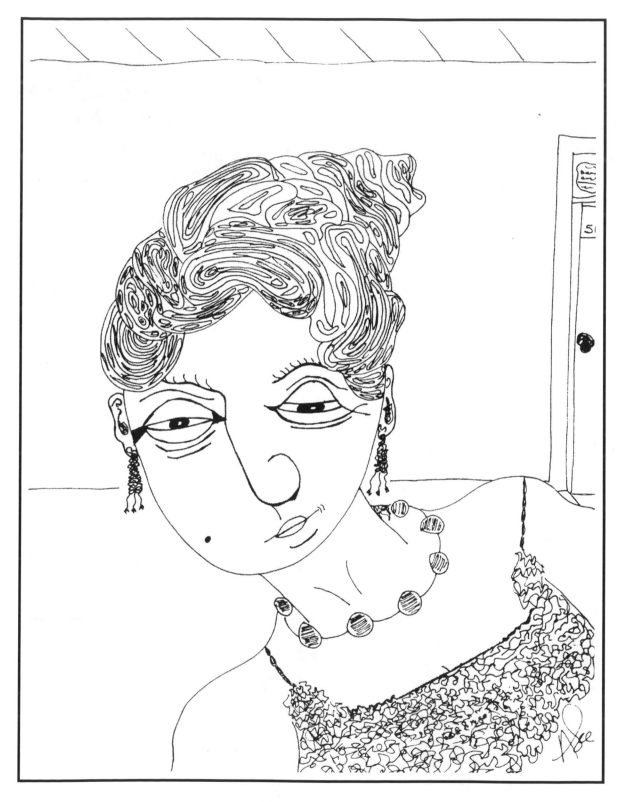

Blind Date

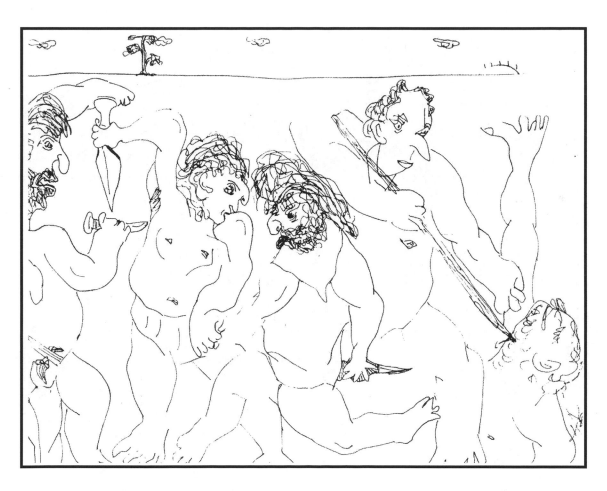

The Killing Of Saul At The Battle Of Gilboa

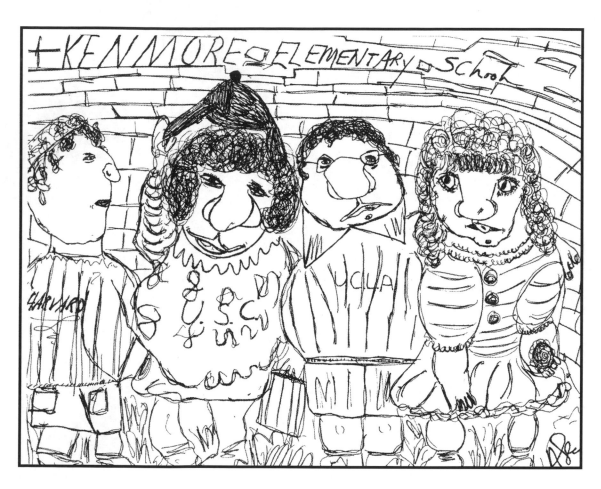

Future Graduates

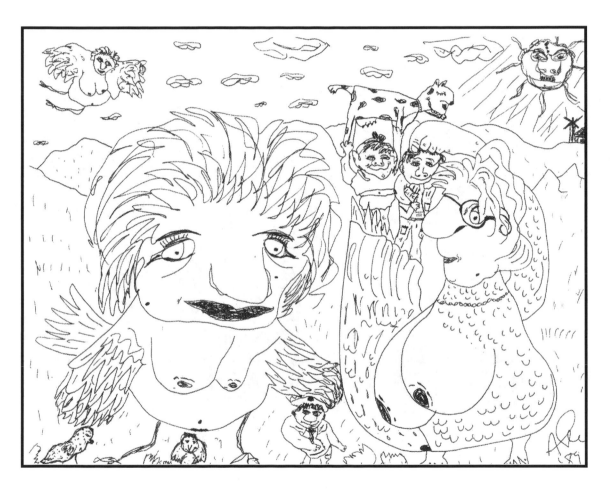

Mother Hens

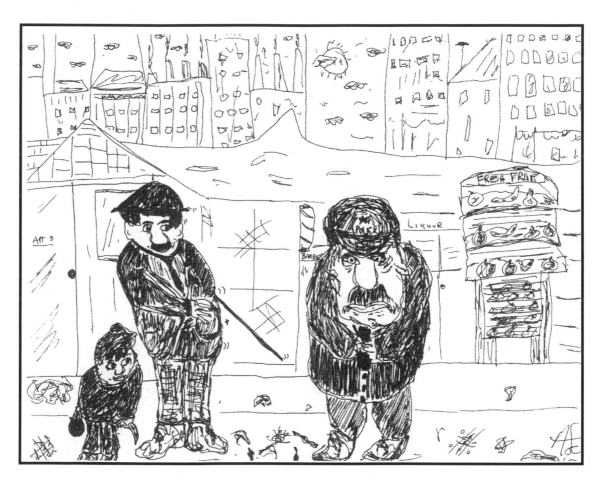

The Kid

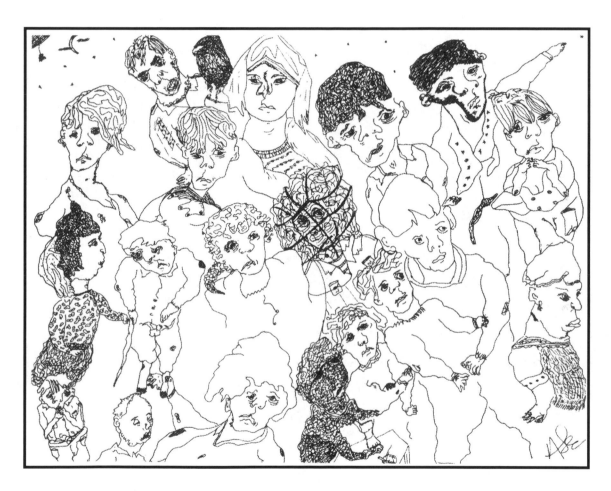

Orphans

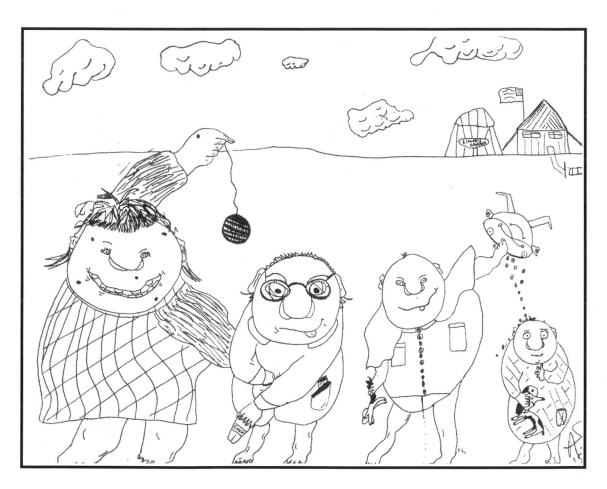

Recess

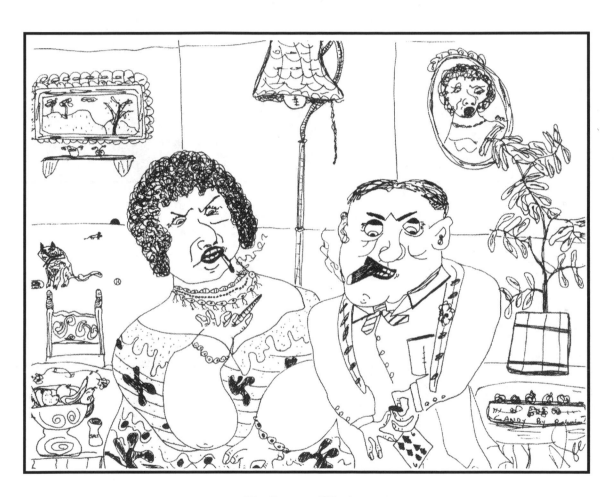

Poker Chip

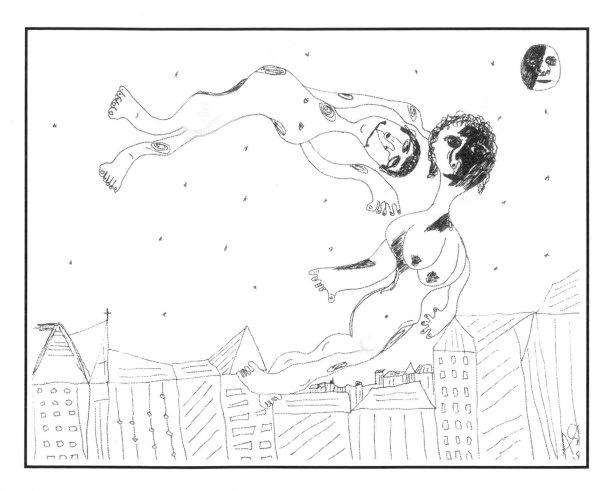

Floating Lovers

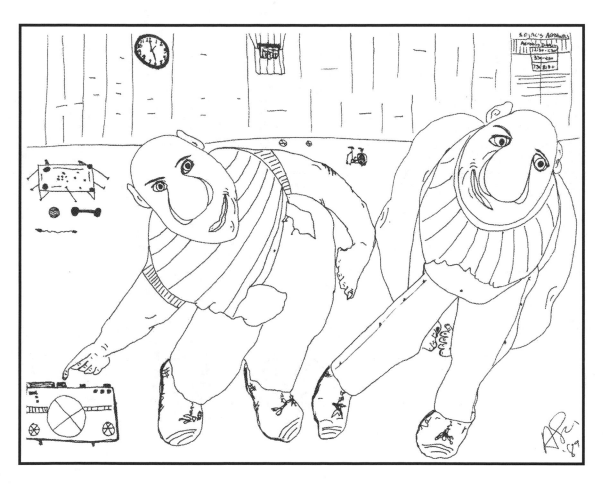

Aerobic Twins

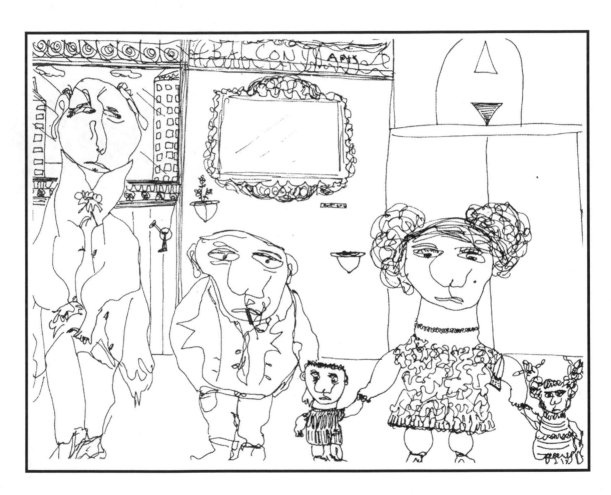

Waiting At The Elevator

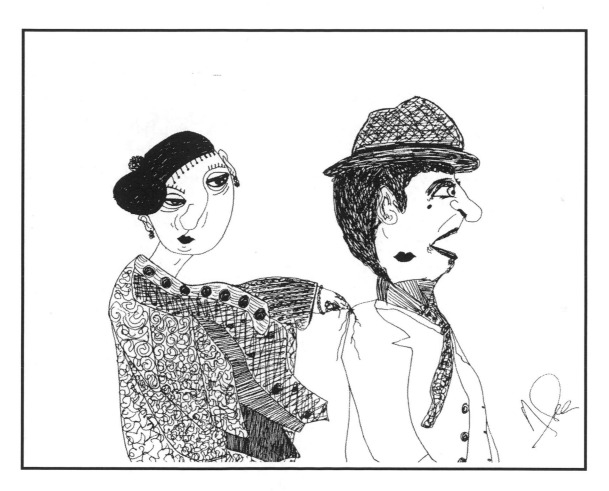

The Kiss

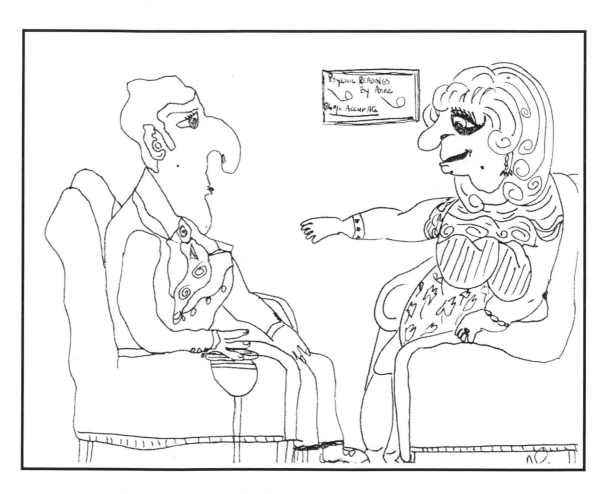

Psychic Readings 86% Accurate

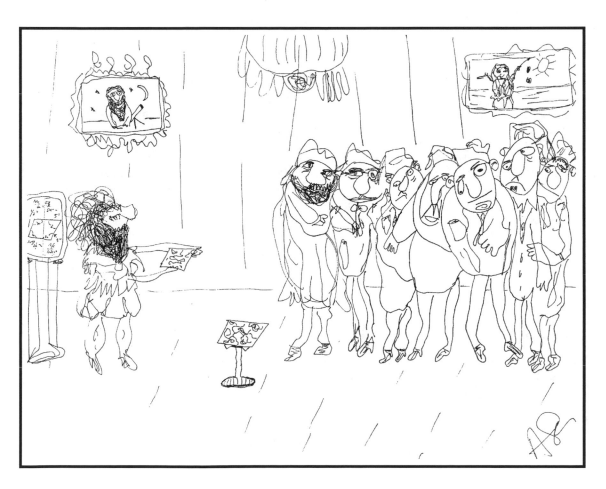

Galileo Faces The Inquisition

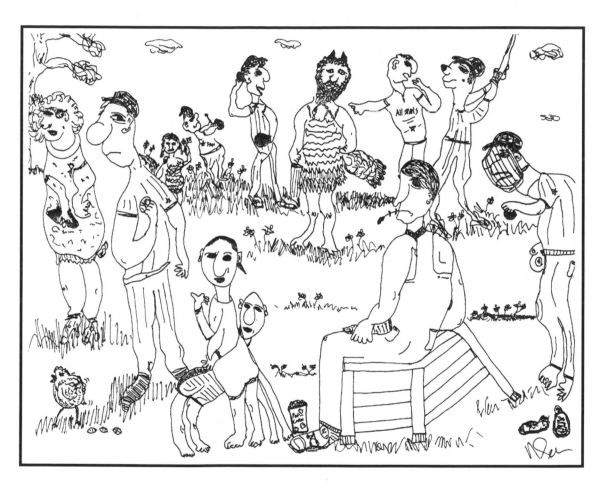

Time Warp

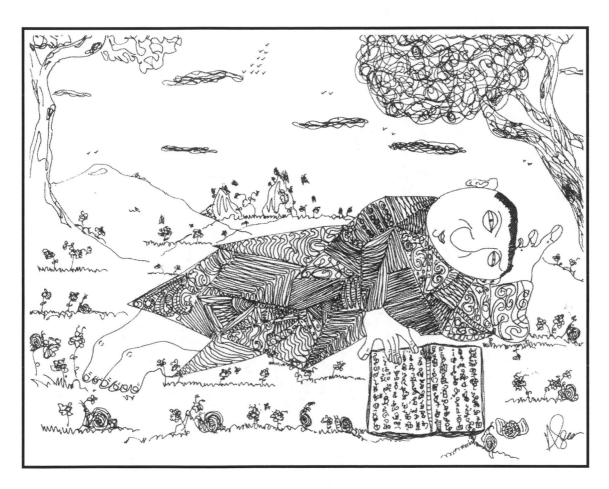

The Reader

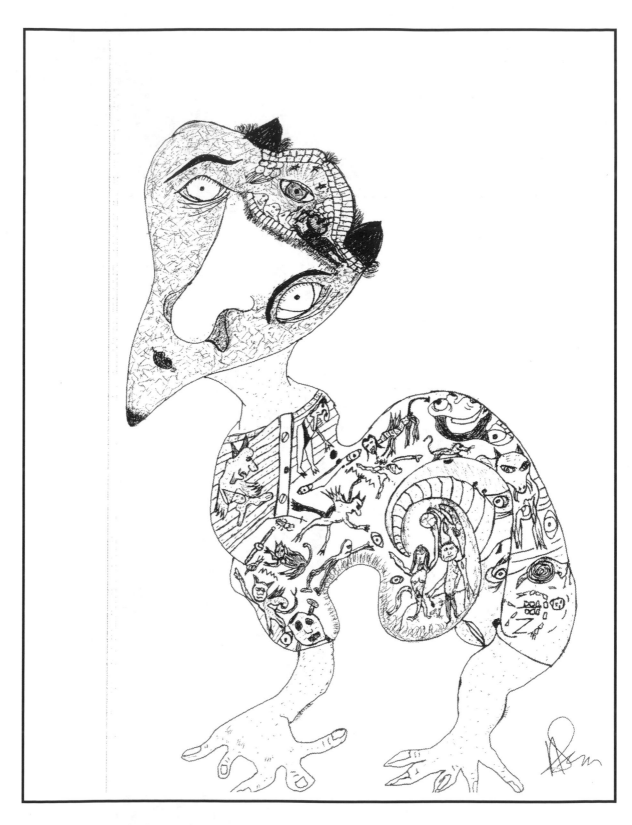

Creature From The Garden Of Eden

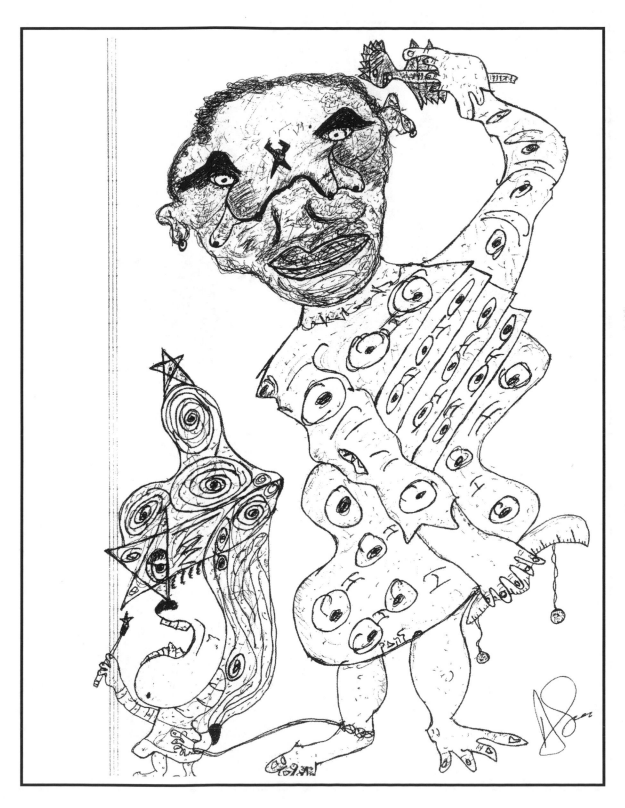

Black Magic

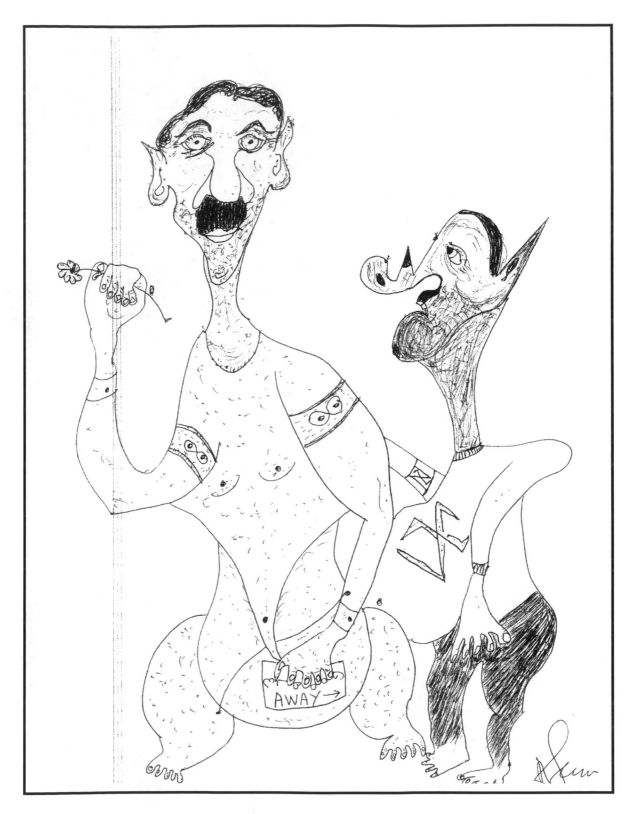

Nazi Fairies

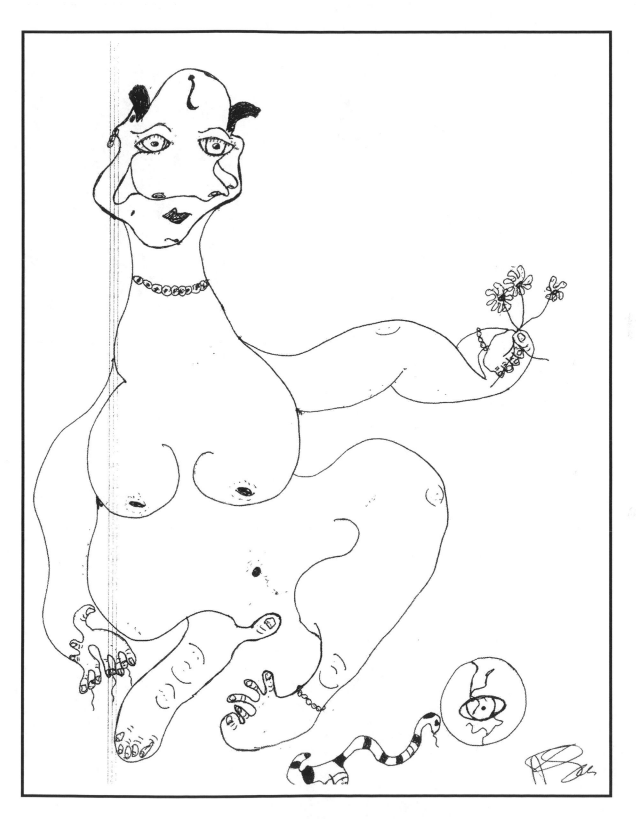

And God Created Eve

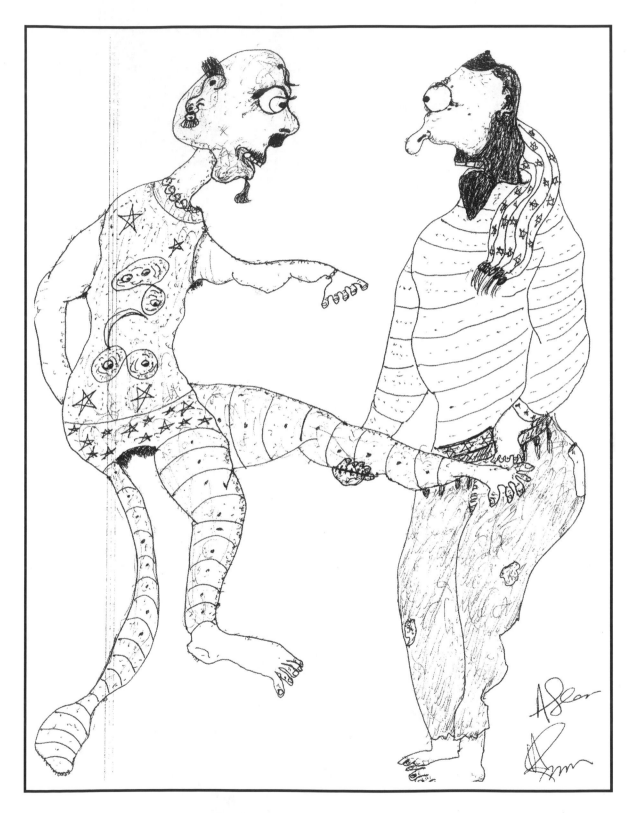

Satan and the Jew

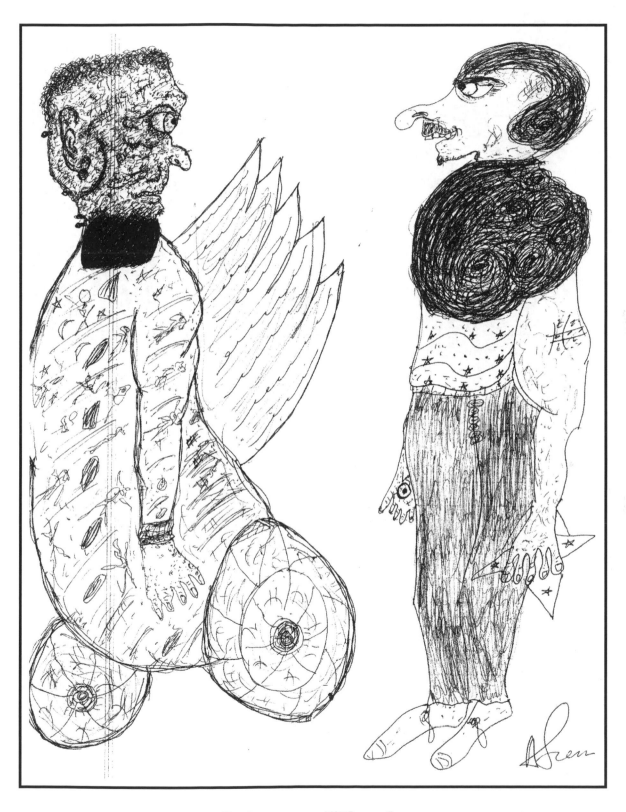

Satan on Wheels

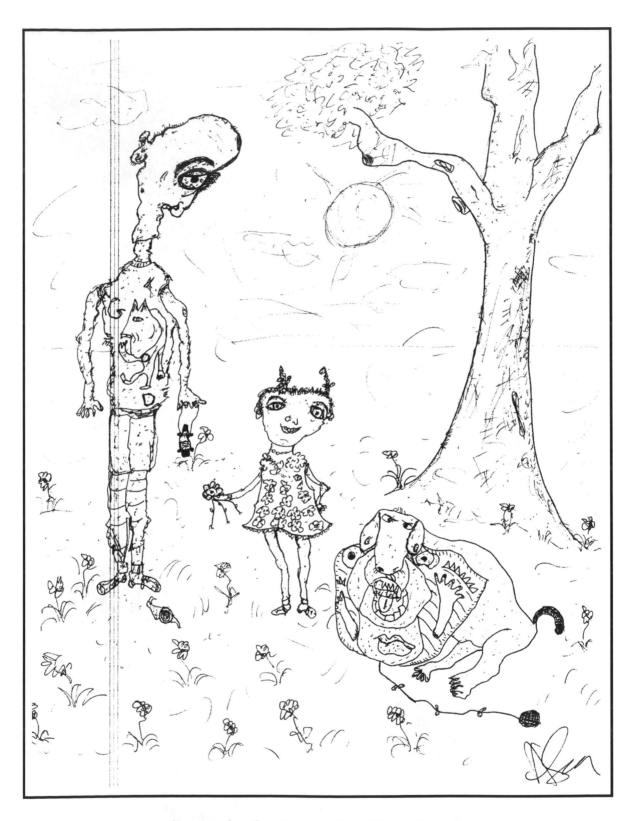

Susie's Outing In The Park

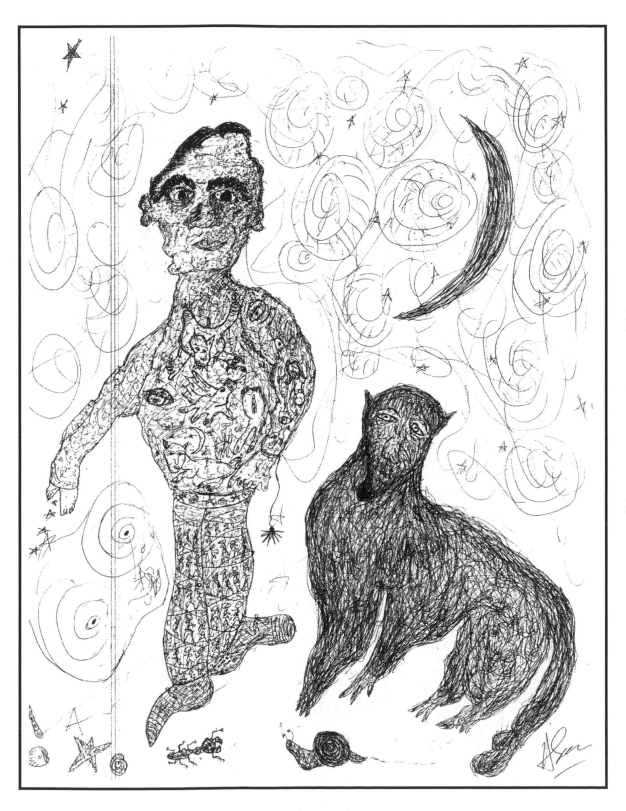

Devon And His Mystical Dog

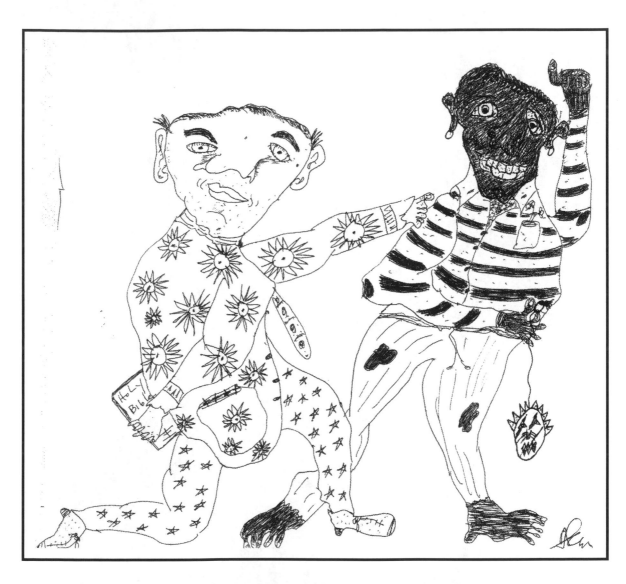

Riverboat Preacher

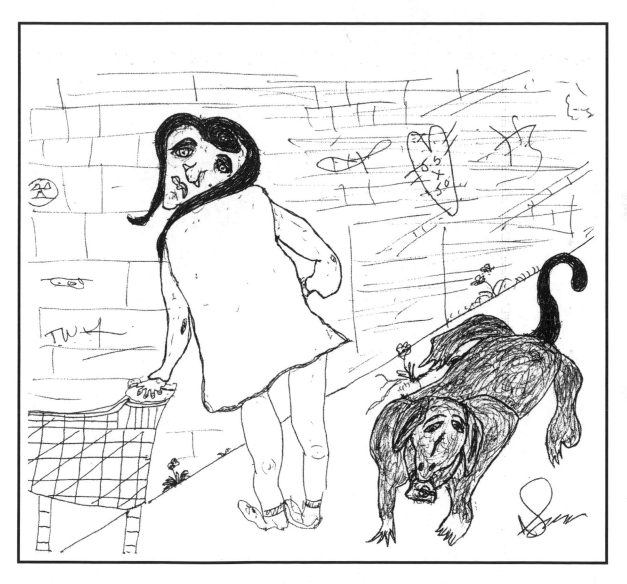

Homeless Girl

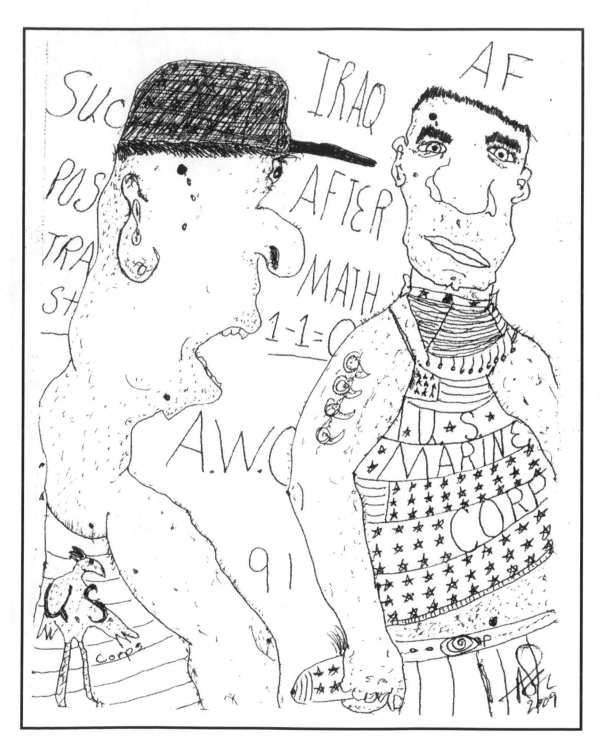

US Marine Corps

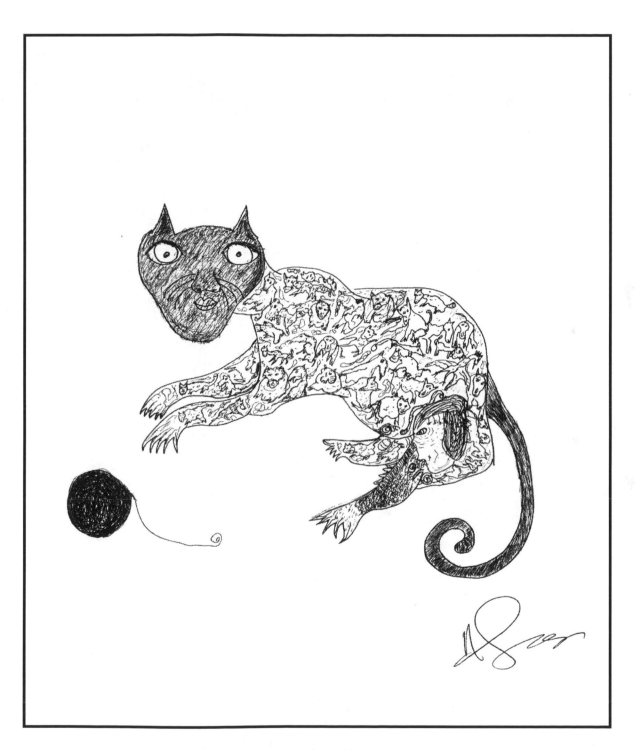

Tattoo Cat

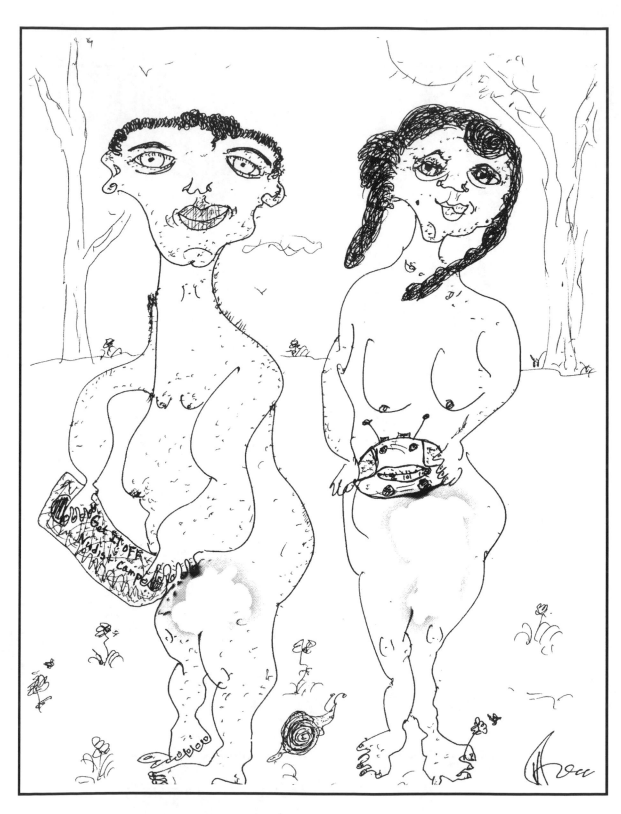

Nudist Camp Couple

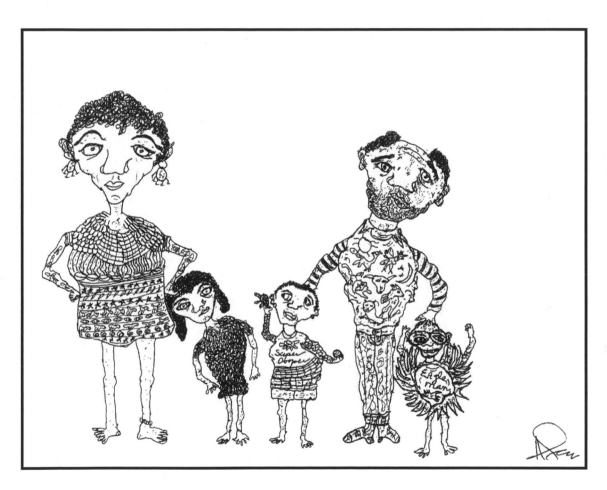

The Zolohoffs

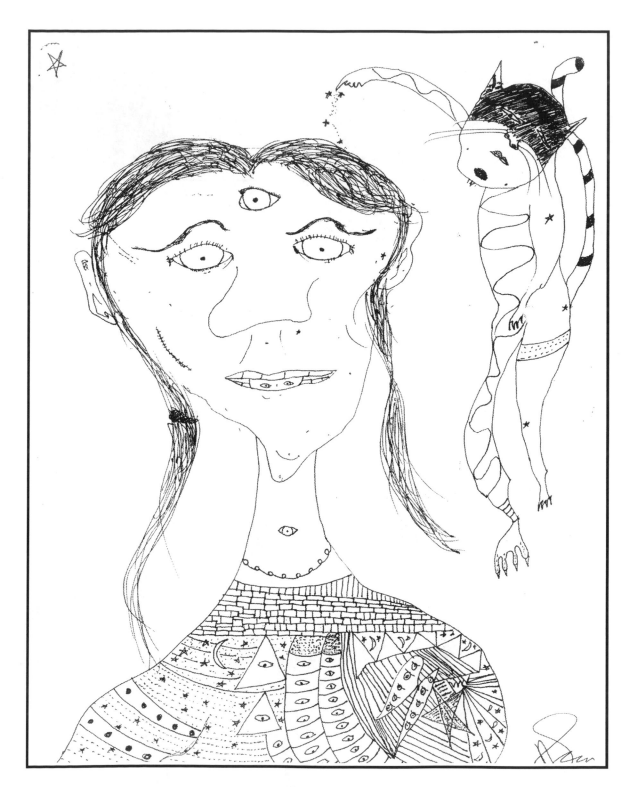

Xymetria

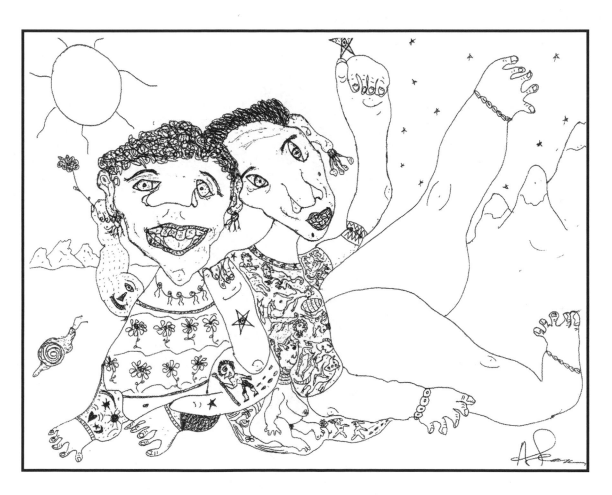

Twin Kenyans

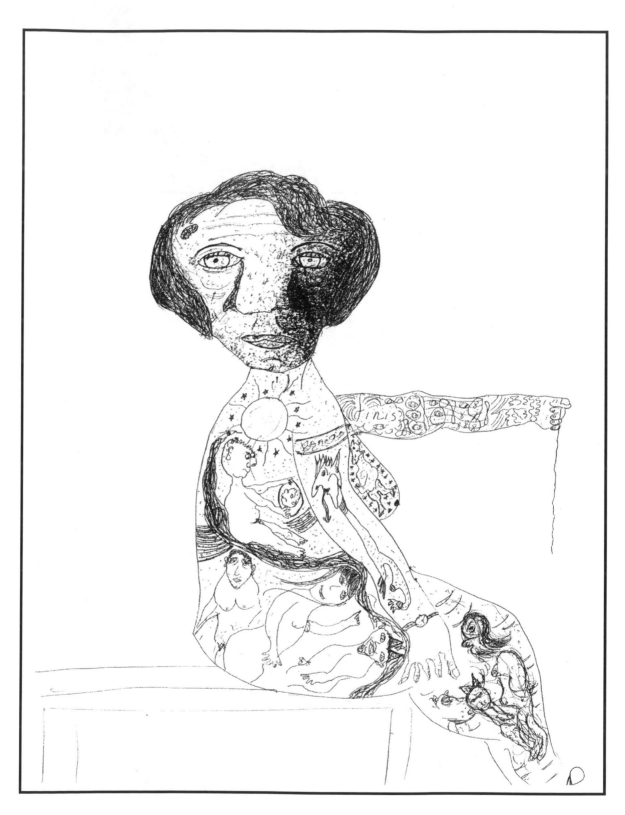

Eve's Dark Side

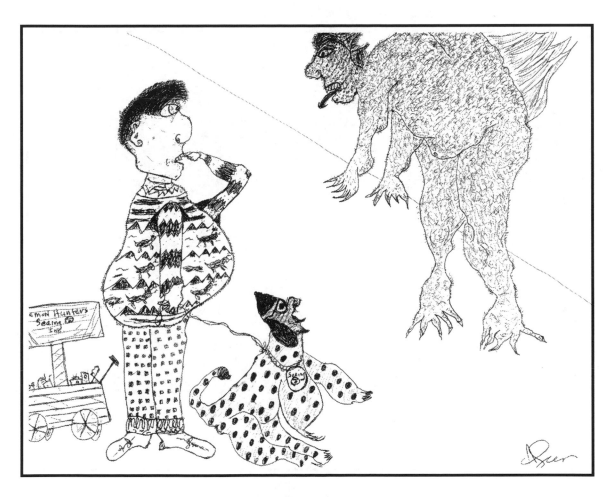

Demon Hunters

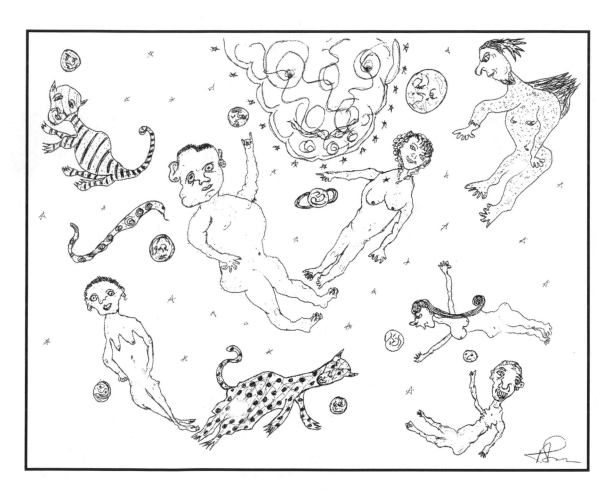

Celestial Forces

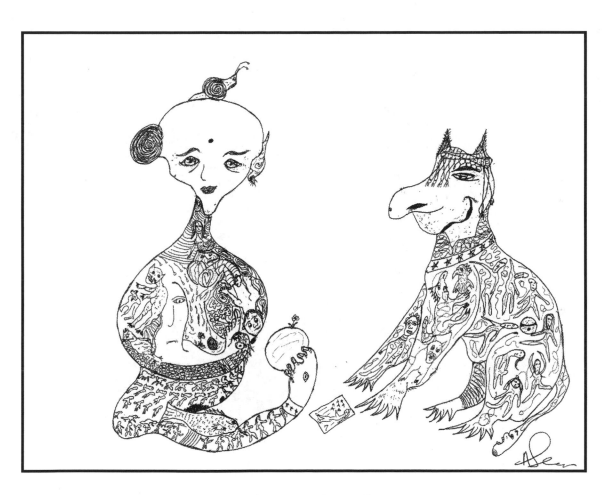

The Tarot Reading

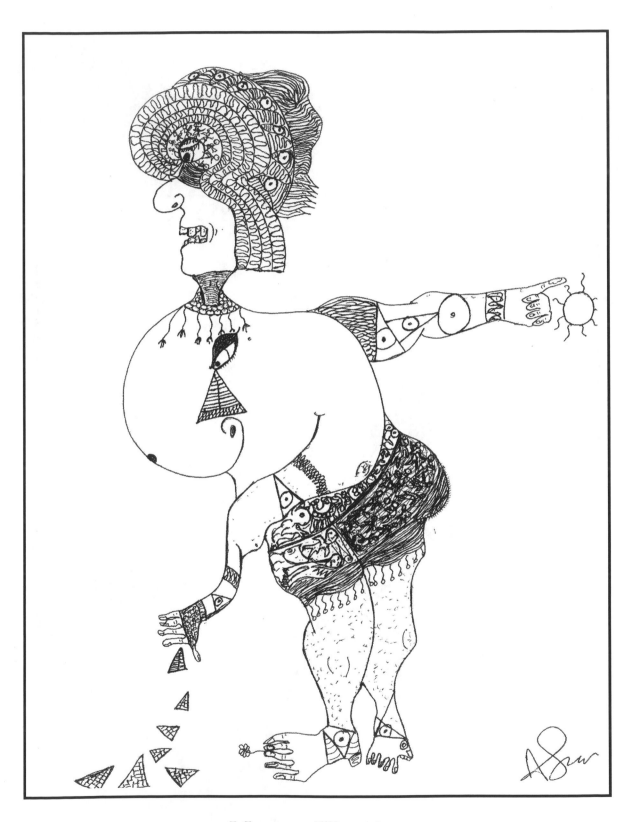

Mayan Warrior

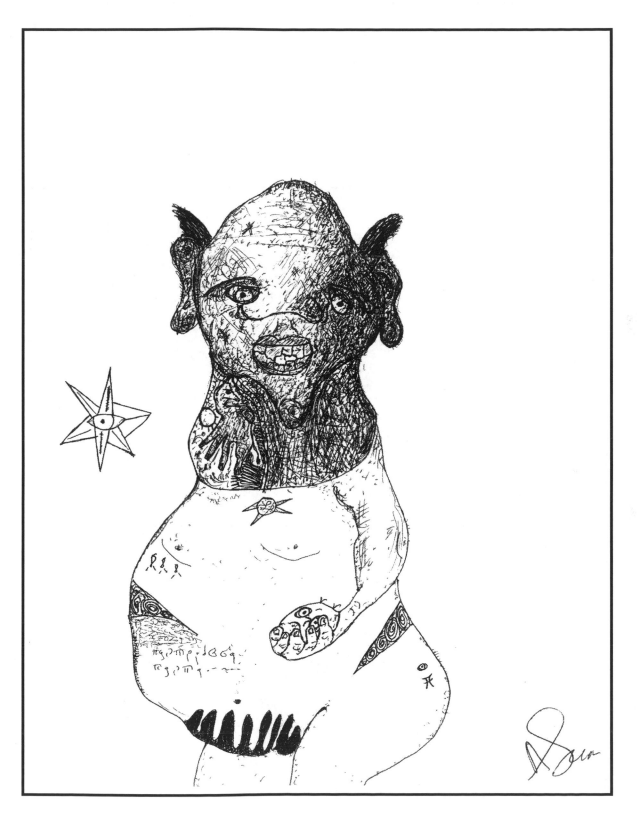

Bolemba from Uranus

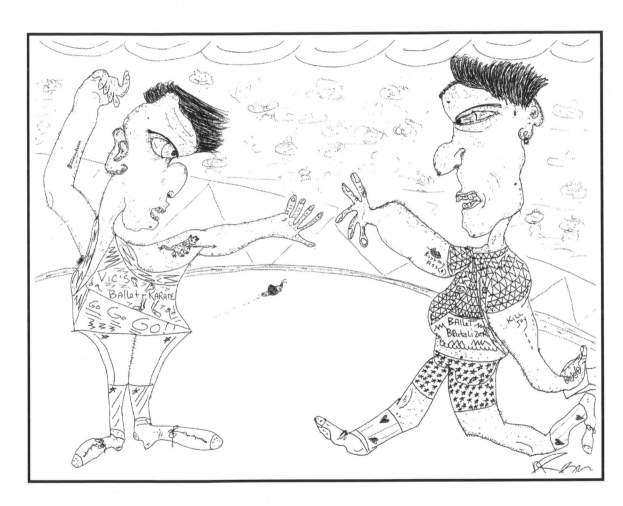

Ballet Karate

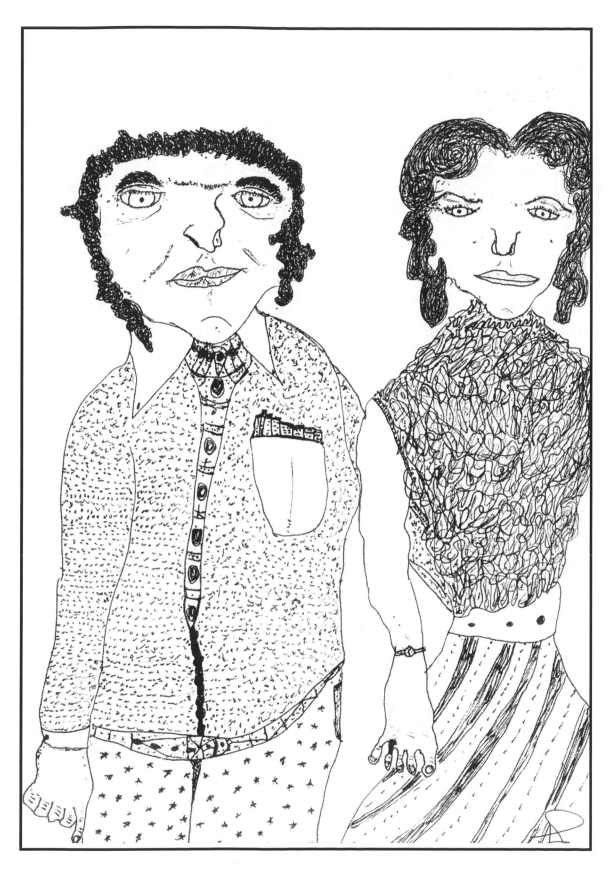

The Bobecks

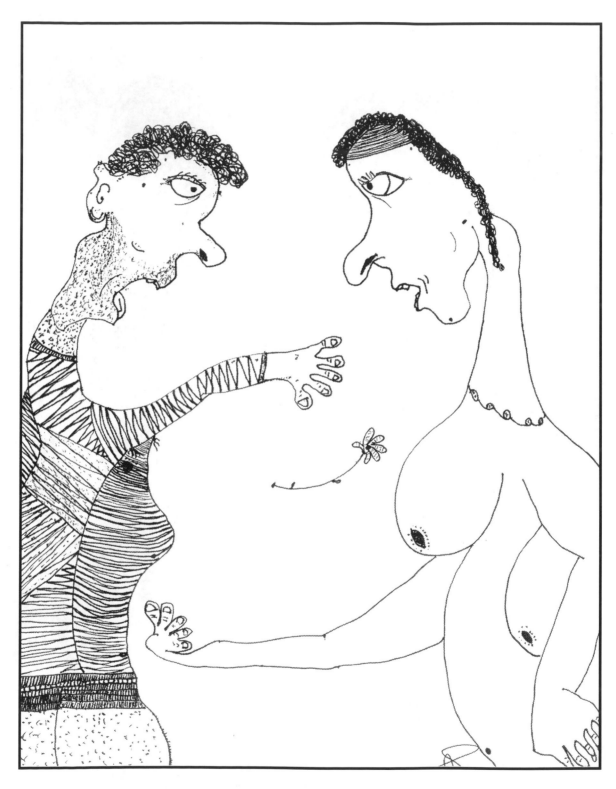

Flower's Lament

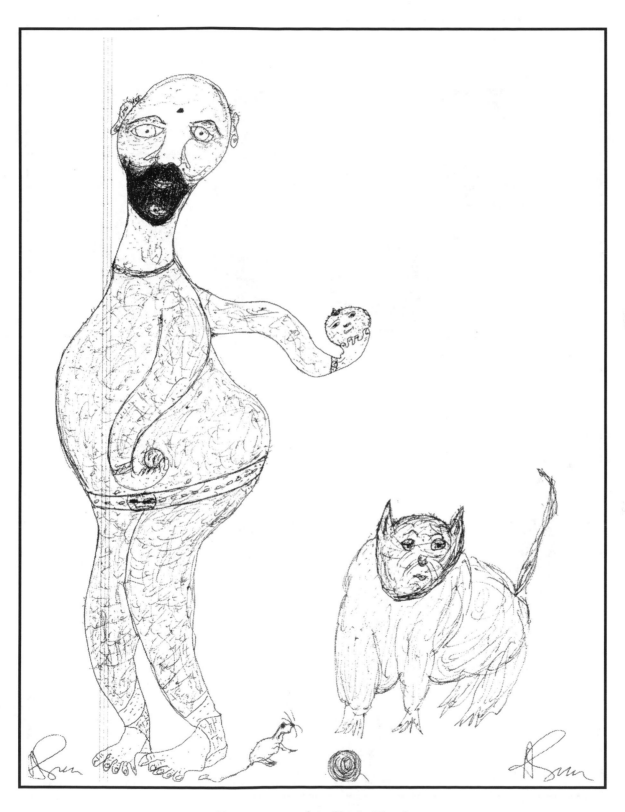

Cayman's Cat Rat

215

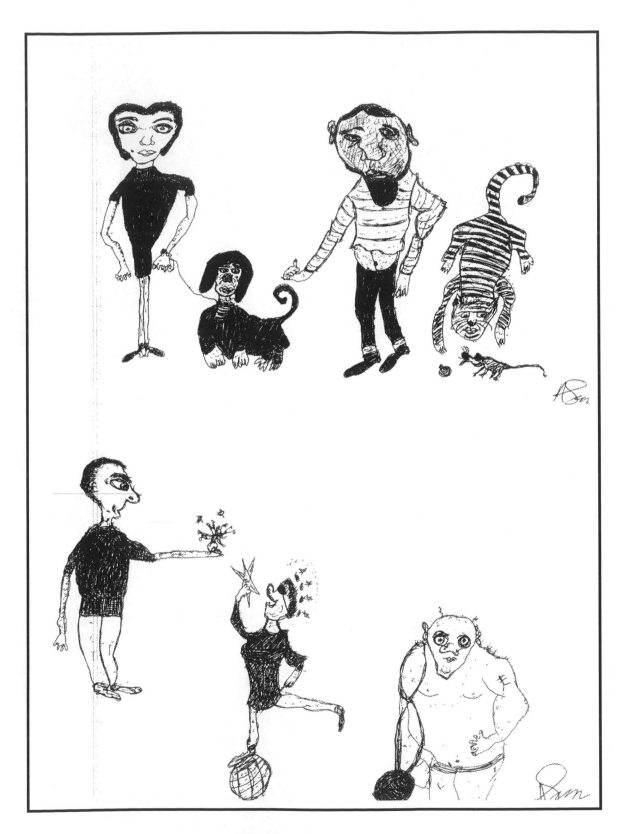

Eight Entities

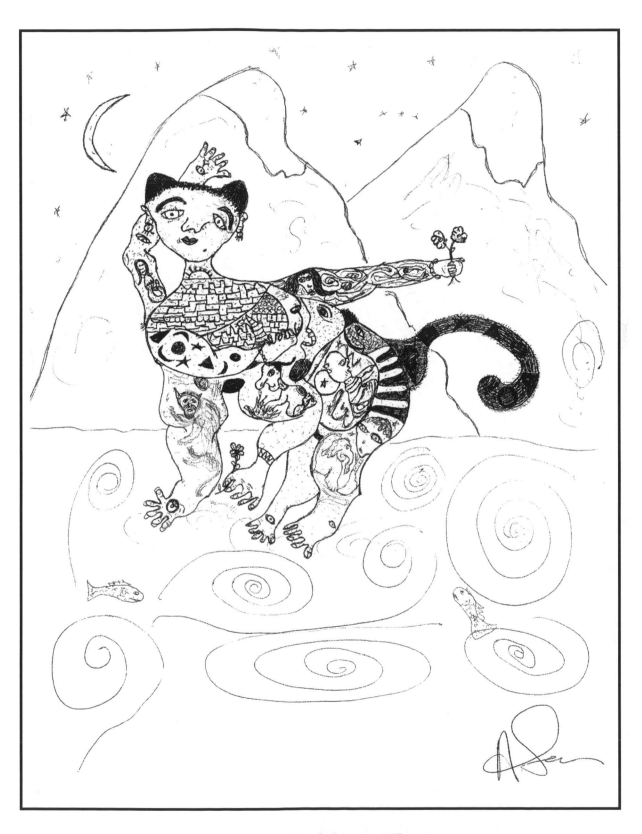

Mazuma Holding Flower

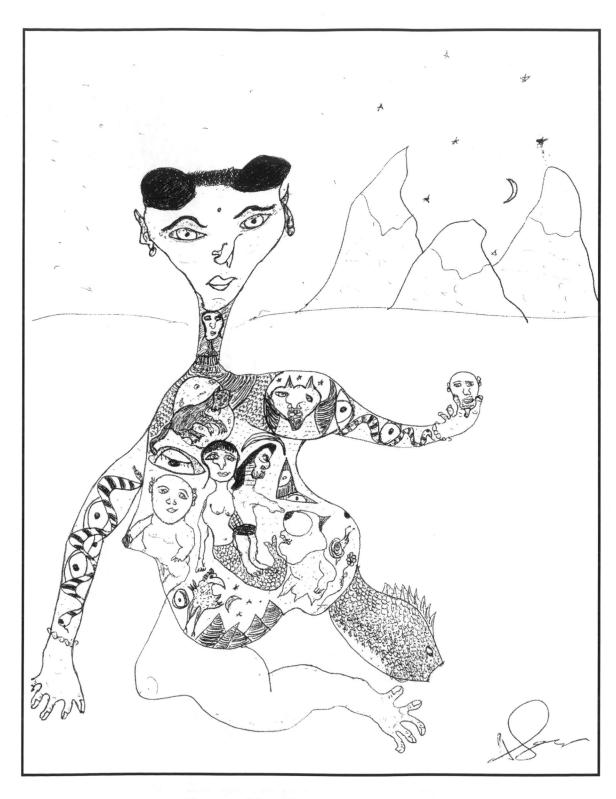

Demelia Holding Head

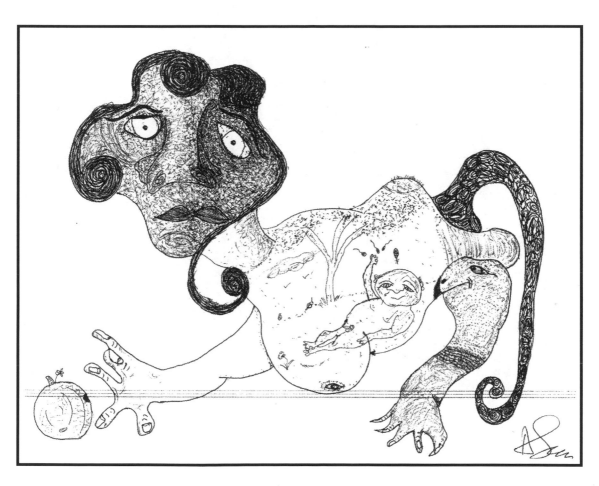

Pregnant Curlassa

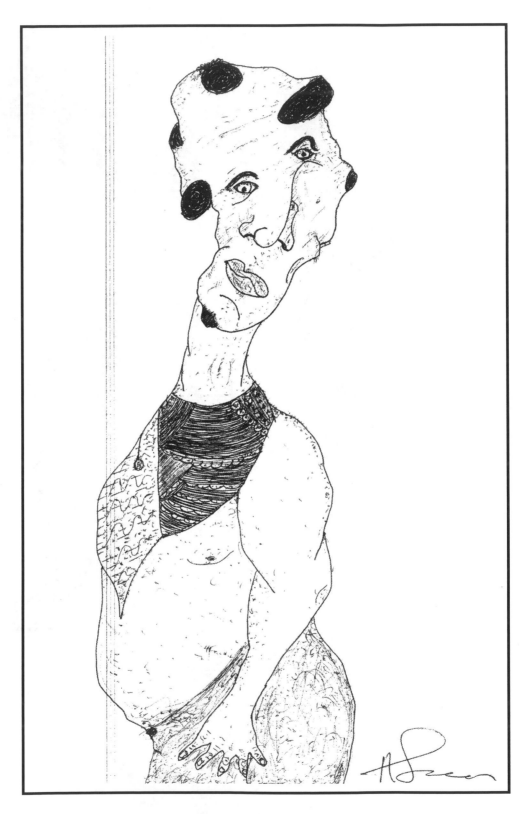

Uncle Georges

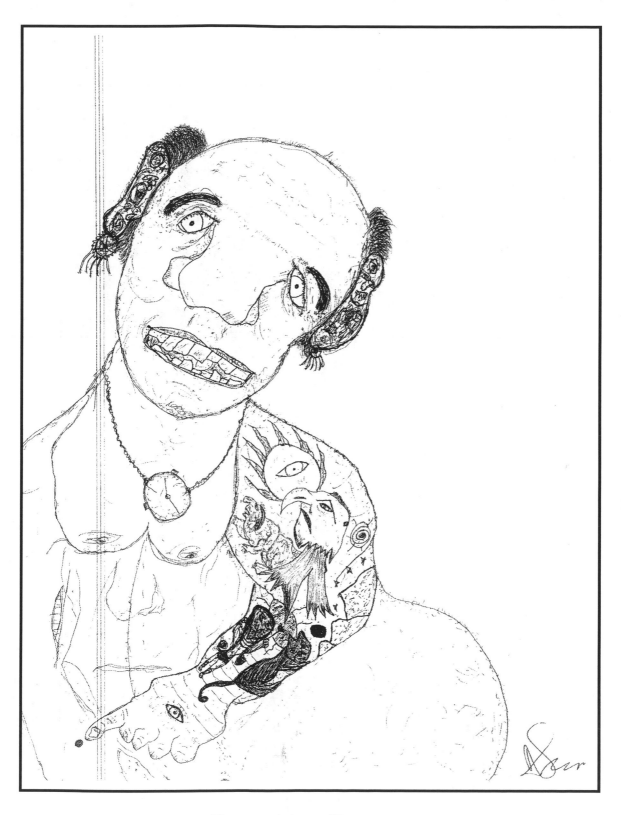

Becoming Brown

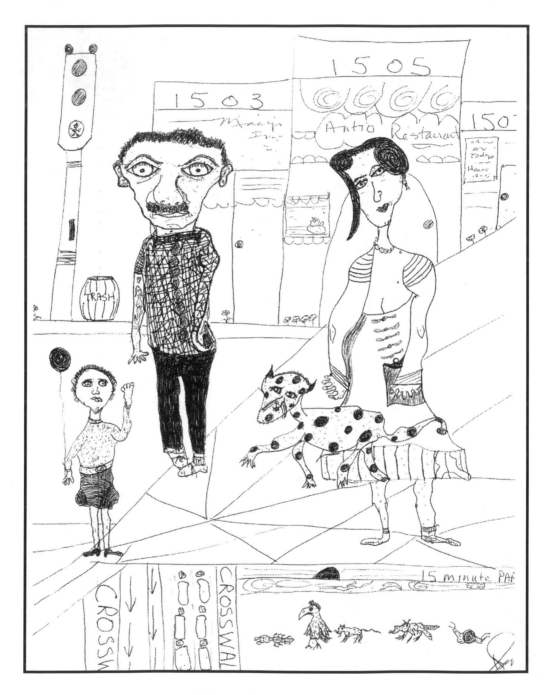

City Crosswalk

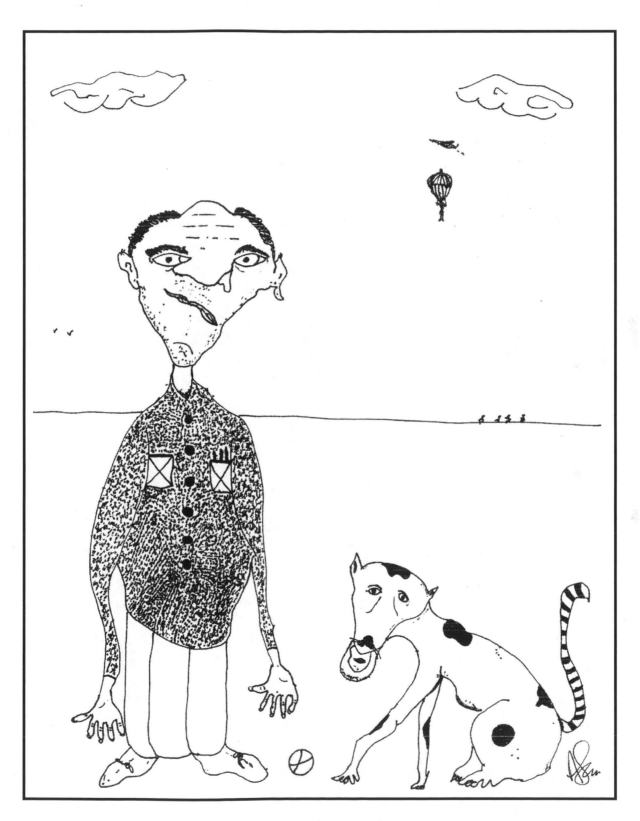

Longuini And Gelato

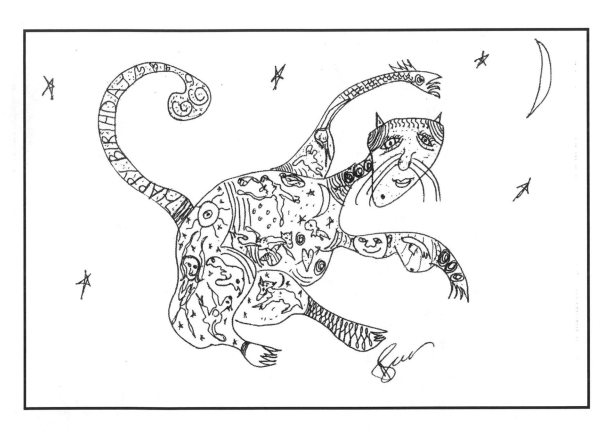

Cat In Heaven

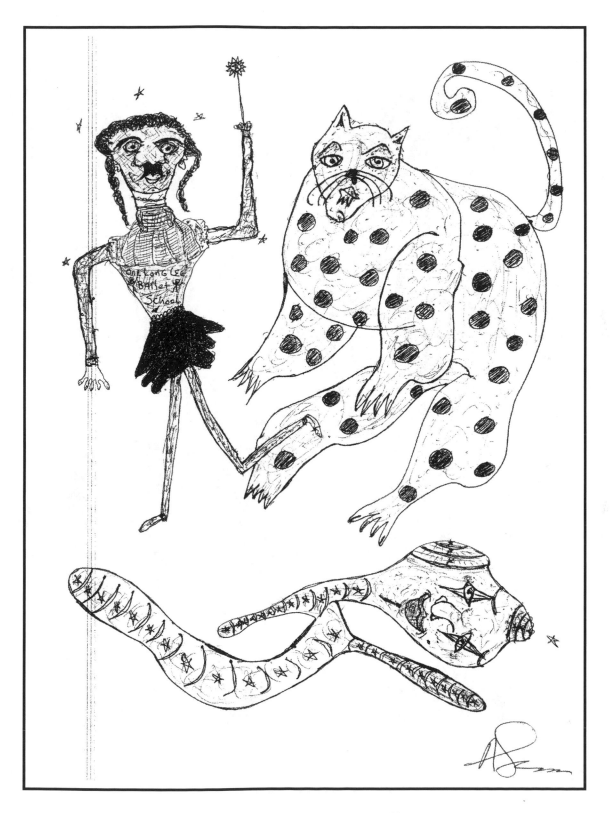

Ballet Fairy With Cat

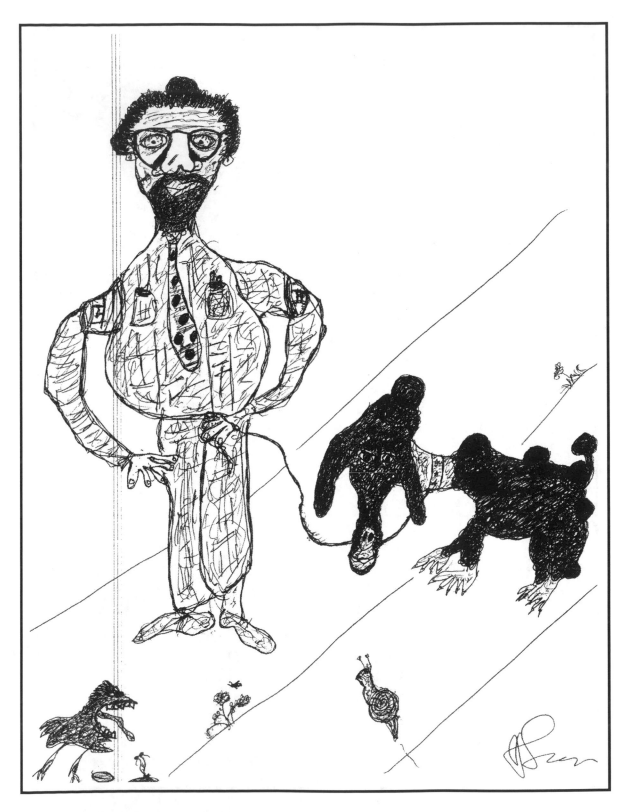

Professor Polinski Walking Kielbasa The Dog

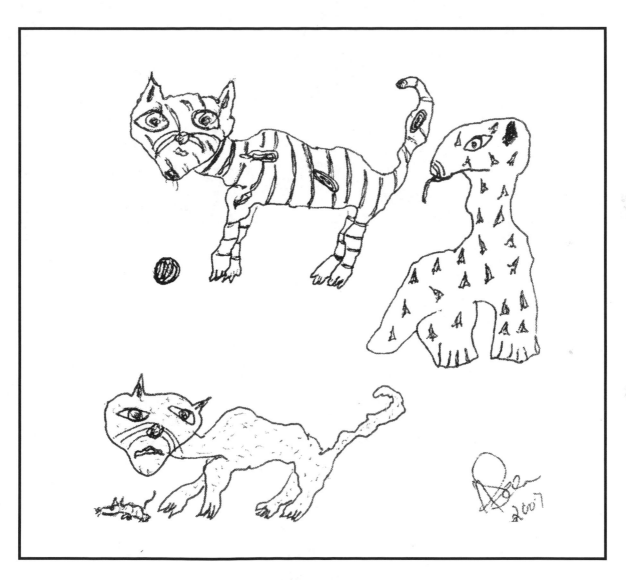

Two Cats And A Dinosaur

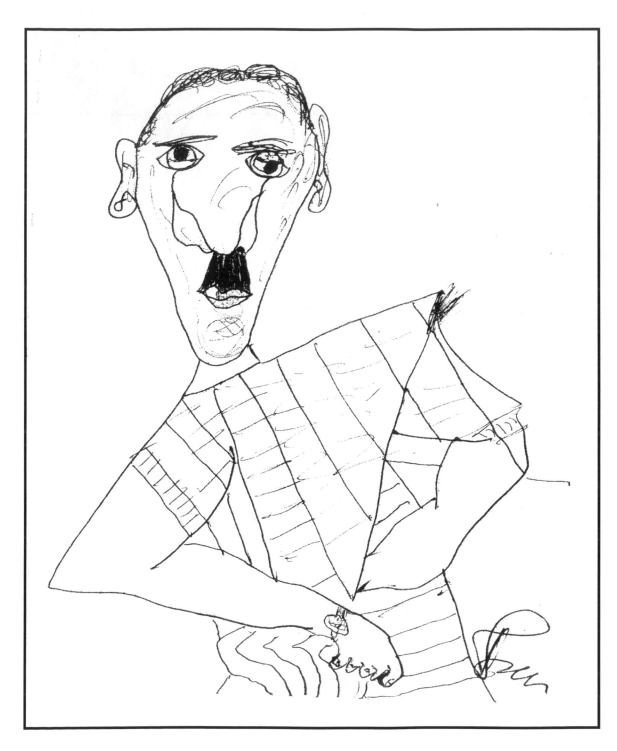

Man In Scalene Shirt

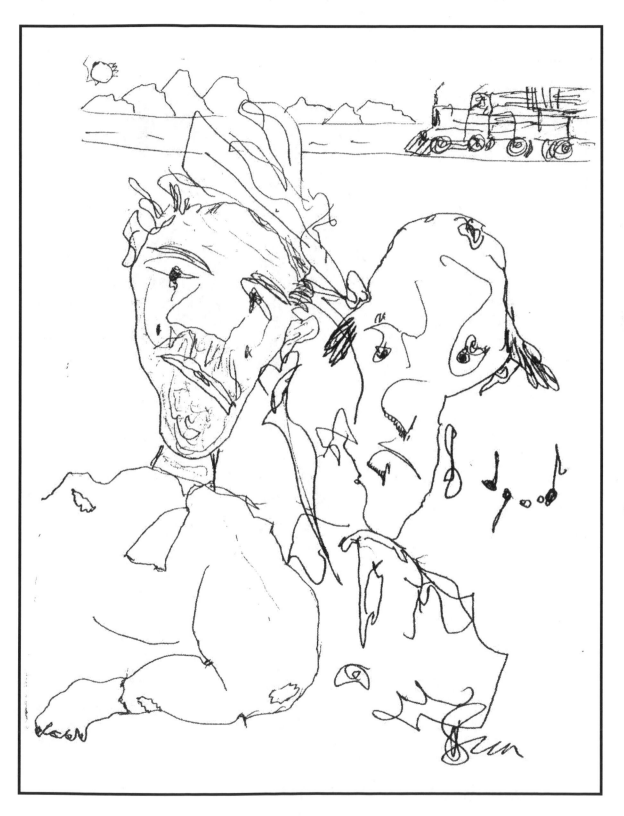

Hobos

229

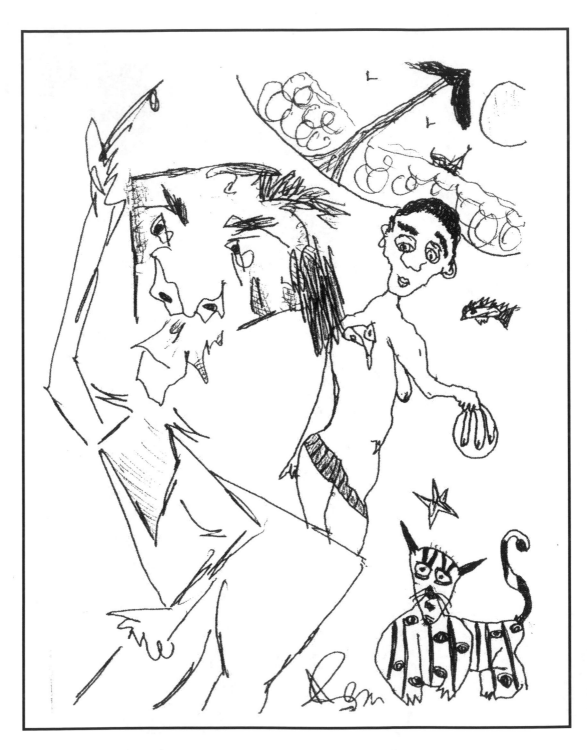

Janek Composing Jamaica Drum Song

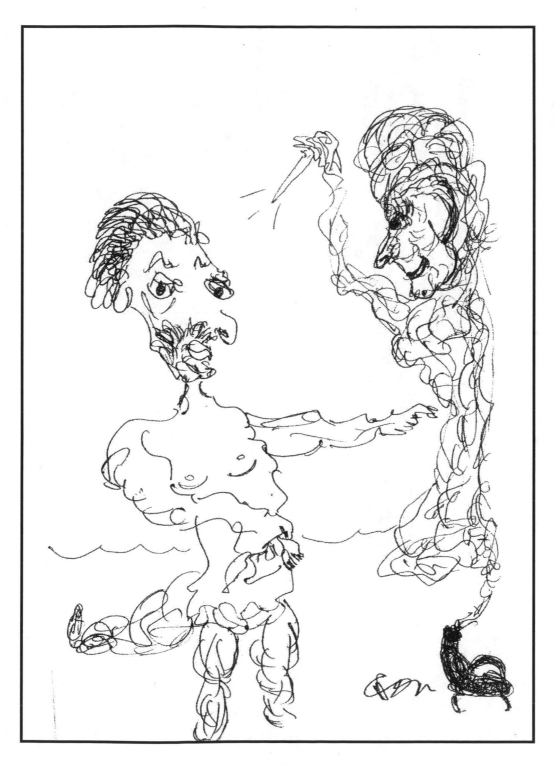

The Death Of Centaur

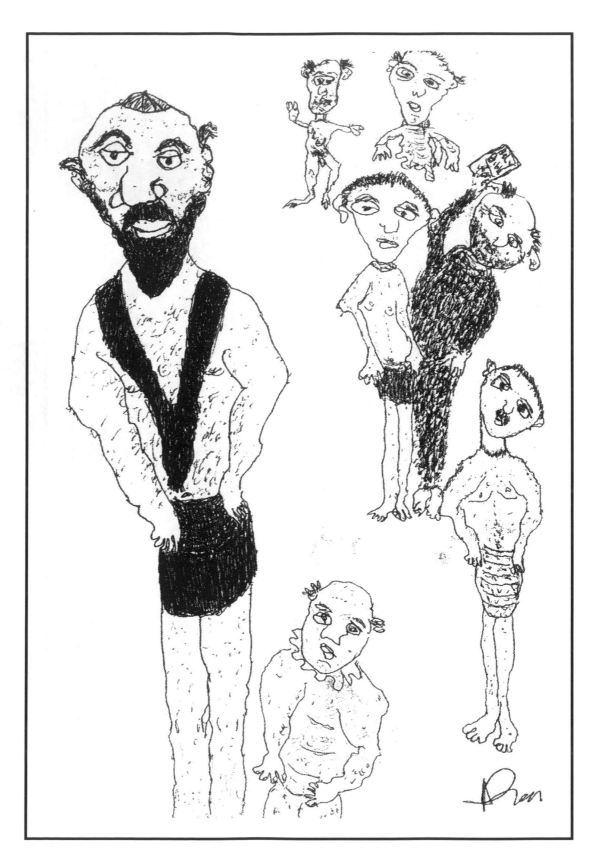

Jogging On The Sabbath

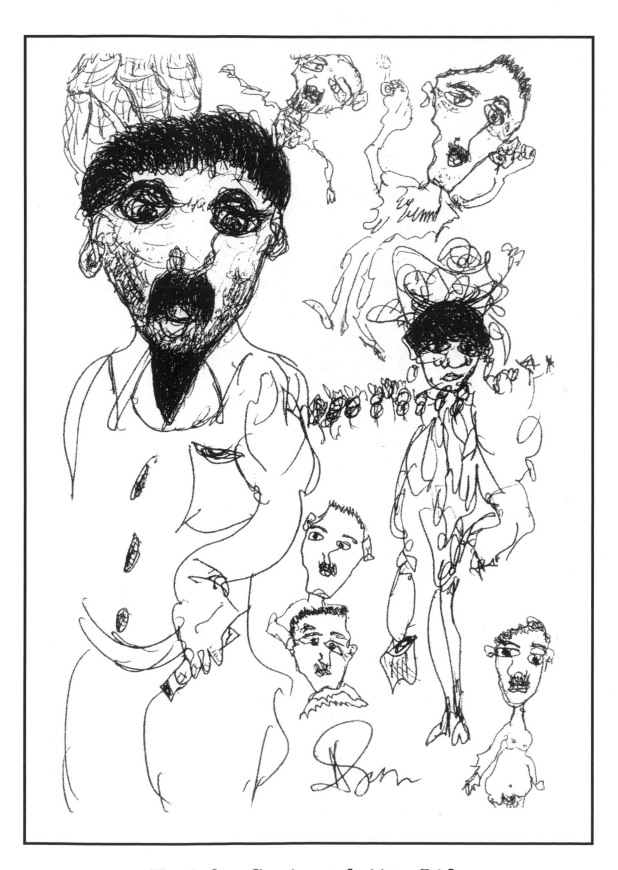

Trotsky Contemplating Life

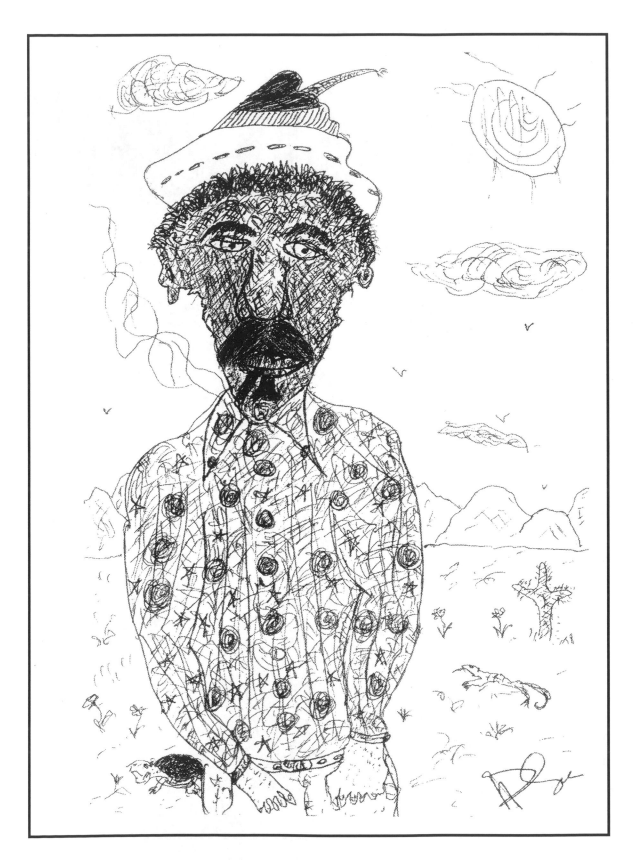

Peruvian Gypsy

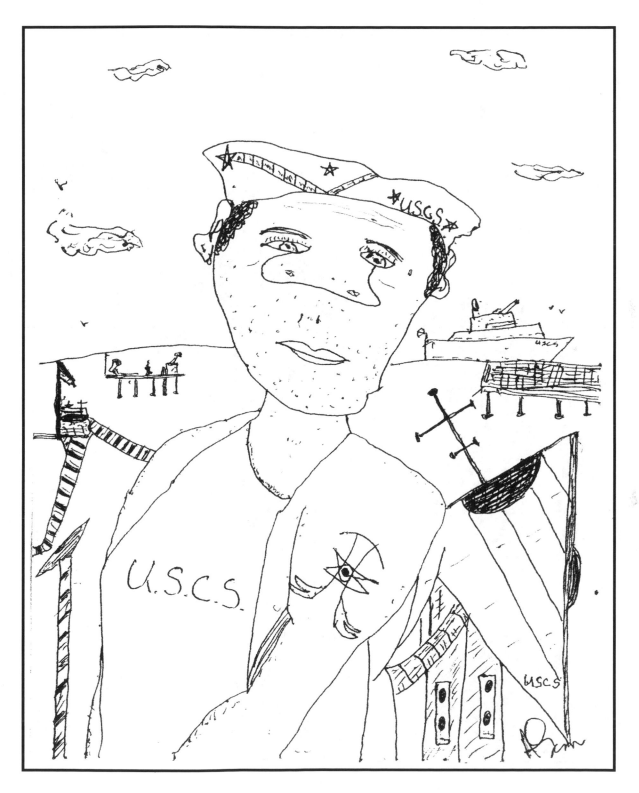

The Sailor

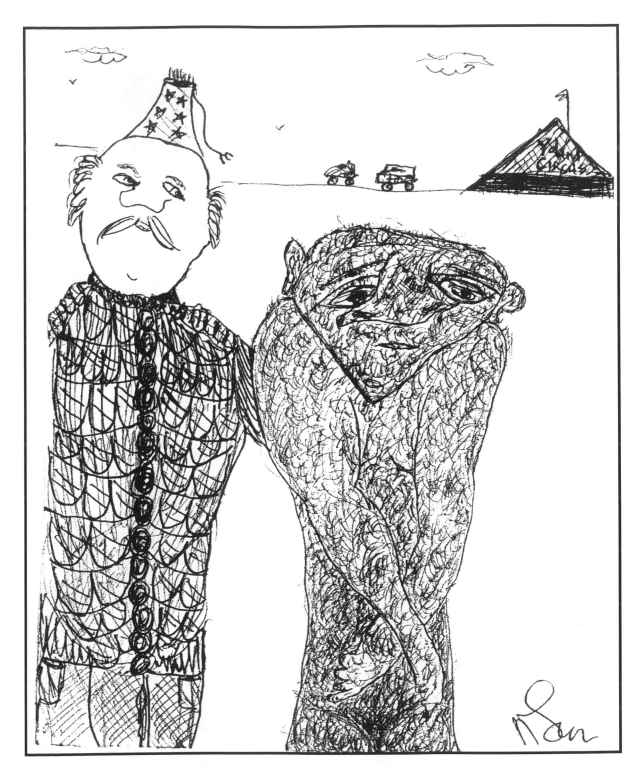

Stromboli And Ape Boy

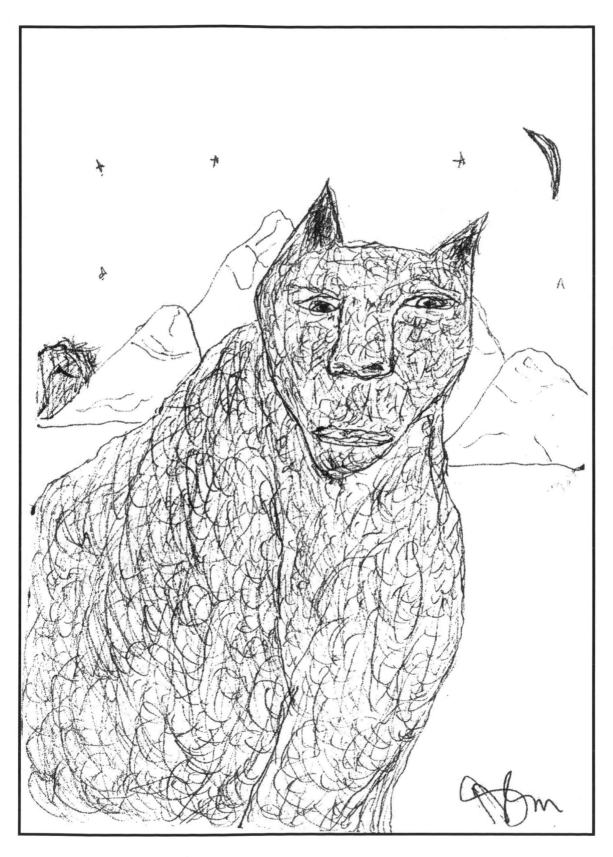

Miloletta The Mountain Cat

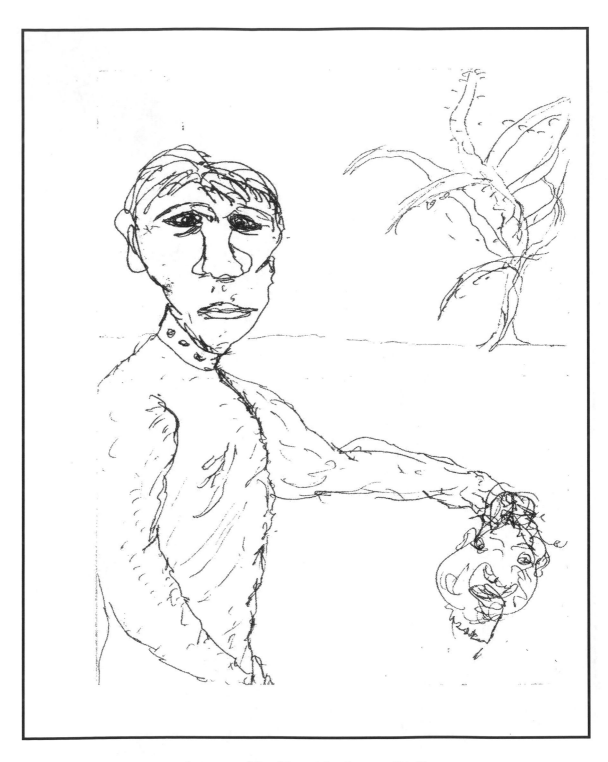

Asmat's Birthday Gift

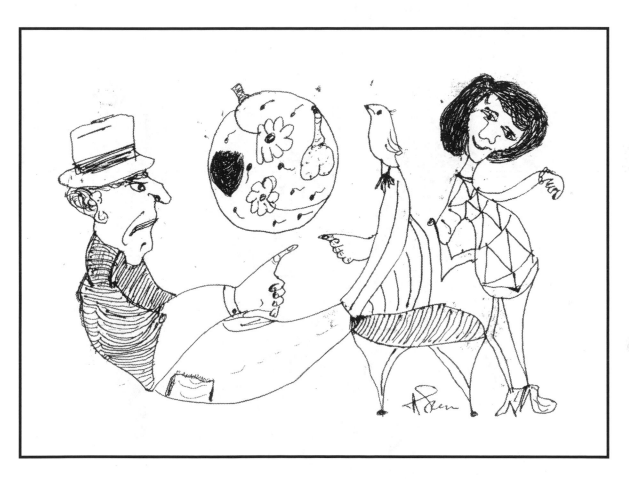

Teaching Mockingbird

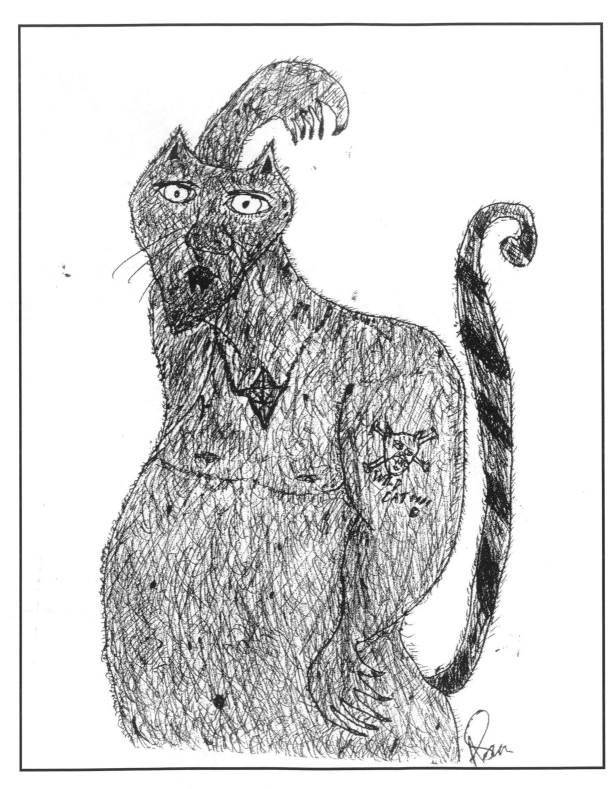

Wildcat

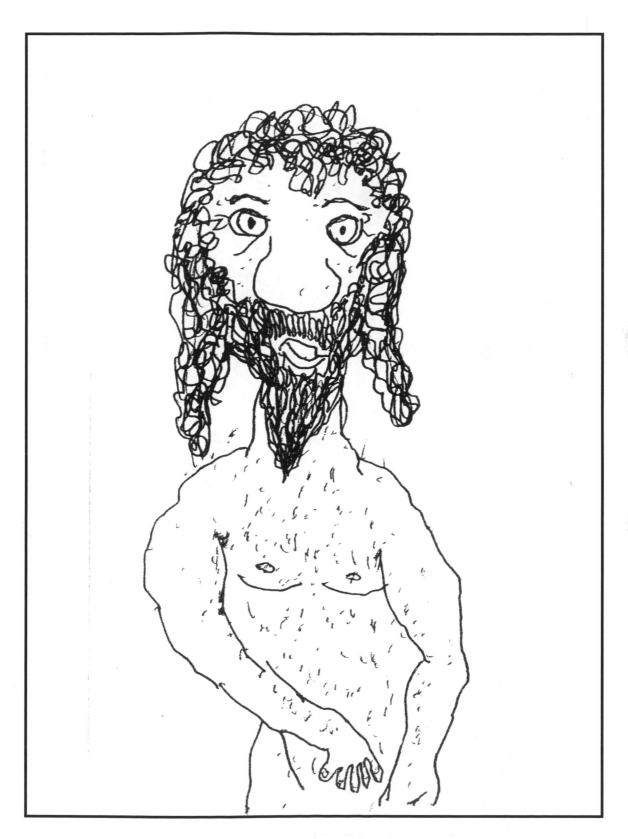

Adam Before Eve

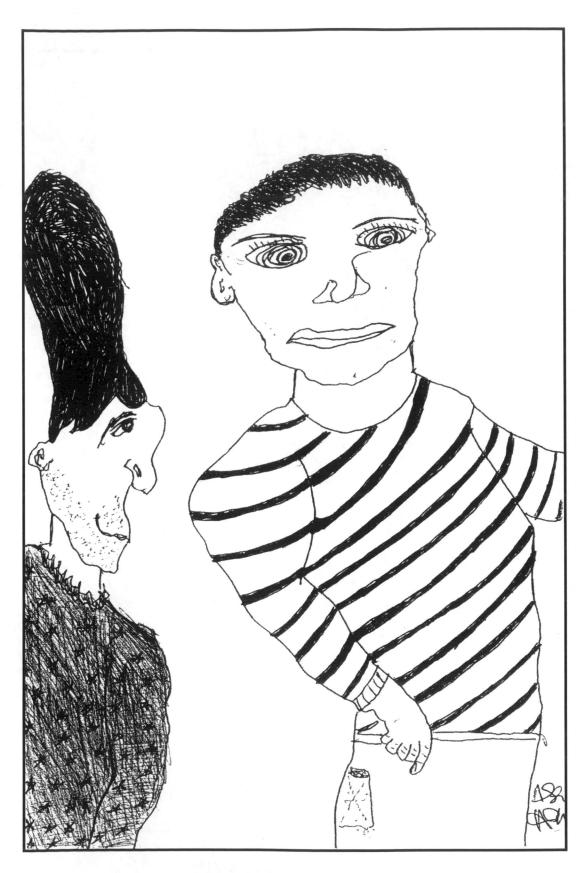

Gay Pride Beehive

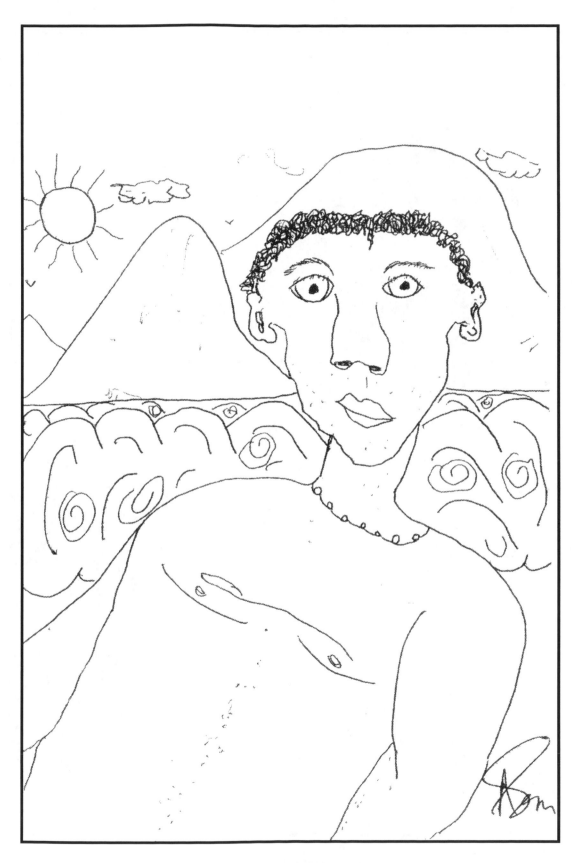

Jules The Surfer

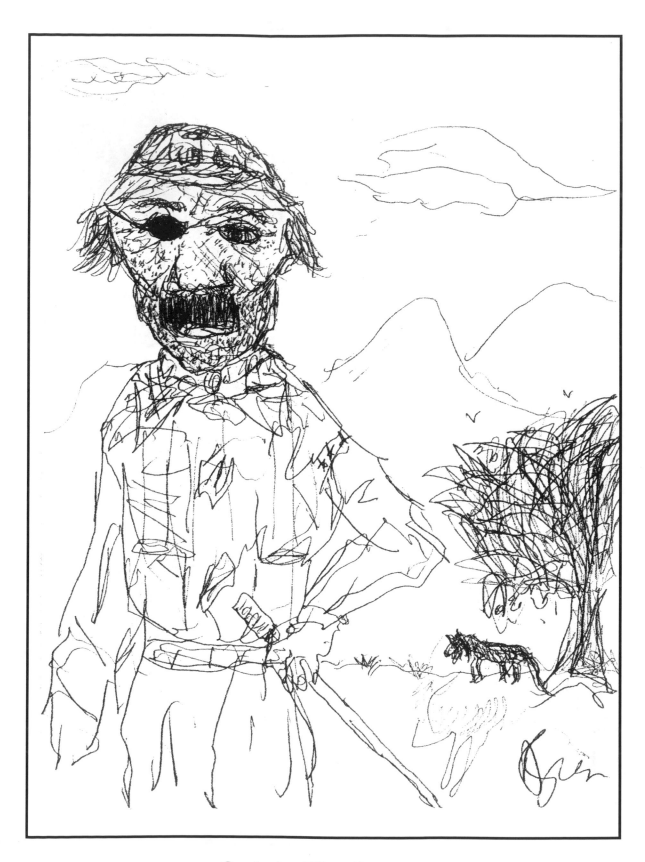

Quinto The Pirate

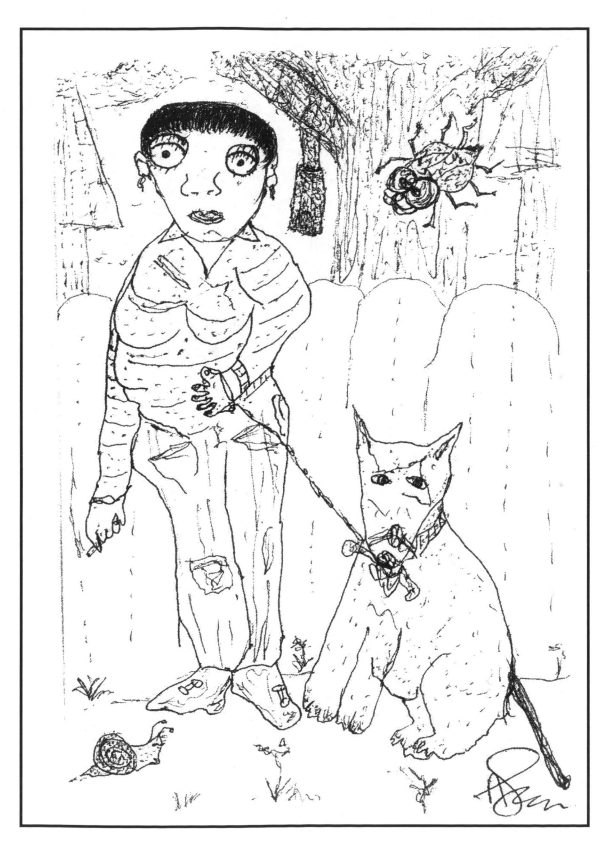

Liza Minelli Walking Her Dog

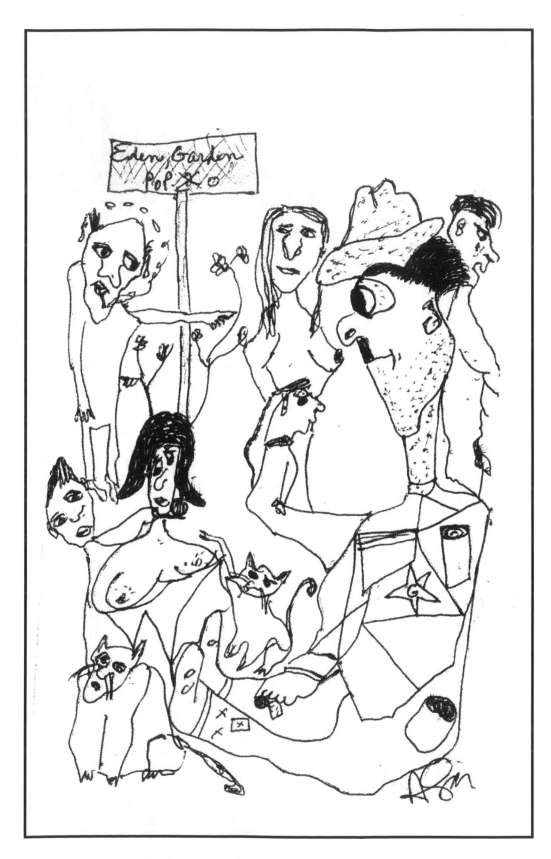

Exodus From Eden

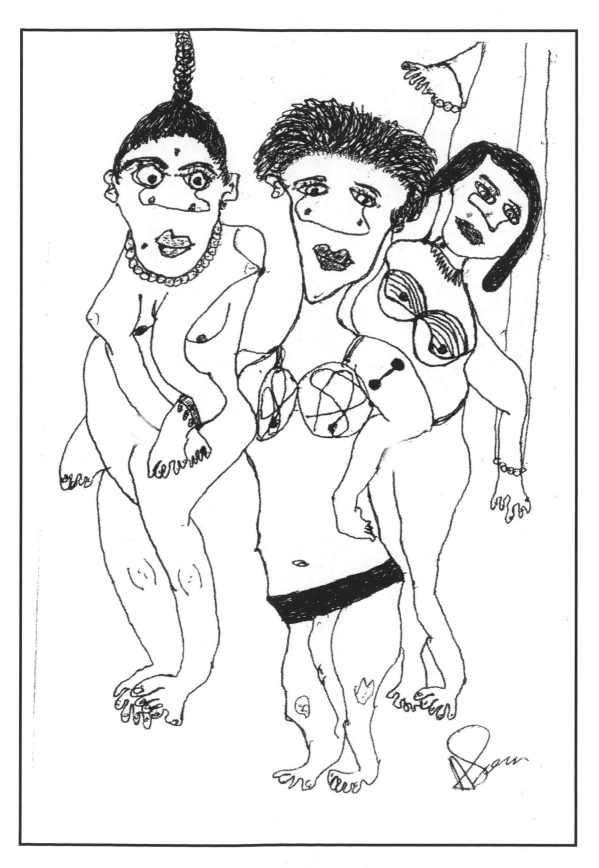

Naked Zuma

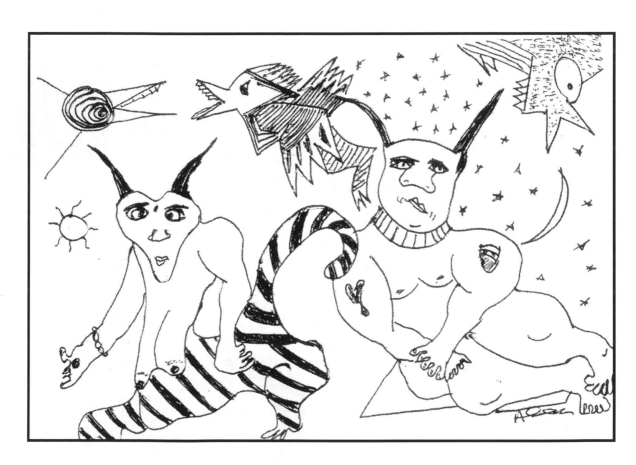

Demons Lounging

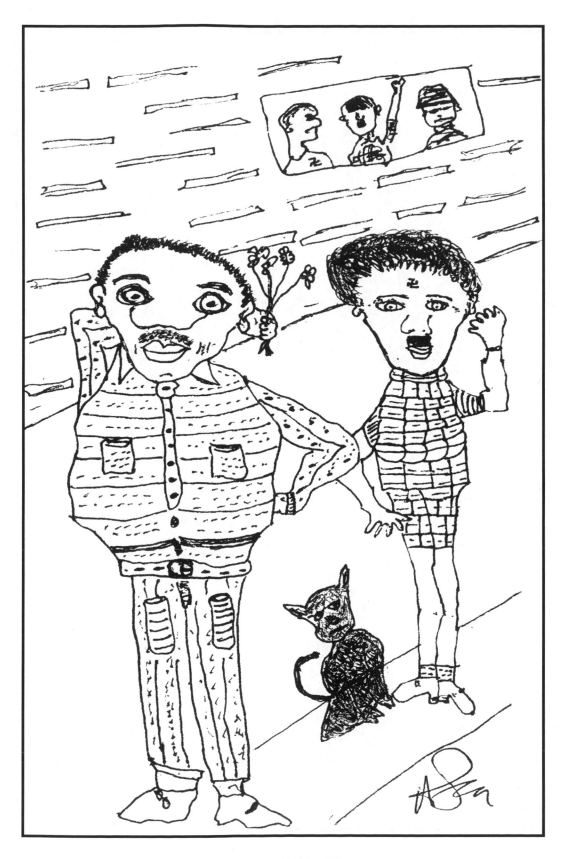

Gay Stroll

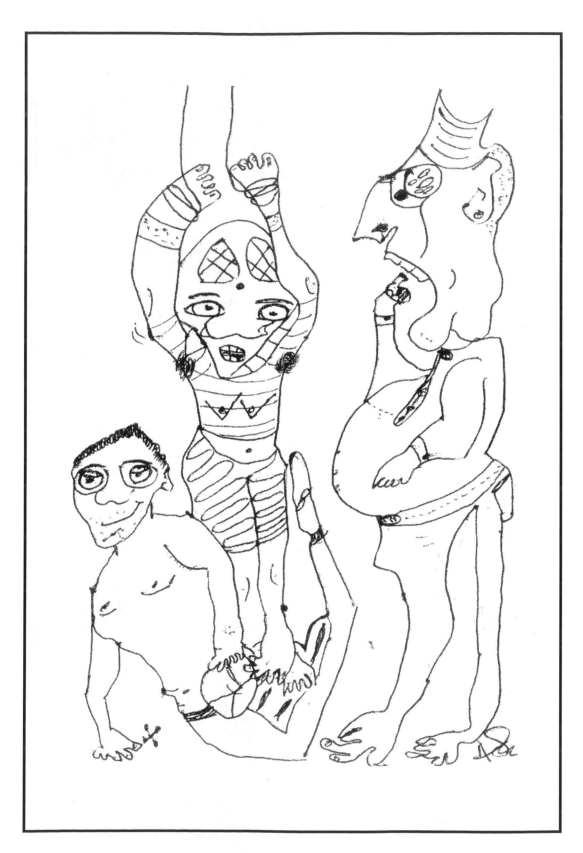

Rude Martian Landing

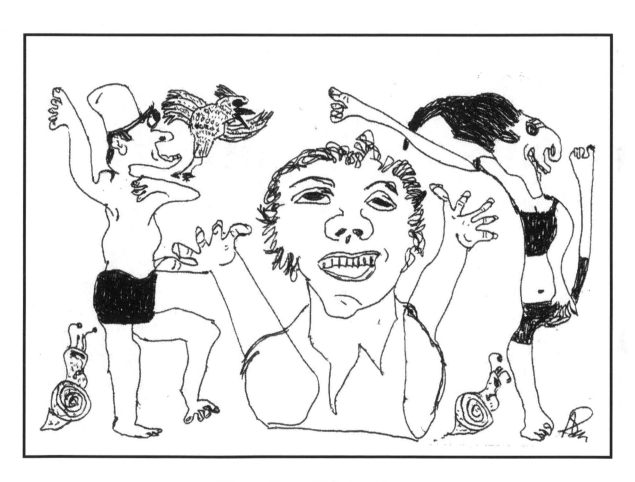

The Joy Of Acting

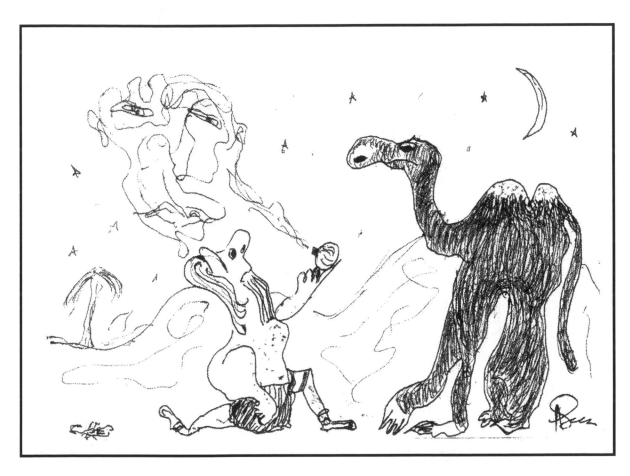

Shelmiel In The Desert

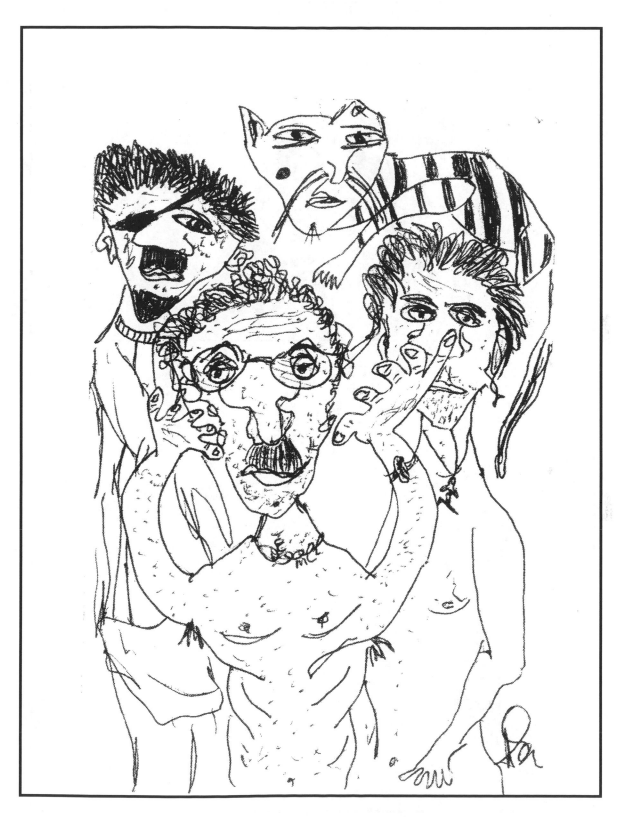

Burning Man Fans

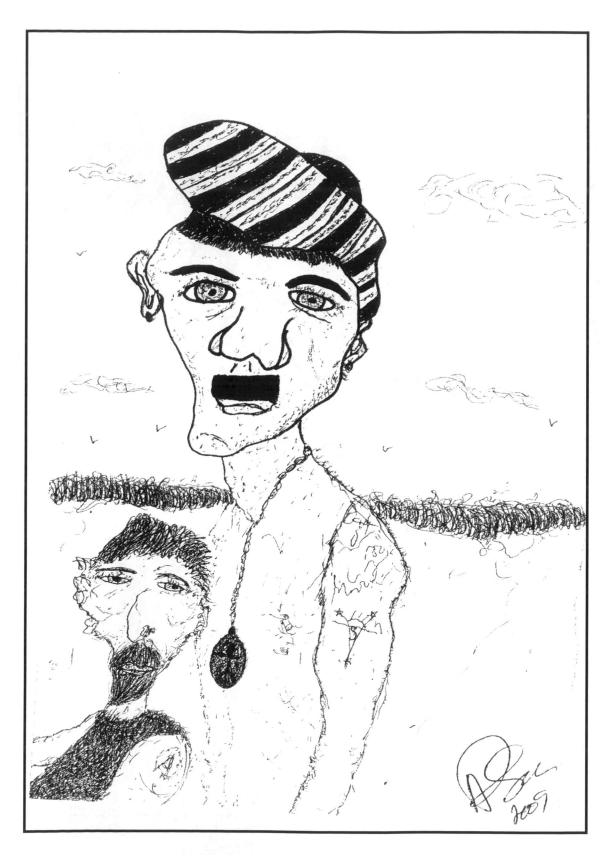

Serbian Man and Friend

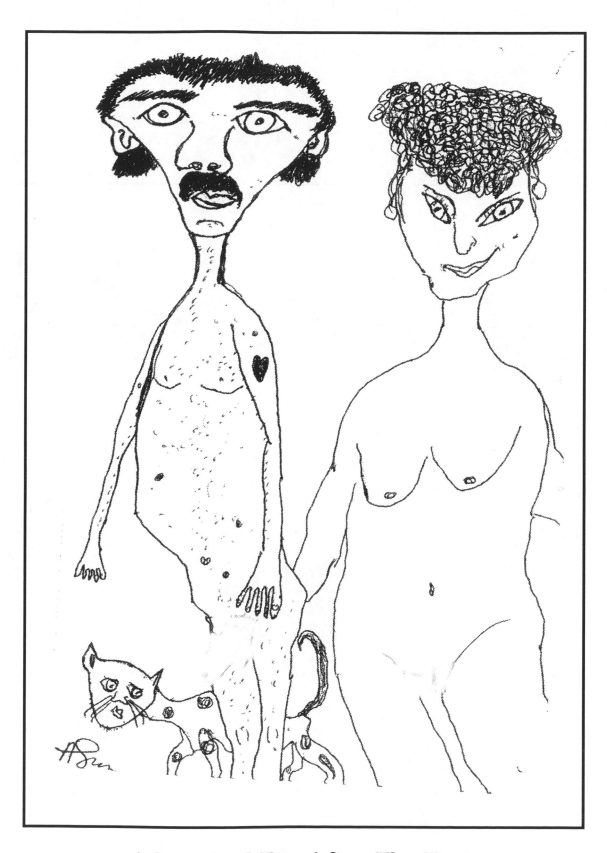

Adam And Eve After The Fact

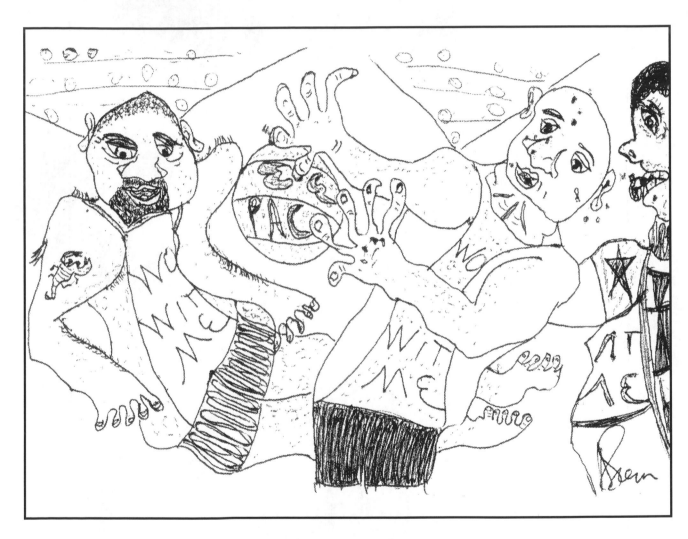

Hot Basketball

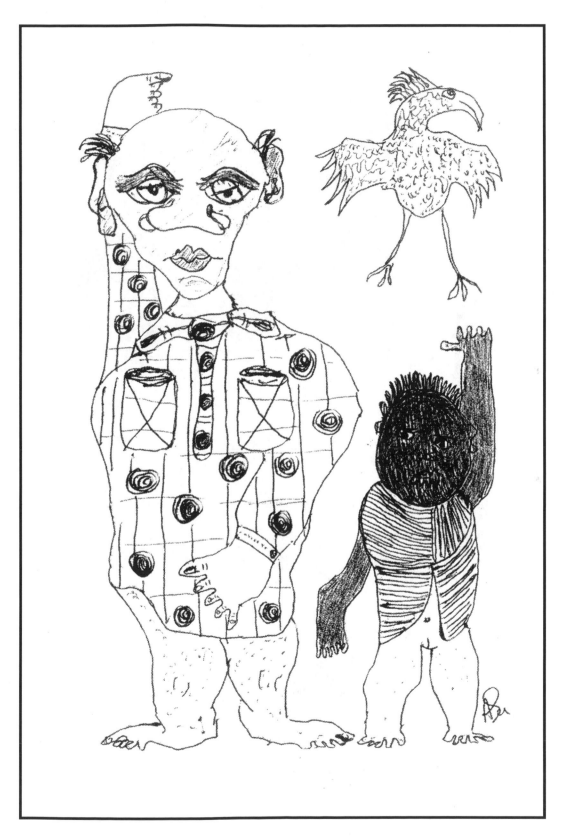

Bozo And Sambo

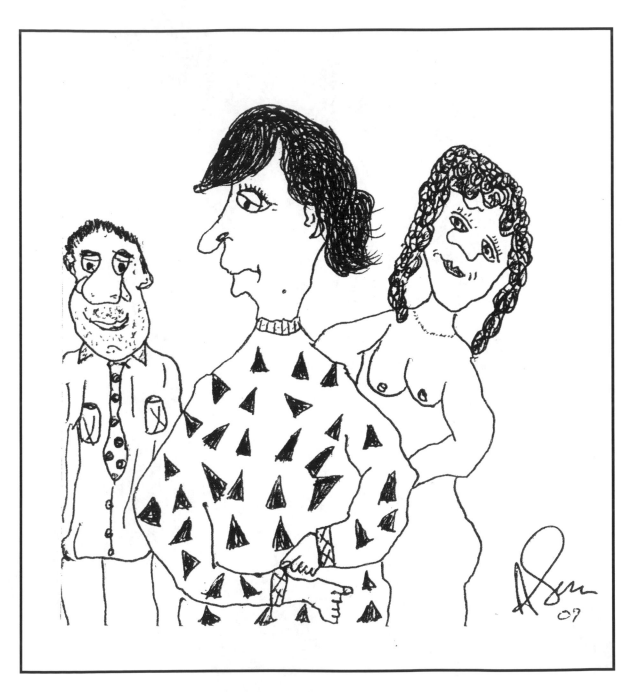

Eve Flirting With Argyle

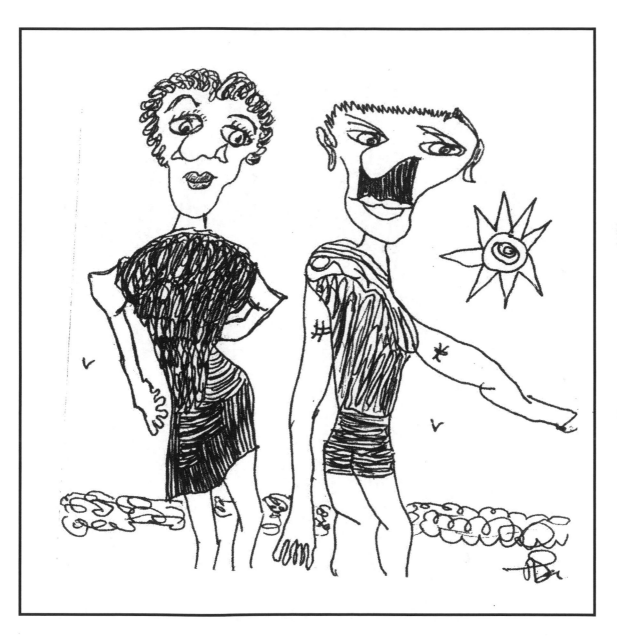

The Francellos

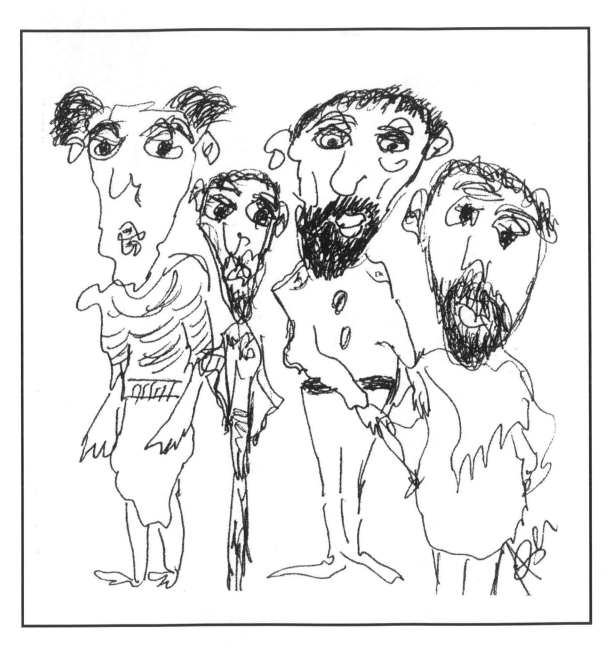

Three Bearded Sons

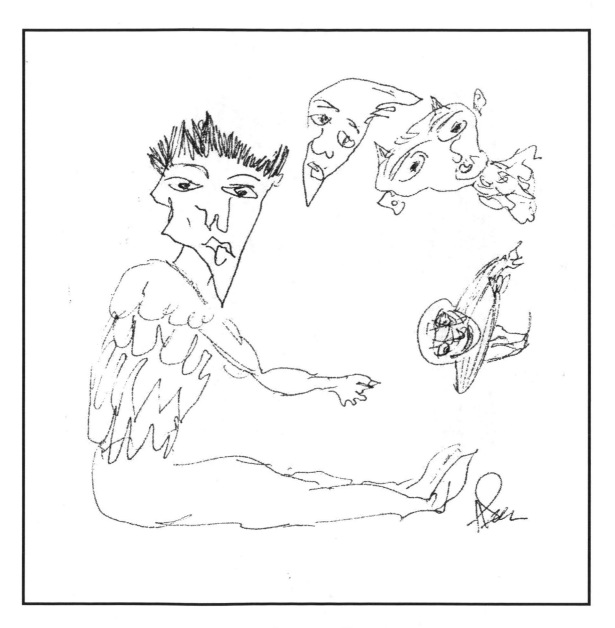

Three Spirit Sit-Ups

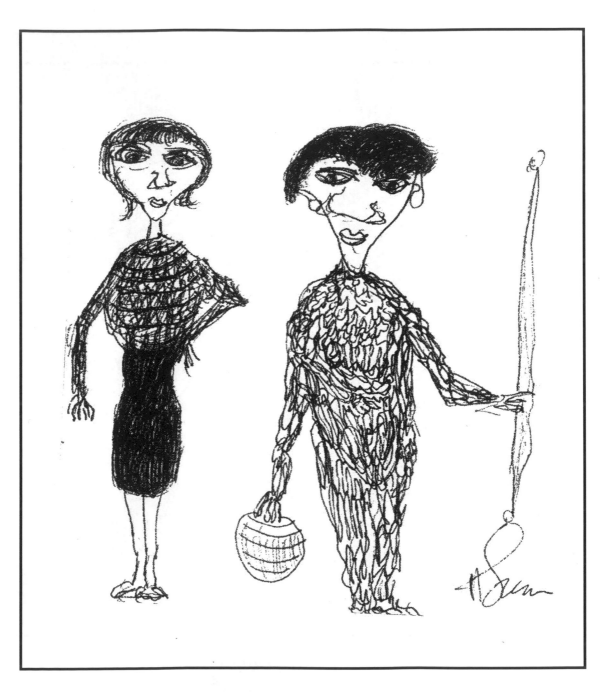

Post Divorce Fishing Trip

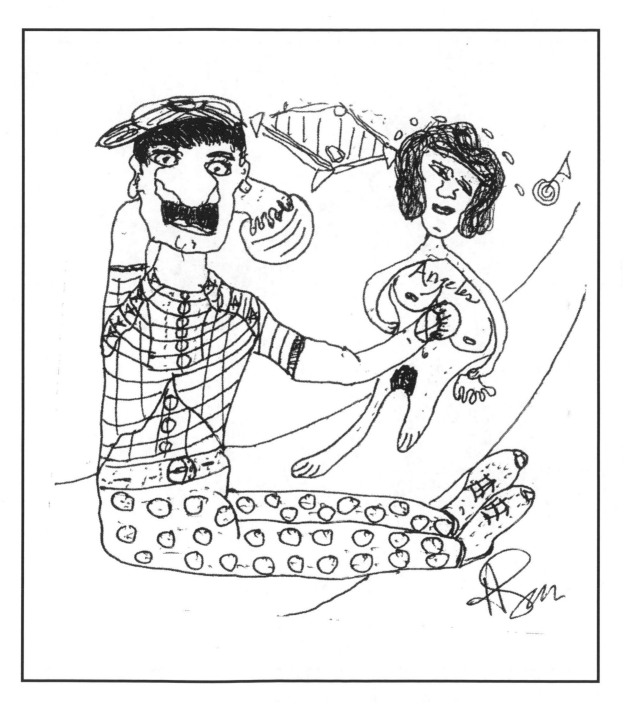

Coed Baseball

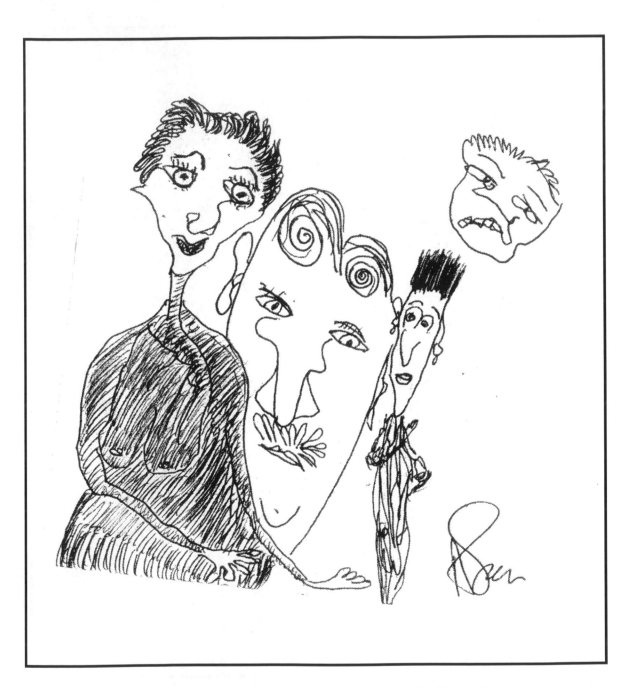

Big Valentine's Day Head Card

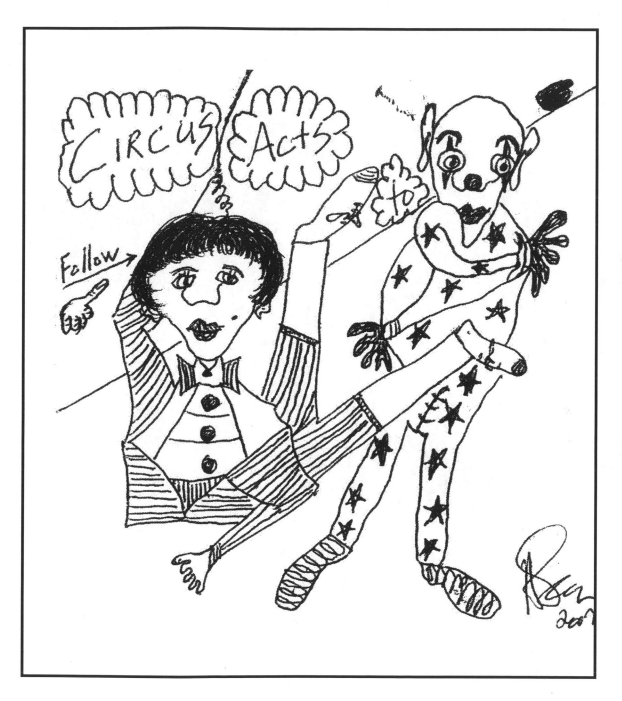

Circus Acts

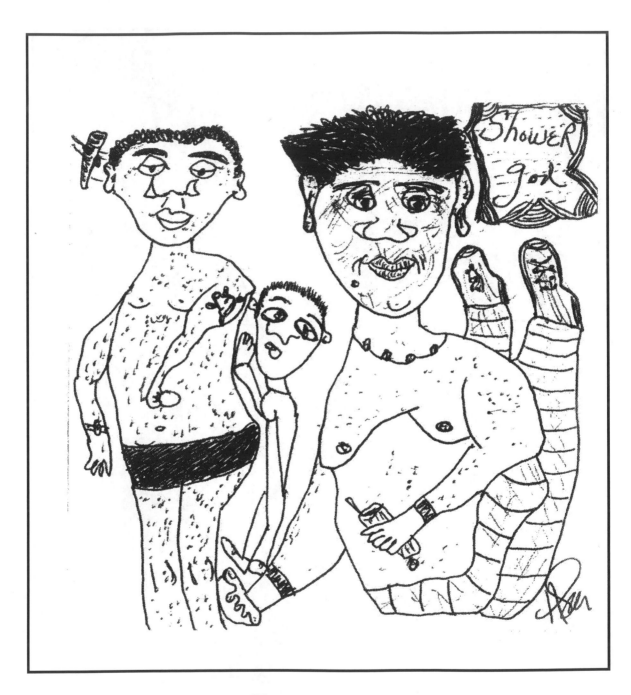

Shower Line

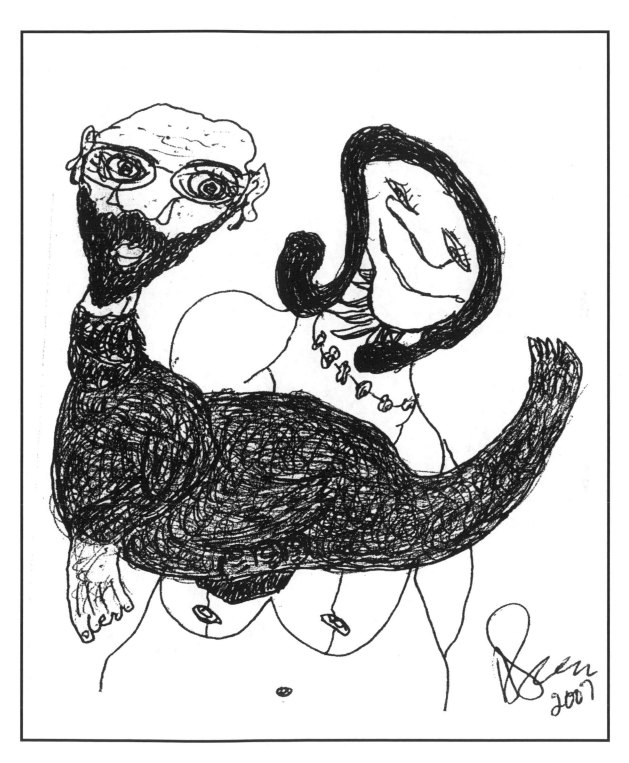

Lou-Seal

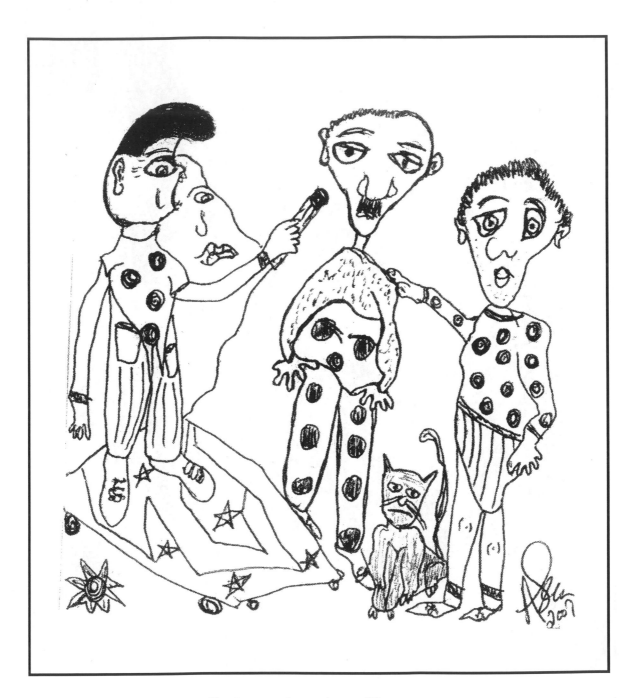

Interviewing Ryan

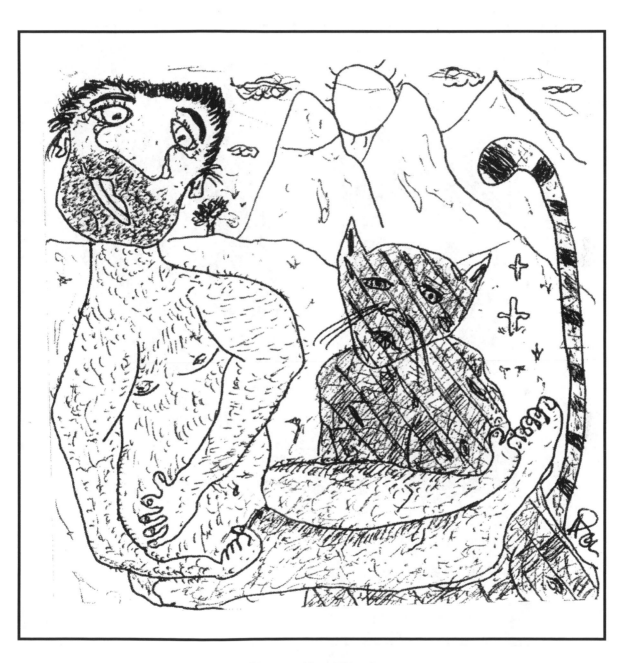

Cain In Nod

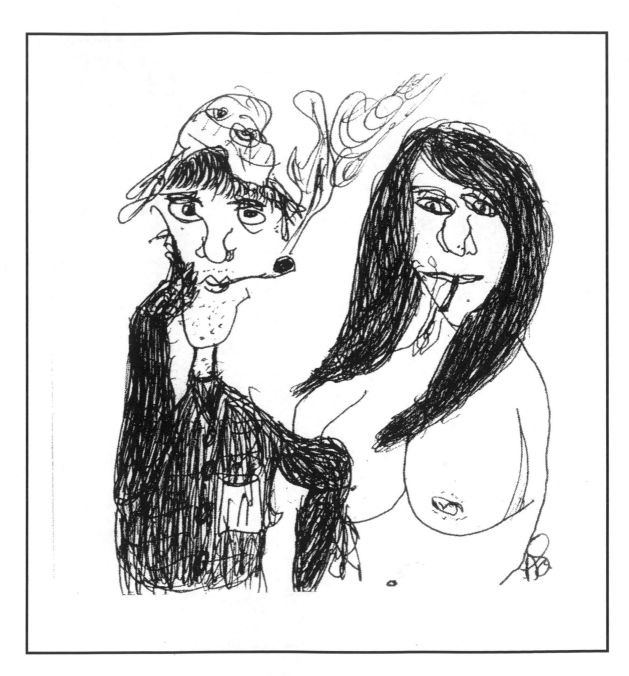

The Joplins

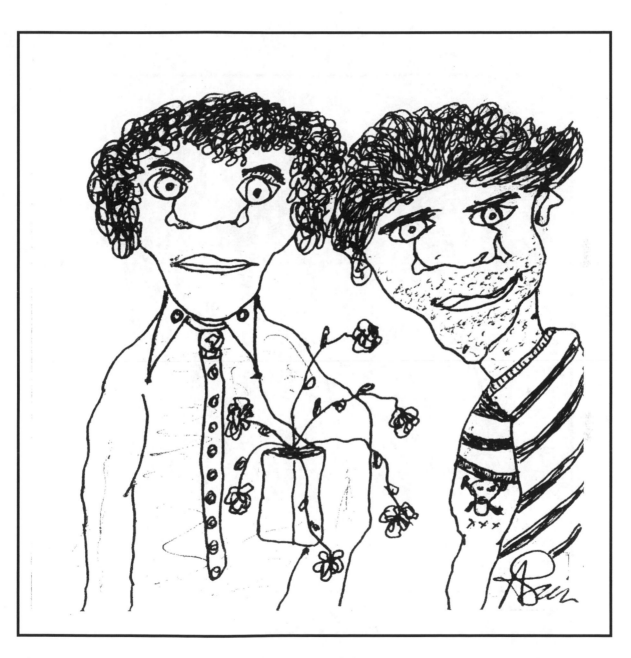

The Florist Brothers

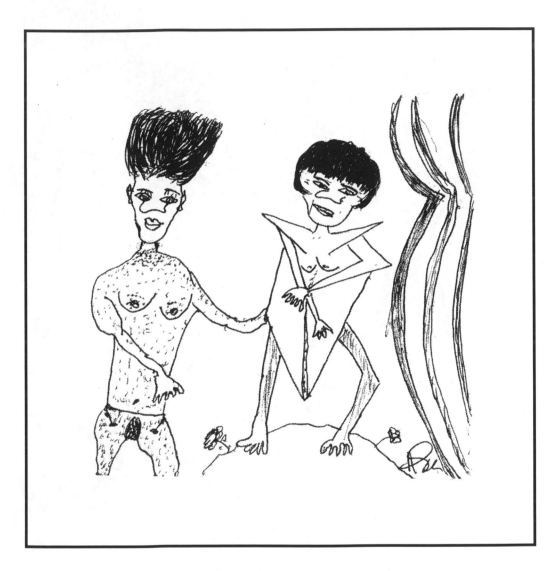

Card Woman

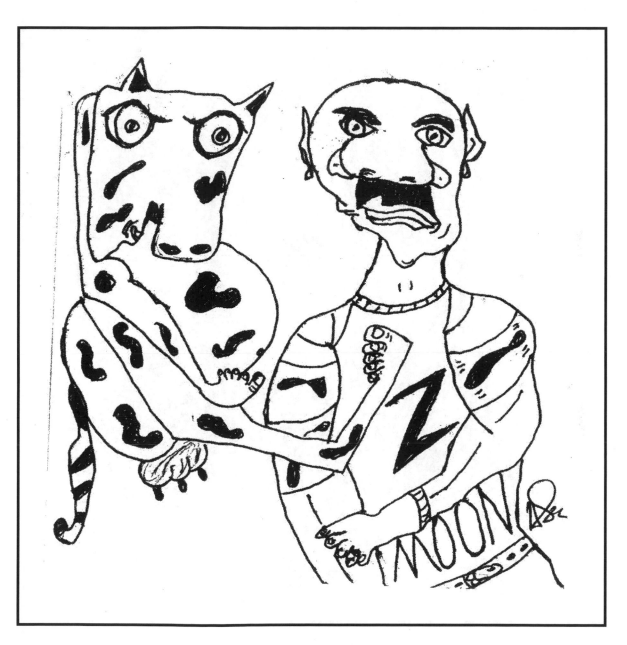

Z Moon

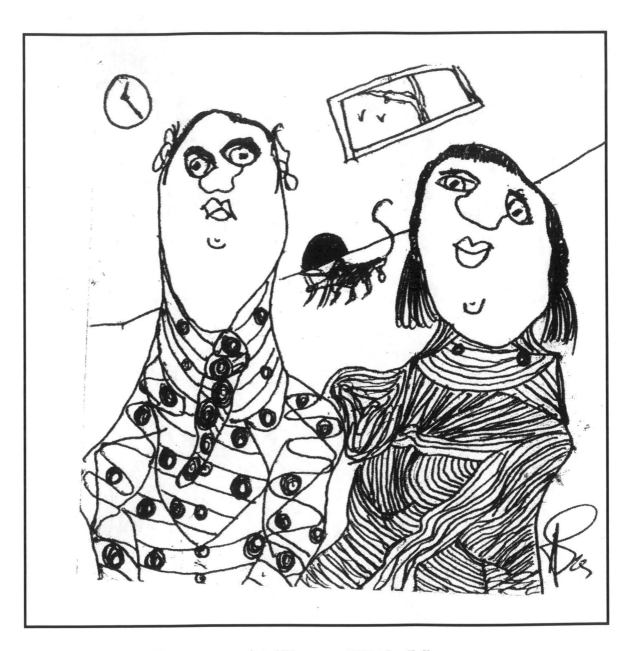

Zippers At Home With Mouse

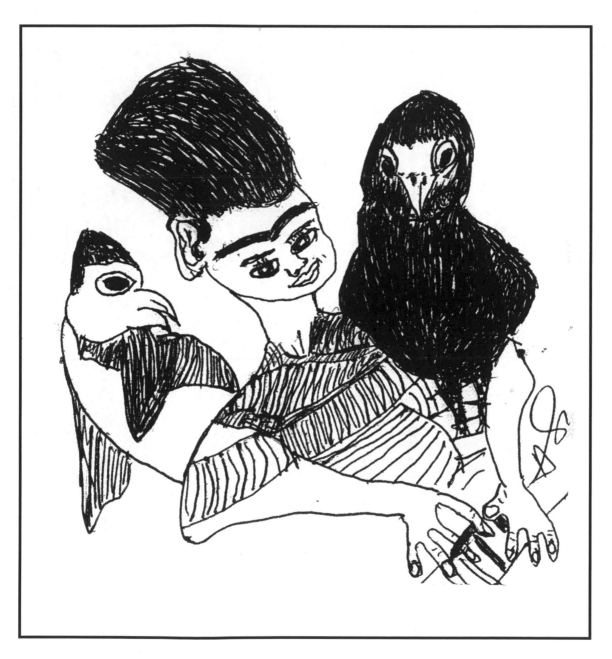

Crow Woman

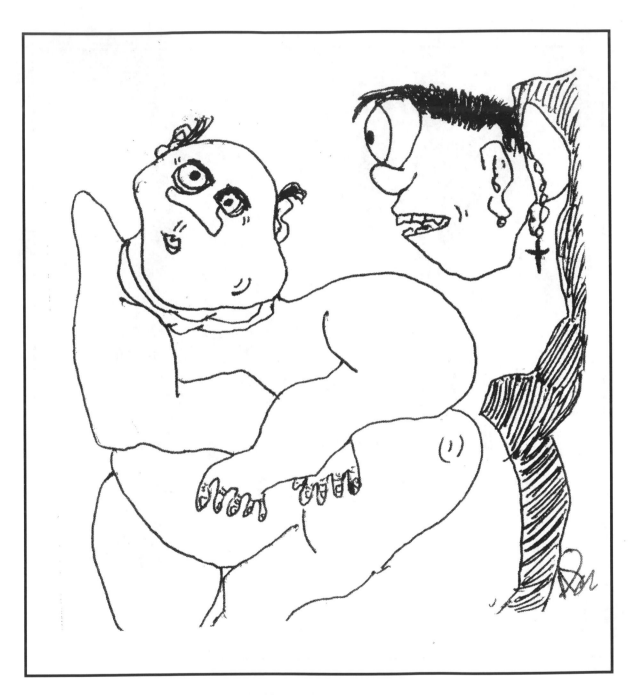

Tess Saddlebag

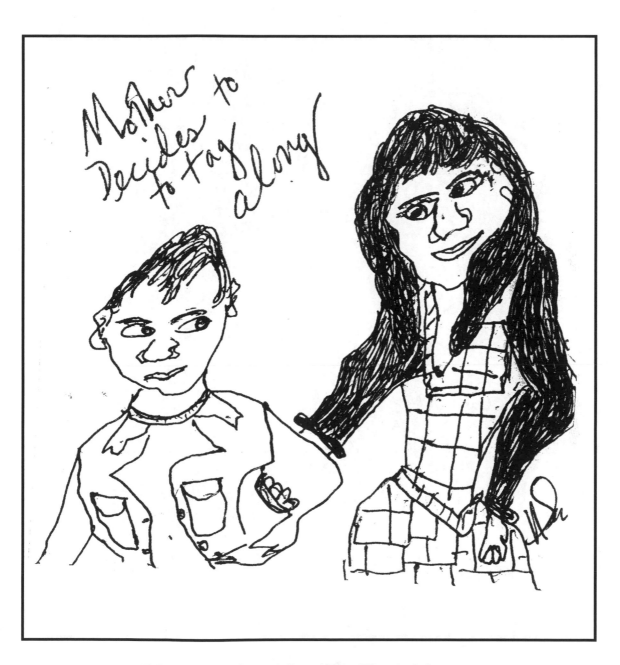

Mother Decides To Tag Along

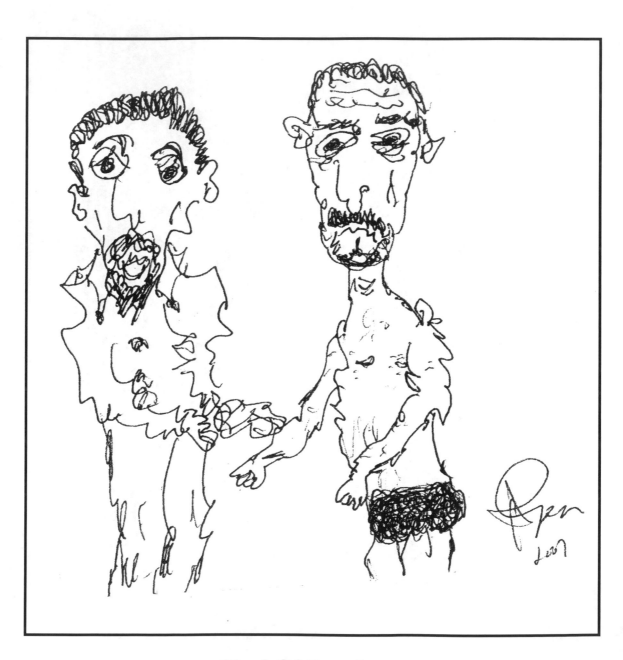

End Of Gaydom

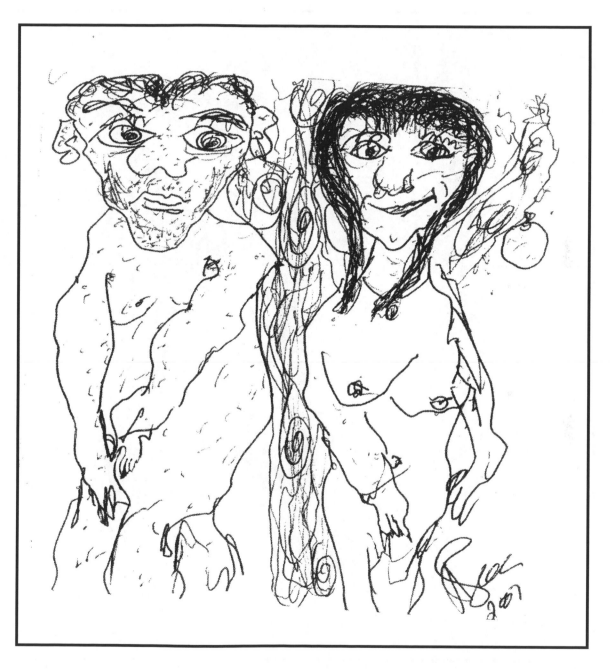

Adam And Eve Hiding Genitals

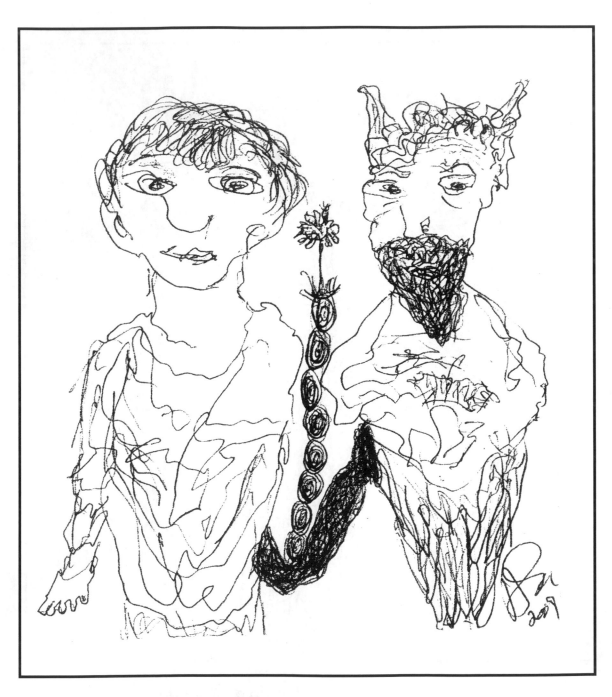

My Pal Satan

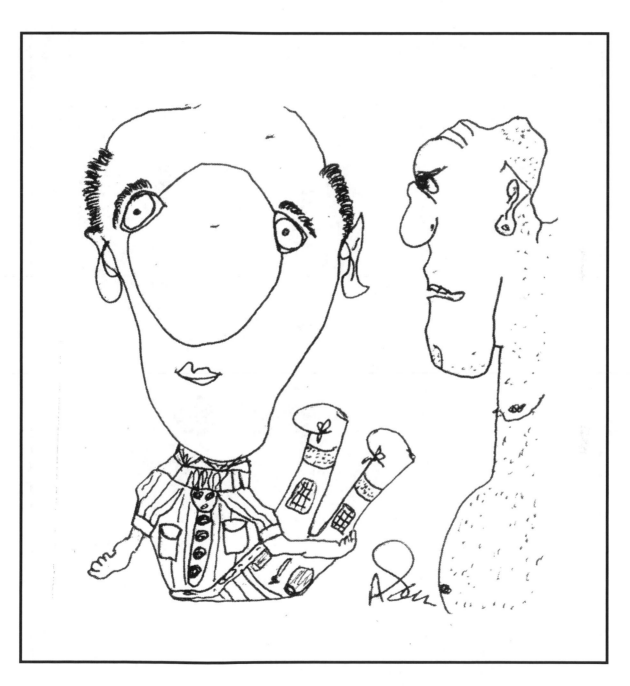

Big Headed Man Doing Yoga

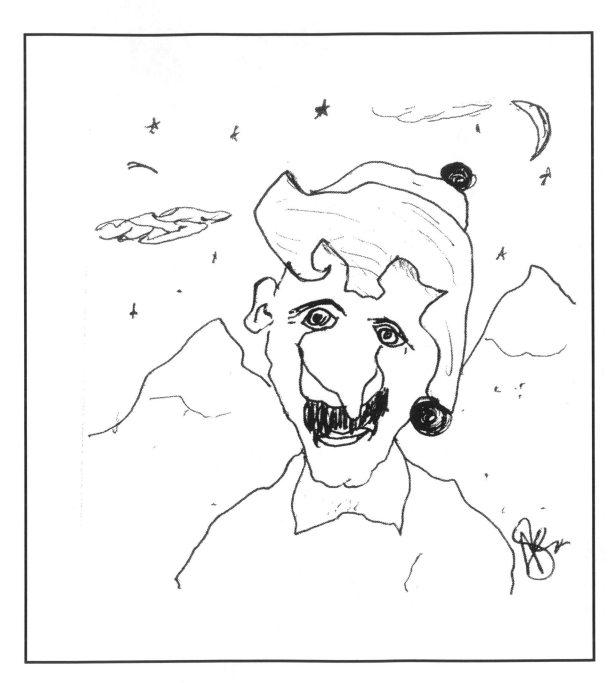

Somecata The Gypsy-Man

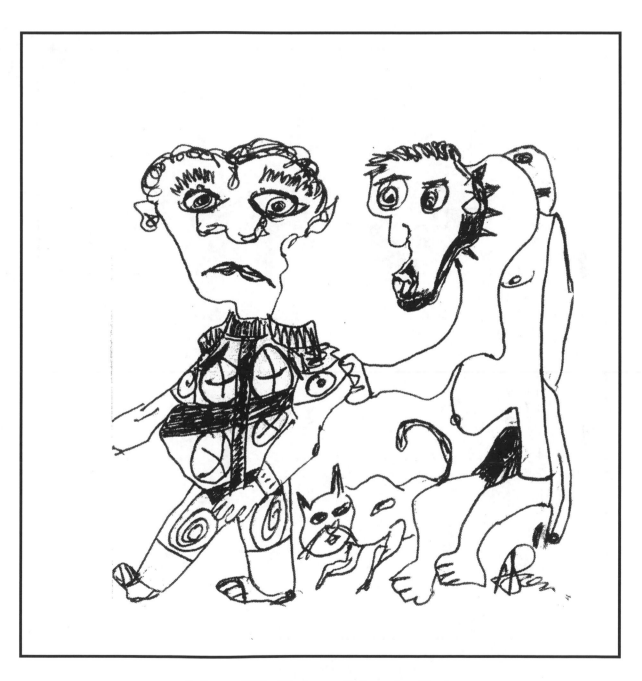

Man Walking Monk Cat

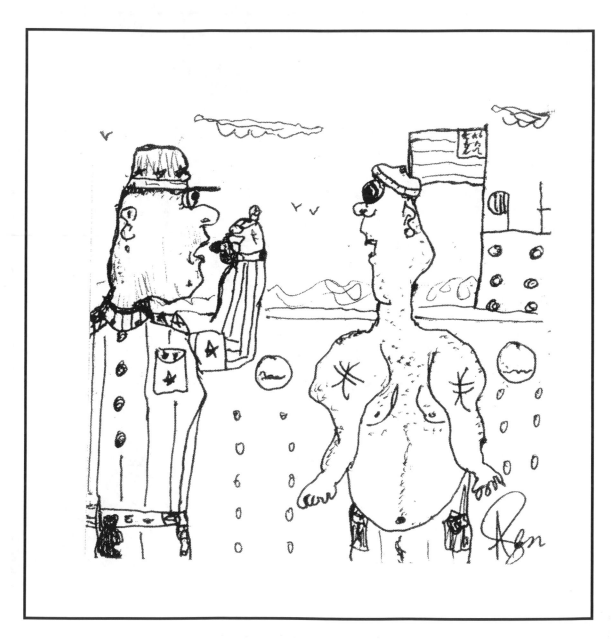

Sailor In Trouble

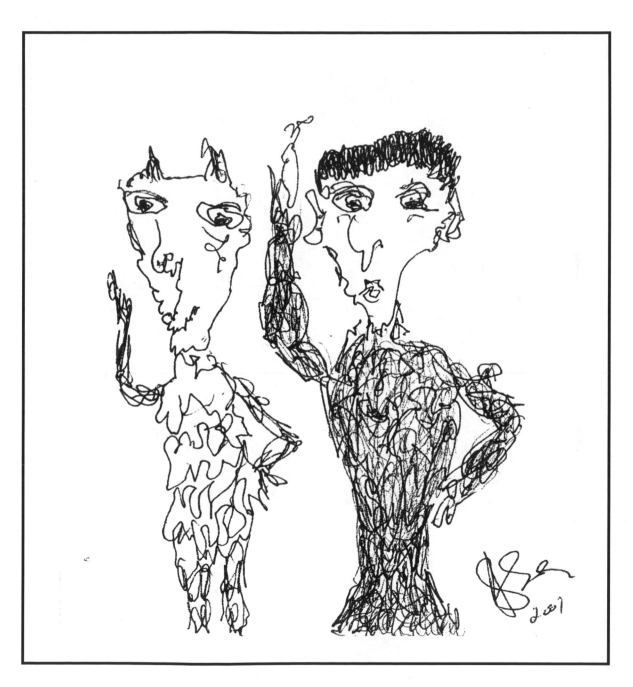

Satan's Curtain Call

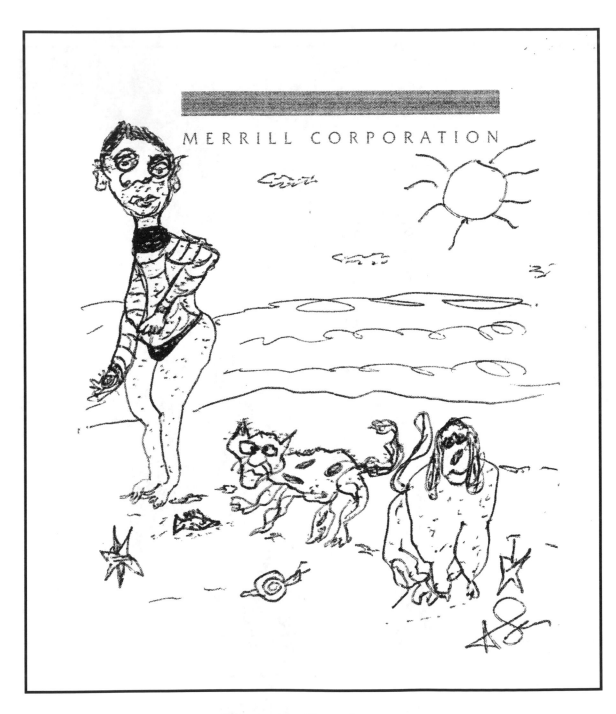

Beach Combing

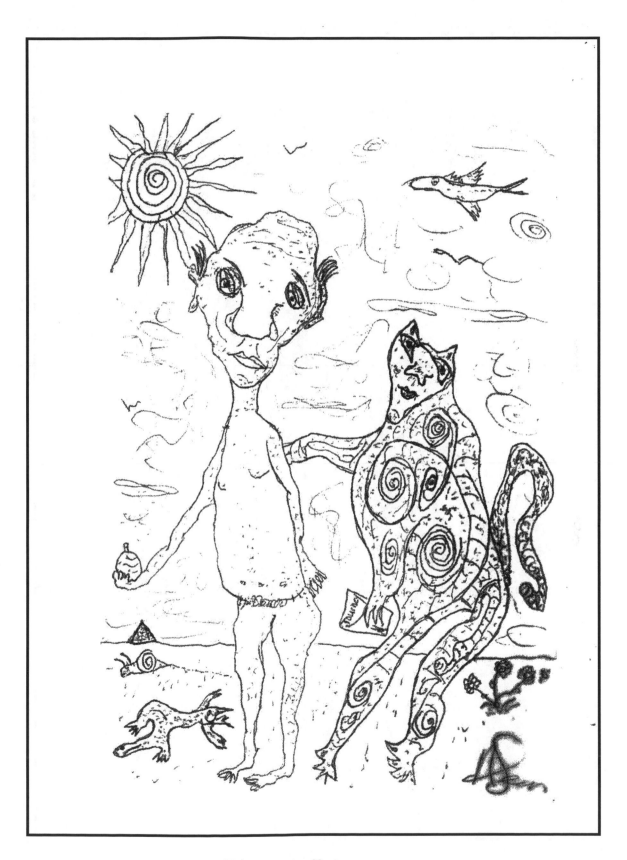

Desert Journey

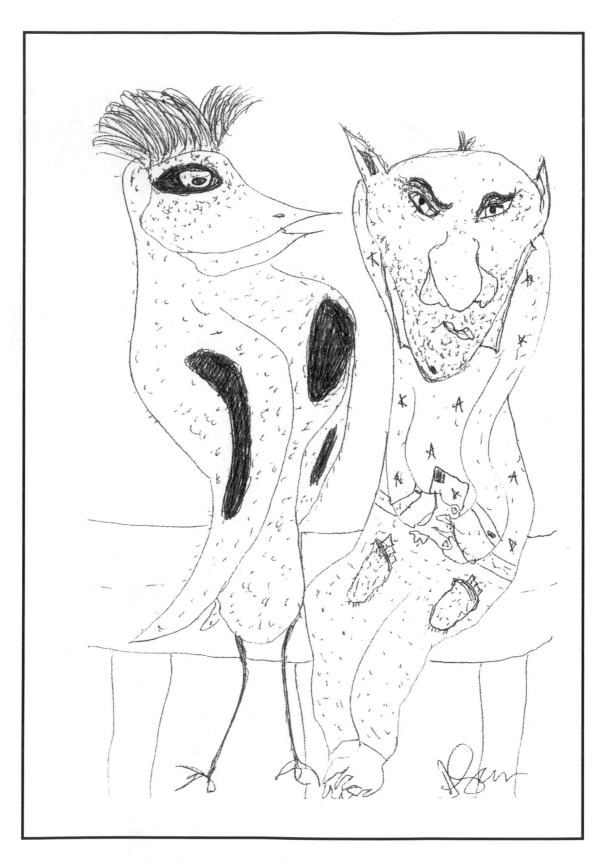

Benched By A Cuckoo Bird

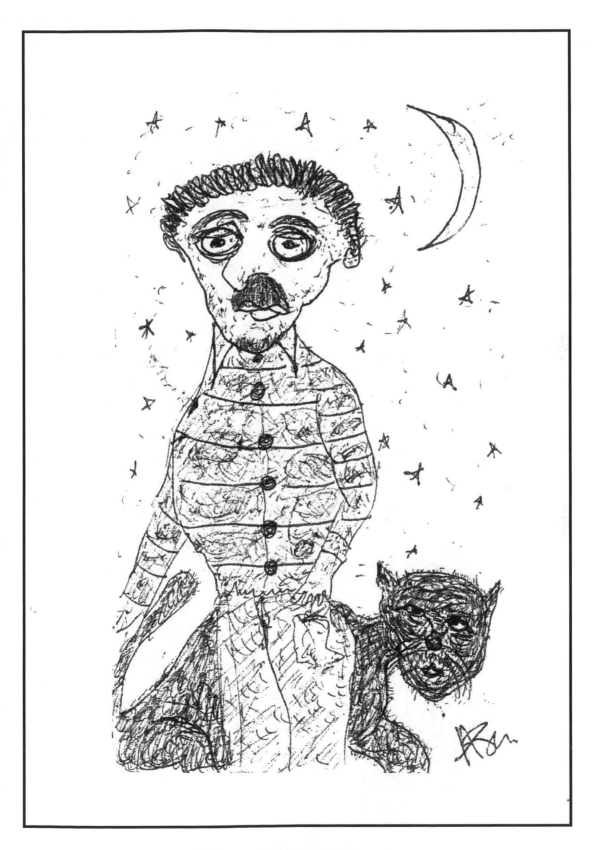

Moonlight Reject

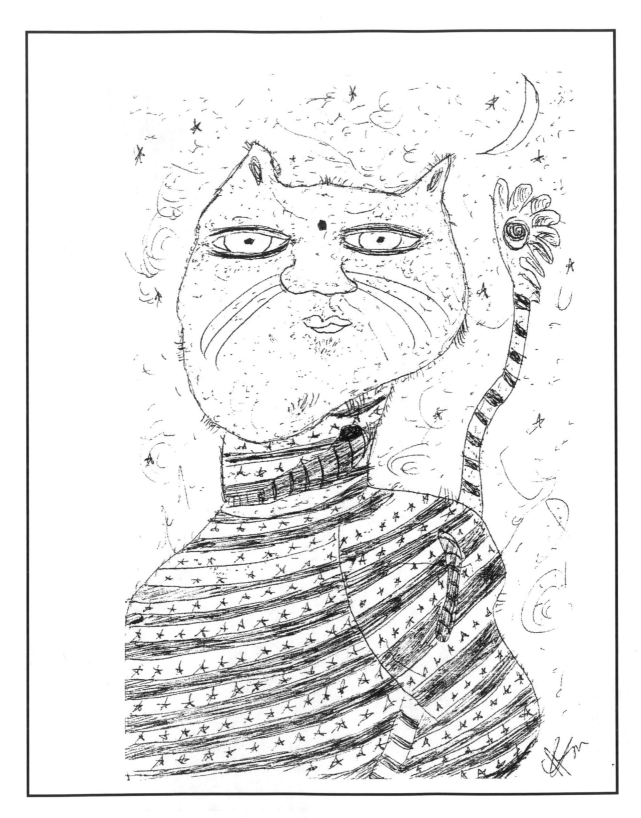

Tom

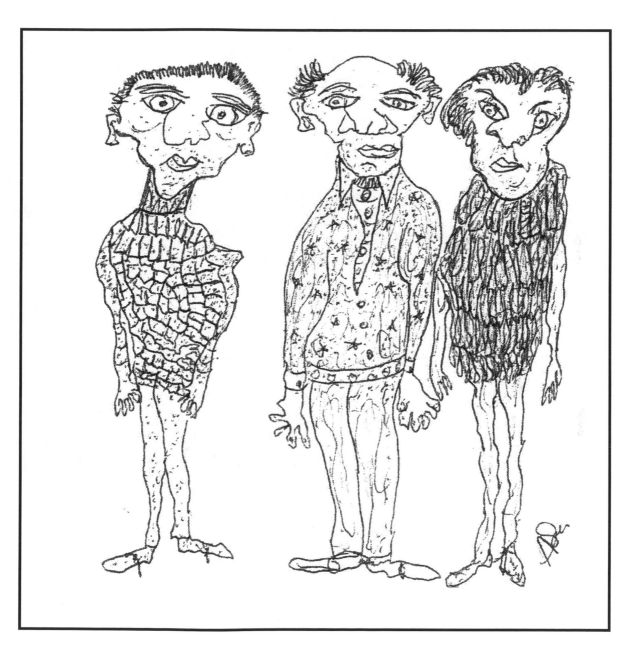

Their Only Son

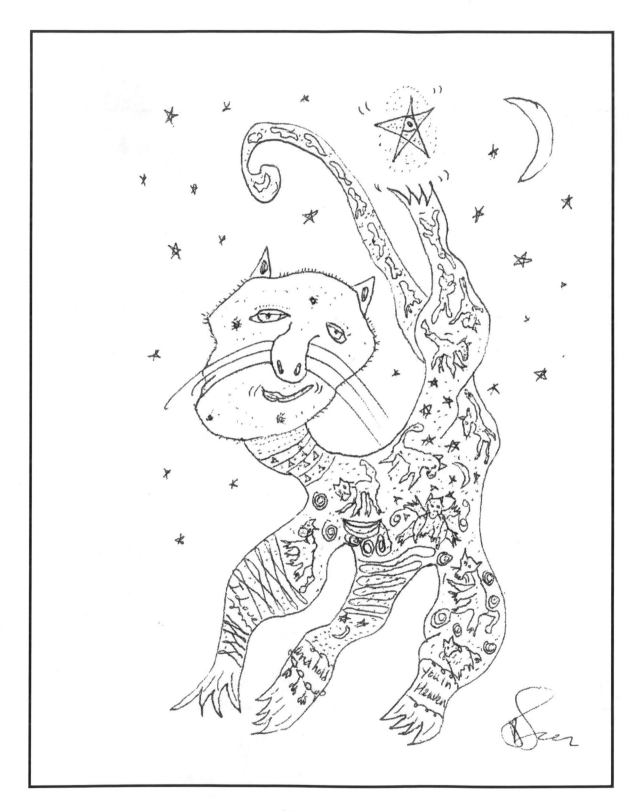

Starcat

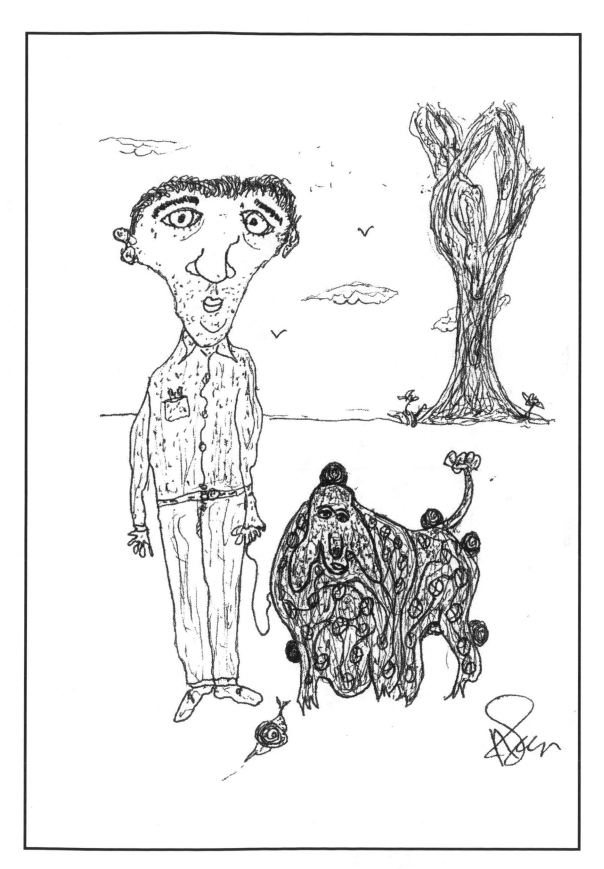

Kyle's Poodle

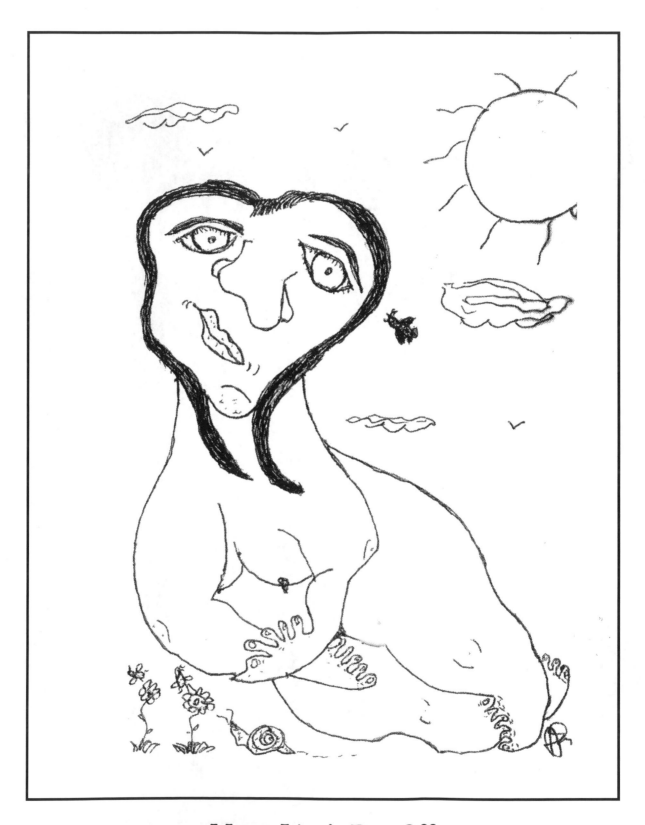

Mona Lisa's Day Off

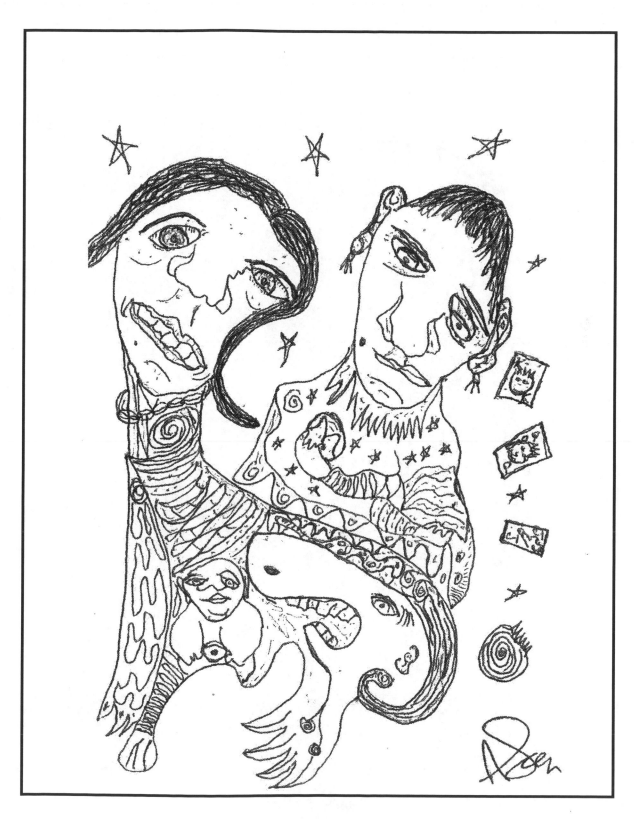

Bad Tarot

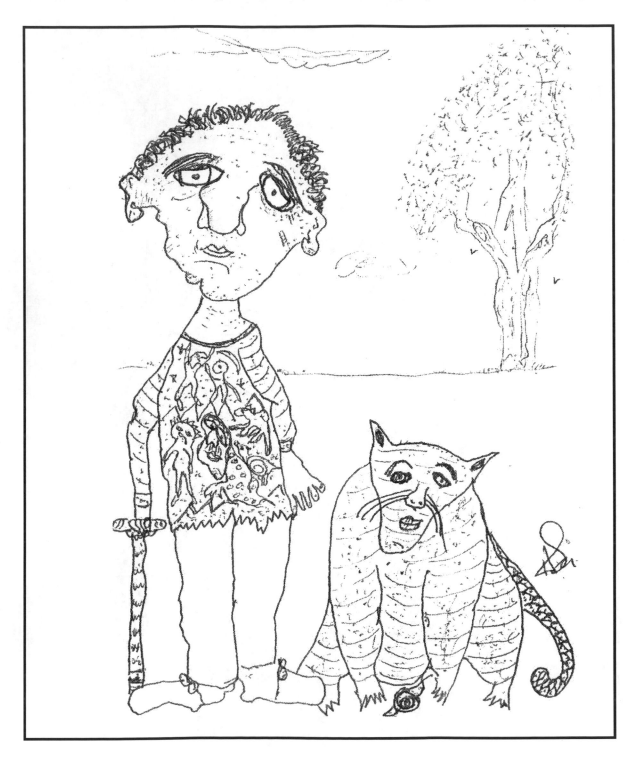

Cat's Pete

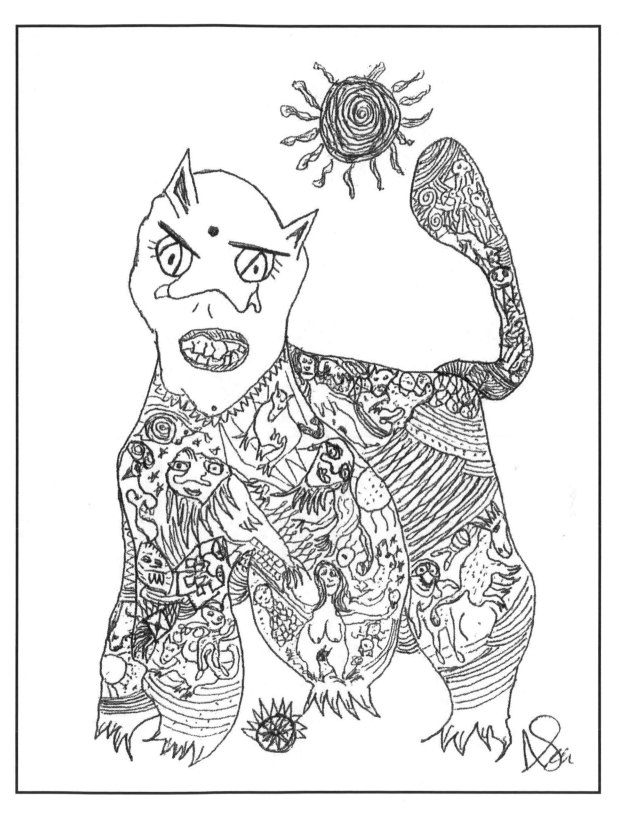

Kabuki Cat

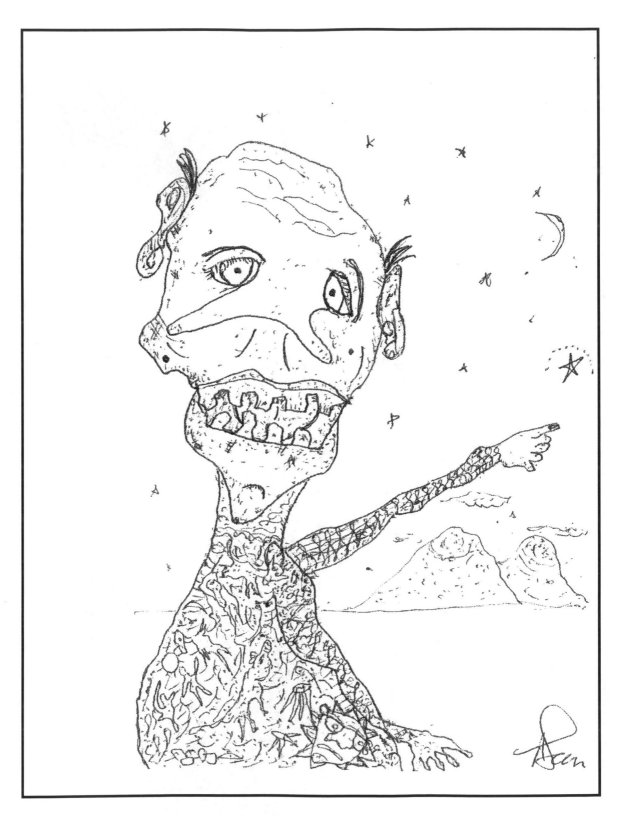

Wisdom Teeth

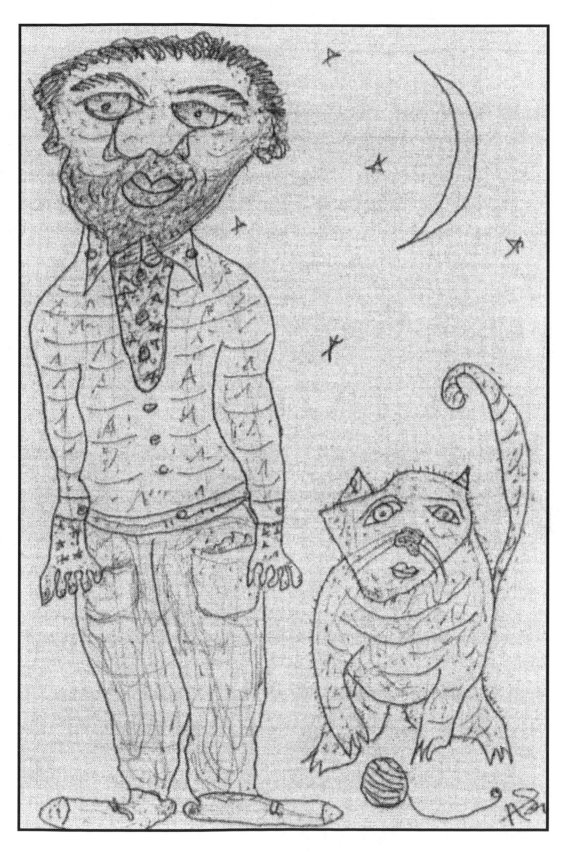

My Cat Cat

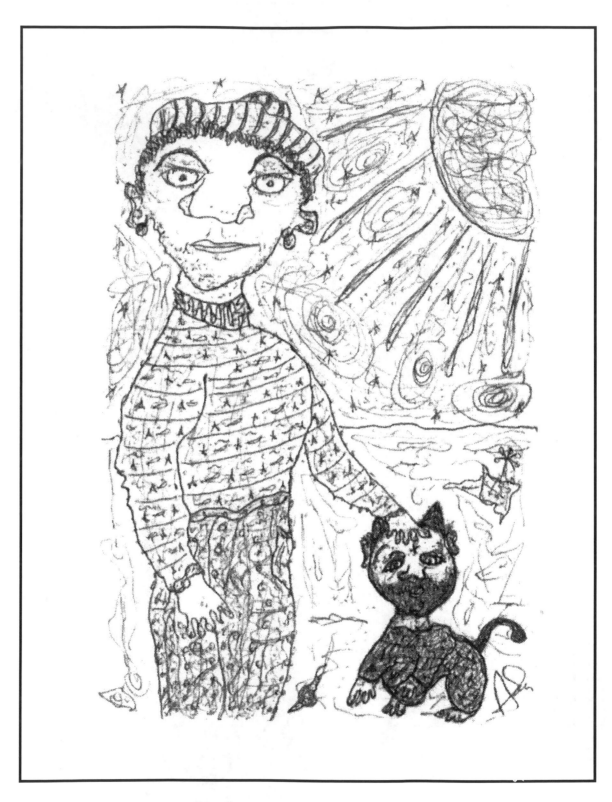

Lancette and Freud

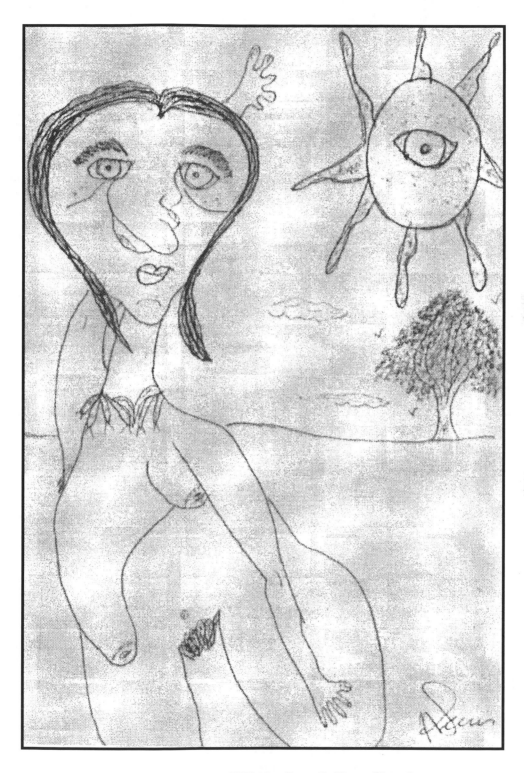

Eve Being Watched By God

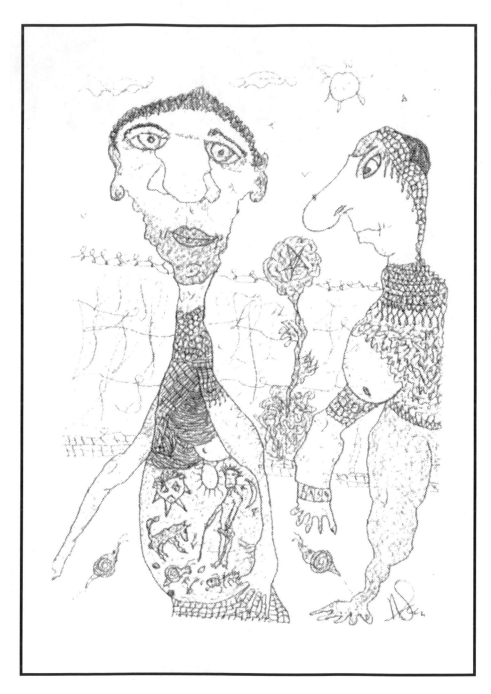

Ellen Phata's Son

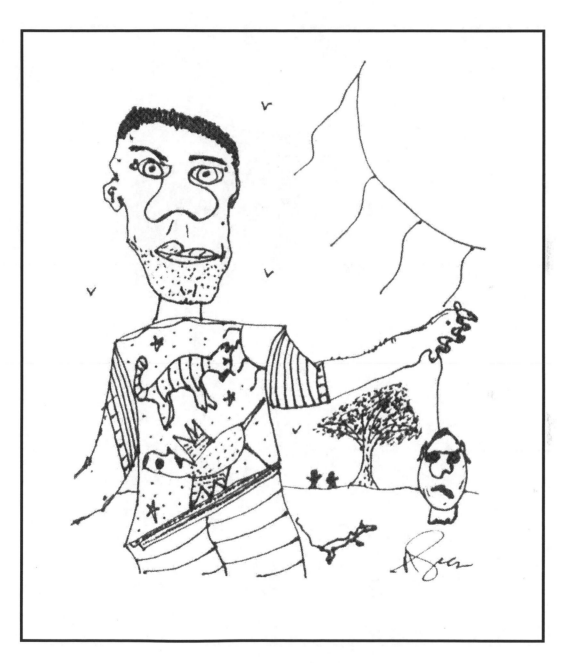

Zuma's Head

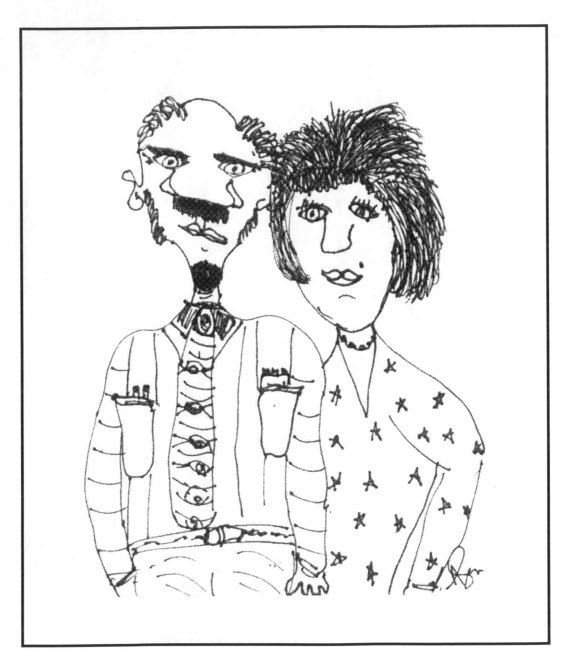

The Gostofs

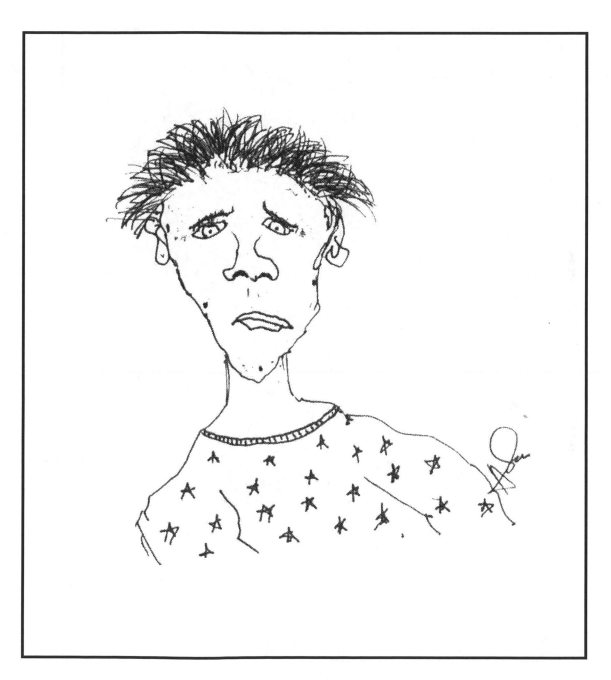

Pajama

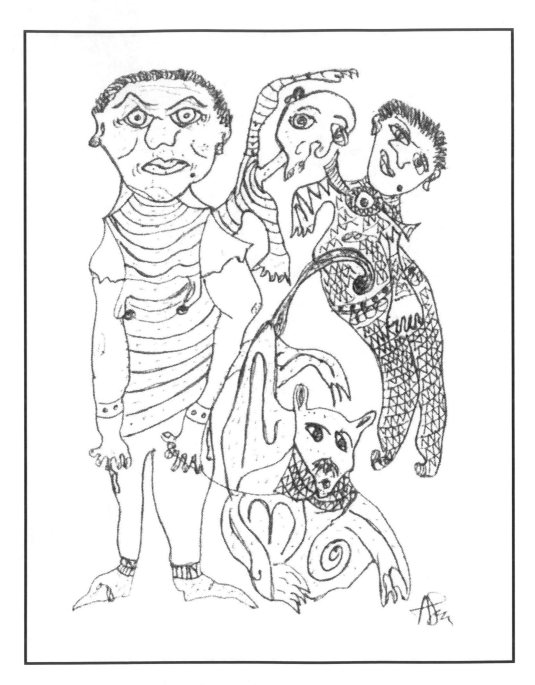

Leaving Home With Pet 'Peeve'

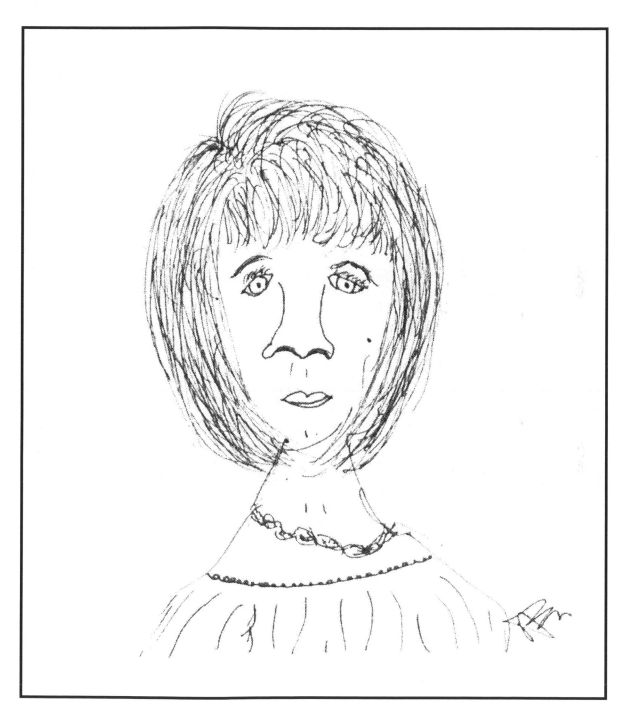

Leticia

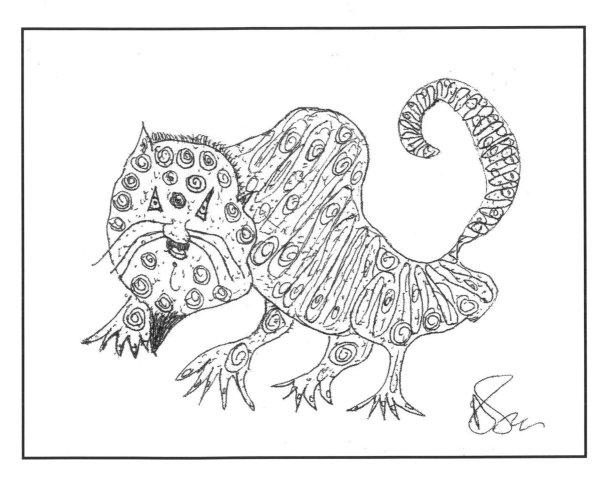

Disney Reject

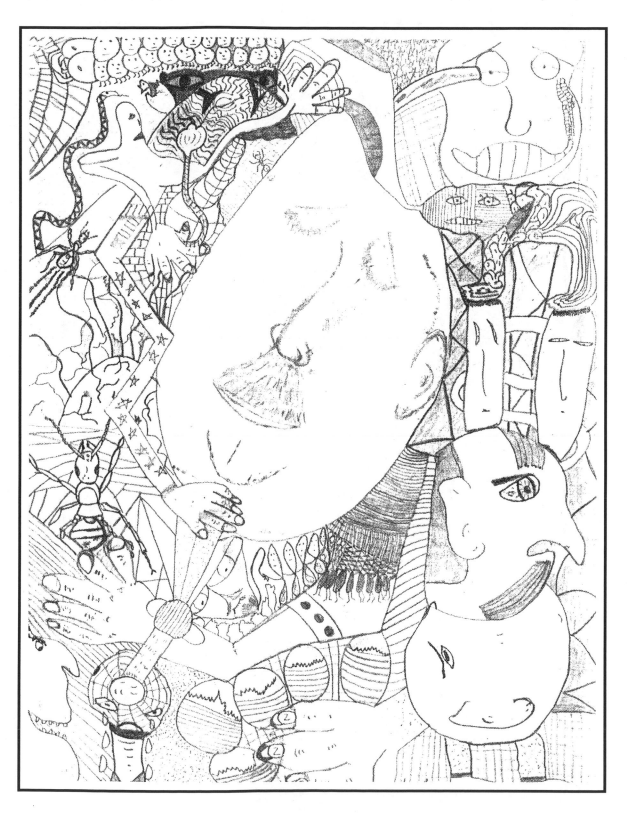

Man Dreams

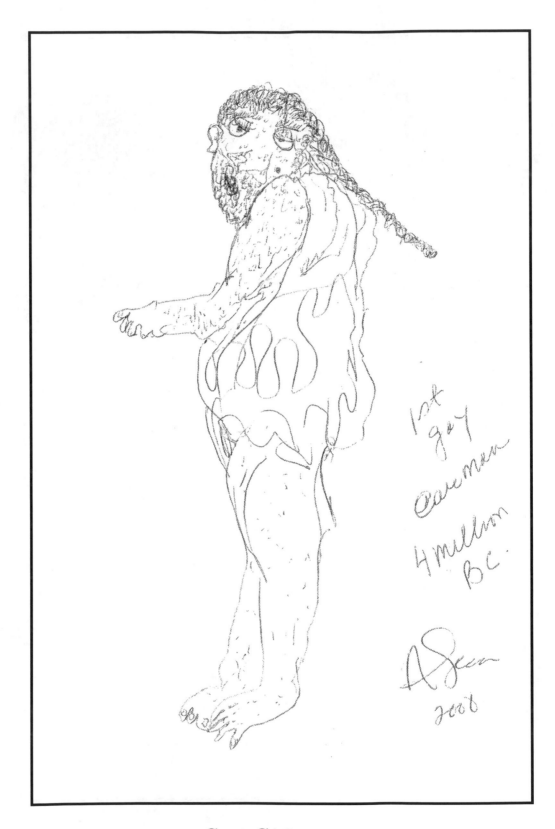

Gay Caveman

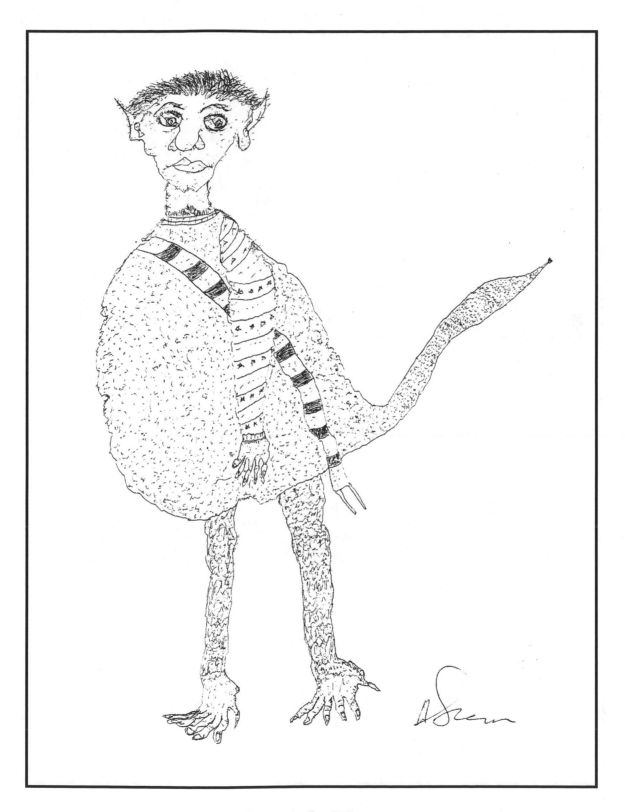

Ostrich Man

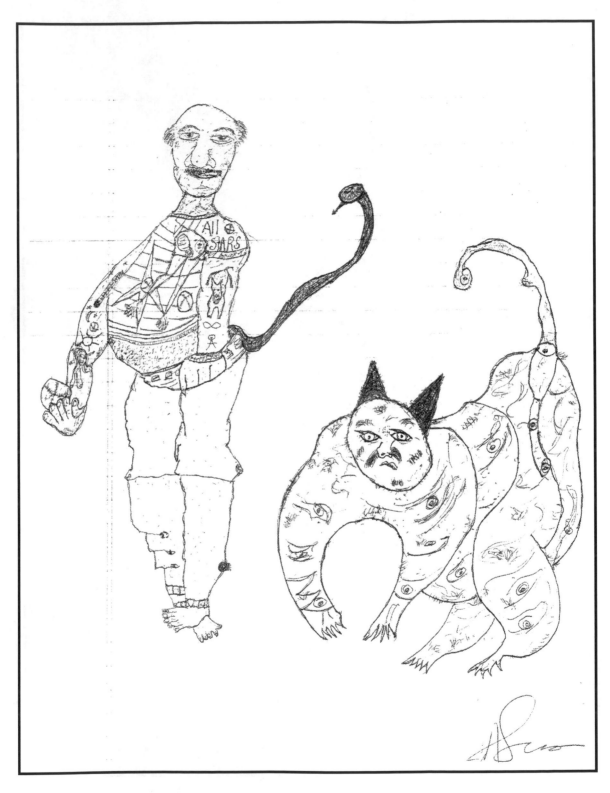

All Stars

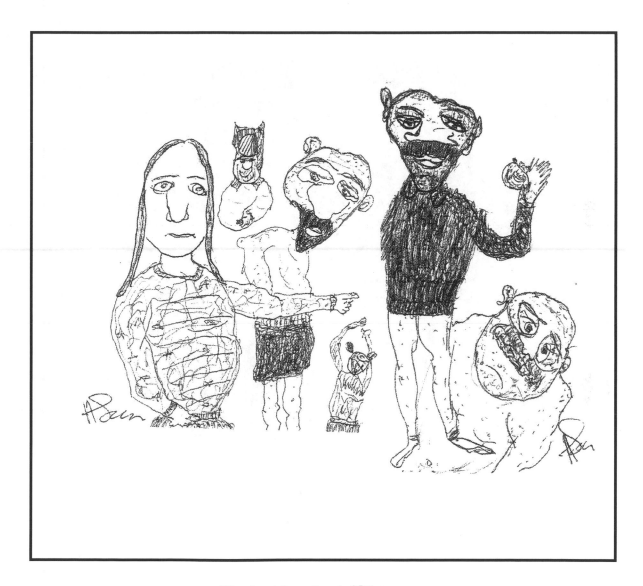

Pointing at Pierre

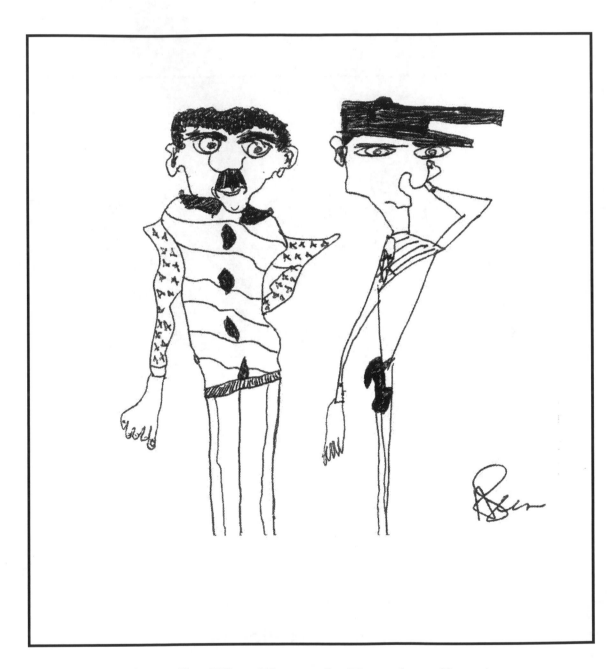

A Gay In The French Foreign Legion

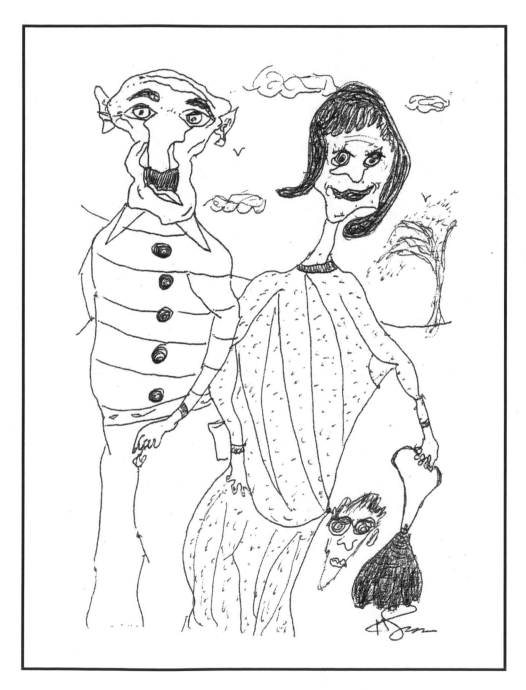

Walking To The Theater

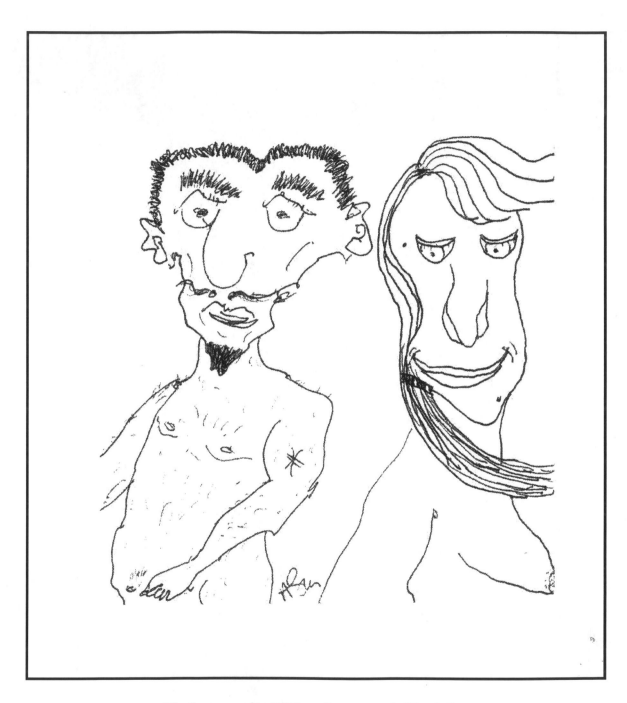

Tolouse's Windswept Bride

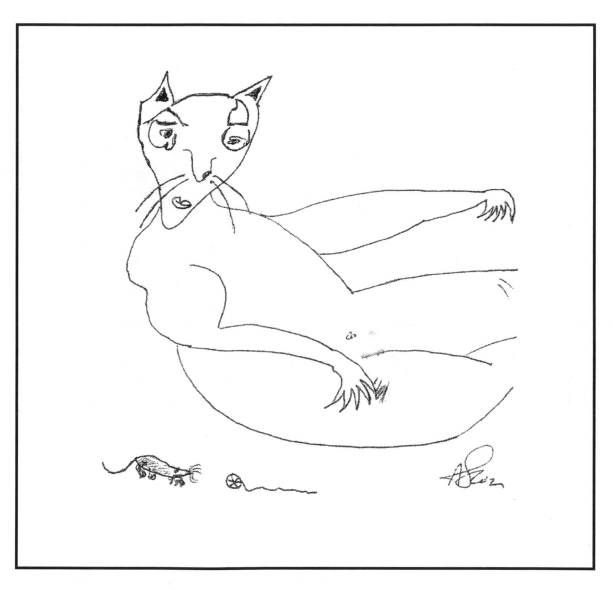

A Feline's Ploy

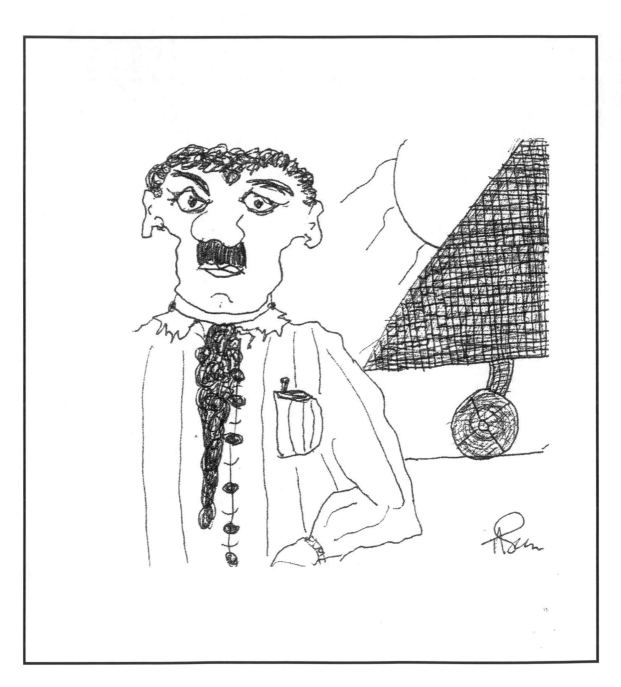

Pyramid On Wheels Tour Guide

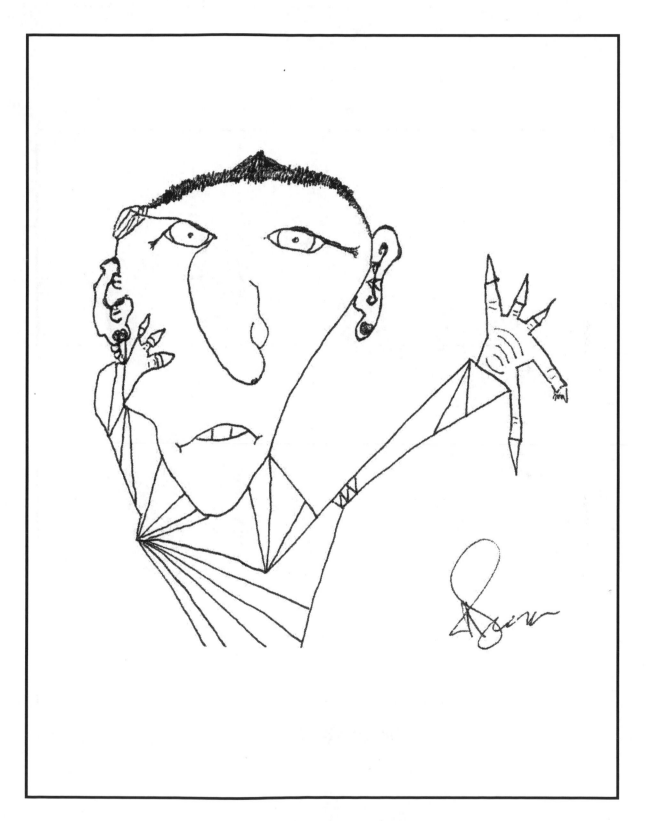

Stop The Mayhem

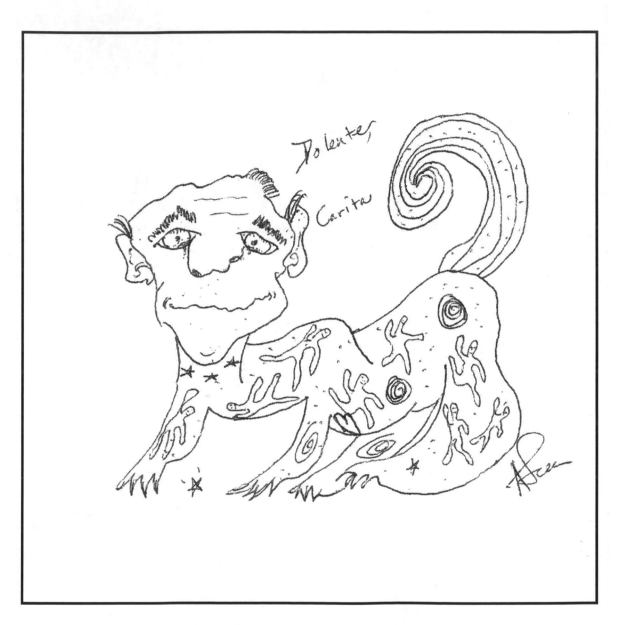

Dolente Carita

About the Author

Neil Baker is a novelist, short story writer, poet, artist, and a world renowned psychic. Neil also holds a degree in Psychology and has been a psychodramatist for a private psychiatric hospital. Neil has also managed a theater, candy store, golf store, All Night 7-11 and a motel. He has been a Child's Activities Director, Senior Director, gravedigger and Big Foot tracker and has accomplished this variety of roles while maintaing a somewhat questionable existence within the severe, physical contours of the earth.